Picturing French Style

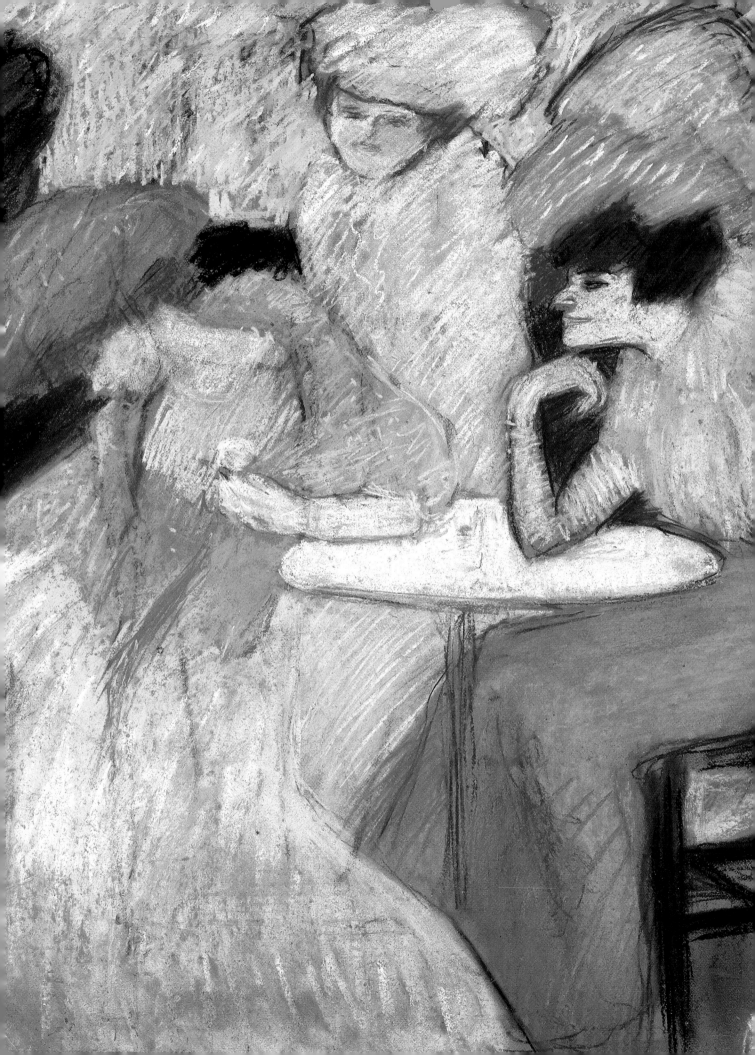

Picturing *French Style*

Three Hundred Years of Art and Fashion

Jill Berk Jiminez

with essays by Kimberly Chrisman Campbell
Melissa Leventon
Sean M. Ulmer

Mobile Museum of Art
Mobile, Alabama

The J. L. Bedsole Foundation
Catalogue Sponsor

The J. L. Bedsole Foundation is a private, charitable foundation established by J. L. Bedsole in Mobile, Alabama, that became fully funded after his death in 1975. The Foundation makes grants for "such public, charitable, scientific, or educational uses or purposes" as its Distribution Committee may select. The Distribution Committee has determined that the continuing health, welfare, and prosperity of the citizens of Southwest Alabama are best assured, first, by providing greater post-secondary educational opportunities for worthy youth and, second, by supporting expanded civic, cultural, artistic, social service, health service, commerce, and economic development opportunities. Currently, the Foundation's primary projects include the J. L. Bedsole Scholars Program, the Martin Luther King Avenue Redevelopment Corporation, and the Centre for the Living Arts. Foundation support is limited to Southwest Alabama.

Cover: Madame Grès, *Evening dress*, pl. 104 (p. 209); right details, top to bottom: Pierre Bonnard, *Study for La revue blanche Poster*, pl. 49 (p. 114); Antoine-François Callet, *Portrait of Louis XVI*, pl. 18 (p. 61); Jules-Joseph Lefebvre, *The Language of the Fan*, pl. 59 (p. 131); Pablo Picasso, *L'apéritif*, pl. 76 (p. 161); Henri Matisse, *Portrait à la toque velours bleue*, pl. 80 (p. 168)

Details: p. 2, Pablo Picasso, *Au café*, pl. 77 (p. 163); p. 30, Antoine-François Callet, *Portrait of Louis XVI*, pl. 18 (p. 61); p. 64, Louis-Hippolyte Lebas, *La marchande d'amour*, pl. 34 (p. 87); p. 90, Jacques-Emile Blanche, *Portrait of Mrs. Holland*, pl. 44 (p. 108); p. 148, Christian Dior, *Soirée fleurie*, pl. 97 (p. 197); p. 210, Matthieu Manche, *World Cup*, pl. 106 (p. 214)

Exhibition Itinerary

Mobile Museum of Art, Alabama
September 6, 2002–January 5, 2003

Norton Museum of Art, West Palm Beach, Florida
February 4–April 27, 2003

Library of Congress Control Number: 2002106745
ISBN: 1-893174-02-6

Distributed by
University of Washington Press
P.O. Box 50096
Seattle, WA 98145-5096

Edited by Suzanne Kotz
Designed by Susan E. Kelly
Proofread by Sharon Vonasch and Carrie Wicks
Index by Frances Bowles
Color separations by iocolor, Seattle
Produced by Marquand Books, Inc., Seattle
 www.marquand.com

Printed by C & C Offset Printing Co., Ltd., Hong Kong

Contents

Lenders to the Exhibition

The Appleton Museum of Art, Ocala, Florida
Birmingham Museum of Art, Alabama
California State University, Long Beach Library
Chicago Historical Society, Illinois
Chrysler Museum of Art, Norfolk, Virginia
Sterling and Francine Clark Art Institute,
 Williamstown, Massachusetts
Columbia Museum of Art, South Carolina
The Columbus Museum, Georgia
Columbus Museum of Art, Ohio
Cooper-Hewitt, National Design Museum,
 Smithsonian Institution, New York
The Costume Institute, The Metropolitan Museum
 of Art, New York
The Detroit Institute of Arts, Michigan
The Fine Arts Museums of San Francisco, California
Flint Institute of Arts, Michigan
The Frances Lehman Loeb Art Center, Vassar College,
 Poughkeepsie, New York
Bernadette Genée Collection, Concerneau, France
GOTSCHO Collection, Paris, France
Herbert F. Johnson Museum of Art, Cornell University,
 Ithaca, New York
Hillwood Museum and Gardens, Washington, D.C.
Hirshhorn Museum and Sculpture Garden,
 Smithsonian Institution, Washington, D.C.
Anne and William J. Hokin Collection, Chicago, Illinois
Honolulu Academy of Arts, Hawaii
Iris and B. Gerald Cantor Center for Visual Arts,
 Stanford University, California
The Jewish Museum, New York
The John and Mable Ringling Museum of Art,
 Sarasota, Florida
Joslyn Art Museum, Omaha, Nebraska
Kent State University Art Museum, Ohio
Krannert Art Museum, University of Illinois,
 Urbana-Champaign

Christian Lacroix Collection, Paris, France
Lauren Rogers Museum of Art, Laurel, Mississippi
Los Angeles County Museum of Art, California
The Louisiana State Museum, New Orleans
Matthieu Manche Collection, Tokyo, Japan
The Maryland Historical Society, Baltimore
Annette Messager Collection, Paris, France
Minneapolis Institute of Arts, Minnesota
Montgomery Museum of Fine Arts, Alabama
Museum of Fine Arts, Springfield, Massachusetts
The Museum of Mobile, Alabama
Museum of the City of New York
National Gallery of Art, Washington, D.C.
The Nelson-Atkins Museum of Art, Kansas City,
 Missouri
New Orleans Museum of Art, Louisiana
North Carolina Museum of Art, Raleigh
Norton Museum of Art, West Palm Beach, Florida
Palmer Museum of Art, University Park, Pennsylvania
Philadelphia Museum of Art, Pennsylvania
The Philbrook Museum of Art, Tulsa, Oklahoma
Private collections
The Santa Barbara Museum of Art, California
The Sarah Campbell Blaffer Foundation, Houston,
 Texas
Snite Museum of Art, University of Notre Dame,
 Indiana
The Speed Art Museum, Louisville, Kentucky
The Stewart Museum at the Fort, Île Sainte-Hélène,
 Montreal, Quebec, Canada
Telfair Museum of Art, Savannah, Georgia
The Texas Fashion Collection, University of North
 Texas, Denton
Timken Museum of Art, San Diego, California
The Toledo Museum of Art, Ohio
Wadsworth Atheneum, Hartford, Connecticut
The Walker Art Center, Minneapolis

Foreword

The City of Mobile marks in 2002 the three-hundredth anniversary of its founding by the French. It is fitting that we celebrate the grand opening of the new Mobile Museum of Art during this anniversary year by bringing to the public *Picturing French Style: Three Hundred Years of Art and Fashion*. This inaugural exhibition features works of art and fashion that highlight the special relationship between these two cultural forces in France. It offers the viewer a chance to explore the reciprocal influences of art and fashion, and demonstrates the collaborative spirit that continues to thrive today among designers and artists.

An art exhibition of this magnitude does not come into being easily. The Mobile Museum of Art has been fortunate in having Jill Berk Jiminez as its curator of special exhibitions. She has worked tirelessly for the past three years to develop *Picturing French Style* and has done an outstanding job. I salute her dedication and tenacity.

Such a project could not occur without the generosity of our museum colleagues throughout the United States and abroad who have graciously lent their treasures to this exhibition. Their willingness to cooperate, at times without having any awareness of the Mobile Museum of Art's past history with organizing exhibitions, is a credit to the cooperative spirit of the museum community. We received many words of encouragement and offers of assistance from curators, registrars, and directors who considered the premise for the exhibition very interesting. It was also exciting to receive enthusiastic responses from contemporary French artists and organizations as well as the French government. I sincerely appreciate all the encouragement we have received from so many individuals.

It has been gratifying as well to receive enthusiastic support from the Mobile community for this exhibition. The board of directors of the museum has, from the beginning, been committed to making this project a huge success. The City of Mobile has been extremely helpful, especially Mayor Michael C. Dow and members of the Mobile City Council, in providing financial support to the staff and the exhibition. Most important, I want to thank The J. L. Bedsole Foundation for their generosity in making this exhibition catalogue possible. The commitment of the Foundation's Distribution Committee will enable this project to be a lasting tribute to Mobile's French heritage and the new Mobile Museum of Art.

Joseph B. Schenk, Director
Mobile Museum of Art

When Fashion Became Art

Kimberly Chrisman Campbell

"Fashion is an art," declared the French journalist Louis-Sébastien Mercier in his *Tableau de Paris* (1781–89), ". . . an art beloved and triumphant, which in this century has received honors and distinctions. This art enters into the palaces of kings, where it receives a flattering welcome. The *marchande de modes* passes through the guards to penetrate the apartments where even the highest nobility cannot enter."[1]

Fashion—*la mode*—historically has been a major economic force in France, but only in the late eighteenth century did it begin to be regarded as an art rather than a mere trade. This significant change in status coincided with the rise of the *marchandes de modes*, and one in particular: Marie-Jeanne "Rose" Bertin, Marie-Antoinette's "minister of fashion."[2]

Marchandes de modes (literally, "fashion merchants") did not just sell fashions, but fashion itself. For most of the eighteenth century, fashion sense was demonstrated not by the cut of one's clothes, which remained relatively static, but by the choice of trimmings and accessories. *Marchandes de modes*, who supplied these trimmings and accessories, thus dictated the entire course of eighteenth-century fashion (fig. 1).

Many of these influential women are anonymous today, and, even in their lifetimes, their names were known to only a select group of elite clients. By 1787, however, Rose Bertin's was "a name known . . . in all the countries of the world," according to a well-traveled witness, the marquis de Bombelles.[3] Today, we take it for granted that fashion designers can become international celebrities, but Bertin's achievement was remarkable for its time. Her origins were undistinguished, and the *ancien régime* offered few avenues for social mobility, particularly for unmarried women. Bertin overcame these obstacles through talent, ambition, ingenuity, and sheer force of personality. In the process, she elevated fashion from a trade to an art.

Born in 1747, Bertin witnessed (and sometimes provoked) profound changes in French society before her death in 1813. She was raised in Abbéville, a textile town north of Amiens, in Picardy. At the age of sixteen, she set off for Paris, where she apprenticed with Madame Pagelle, an established milliner who supplied the French and Spanish courts. By 1770 Bertin had left Madame Pagelle's establishment for

the Rue Saint-Honoré, the center of the Parisian fashion world, then and now. There she opened her own shop, or *magasin de modes*.

From the start, she was a success. Many of Madame Pagelle's customers followed Bertin to her new premises. Her fame spread through word of mouth; the princesse de Conti recommended her to the duchesse de Chartres, who in turn recommended her to the newly crowned queen, Marie-Antoinette, in 1774.[4]

The queen was a born fashion victim. Blessed with youth, beauty, wealth, exquisite taste, and good intentions, she was also extravagant, immature, and highly susceptible to flattery. Her wardrobe was subjected to intense public scrutiny and the rigid constraints of court etiquette. Every season she bought twelve formal court gowns *(grands habits)*, twelve informal gowns, and twelve hooped gowns for card parties and dinner parties, not including muslin and cotton gowns.[5] Most of these dresses were discarded at the end of the season, snapped up by the queen's ladies-in-waiting to be sold to secondhand clothes dealers, made into cushions, or altered for their own use.[6] Obviously, Bertin was not Marie-Antoinette's only *marchande de modes;* the task of clothing the queen was far too demanding for just one person, and Bertin had hundreds of other clients to accommodate. But no other *marchande de modes* was allowed such free and frequent access to the queen, or to the royal treasury.

It was Bertin who passed through the palace guards to the queen's private apartments, entering them for the first time in 1774, shortly after Louis XVI's coronation. Madame Campan, a lady-in-waiting, never forgot that day and its "evil consequences":

Fig. 1. *Magasin de modes*, from François-Alexandre de Garsault's *L'Art du tailleur*, 1769. The British Library, London.

> The skill of the milliner, who was received into the household, in spite of the usual custom which kept all persons of her description out of it, afforded her the means of introducing some new fashion every day. Up to this time, the queen had shewn [*sic*] but a very plain taste in dress; she now began to make it an occupation of the moment; and she was of course imitated by other women. Every one instantly wished to have the same dress as the queen, and to wear the feathers and flowers to which her beauty, then in its brilliancy, lent an indescribable charm. The expenditure of young women was necessarily much increased; mothers and husbands murmured at it; some giddy women contracted debts; unpleasant domestic scenes occurred; in many families quarrels arose; in another, affection was extinguished; and the general report was—that the queen would be the ruin of all the French ladies.[7]

Thus, Rose Bertin and Marie-Antoinette were inextricably linked in the public imagination, and it was Bertin's name that became synonymous with the sartorial elegance and excess of the court of Louis XVI.

It would be impossible to exaggerate the deference with which Bertin was received at Versailles or the outrage this provoked. The vicomtesse de Fars complained: "The best place in the court theater was reserved for a shopgirl, whom the duc de Duras escorted by the hand."[8] The queen broke protocol to allow Bertin into her private apartments, where the *marchande de modes* had ample opportunity to tempt the royal fancy with "new and numerous" fashions, in Madame Campan's words.[9]

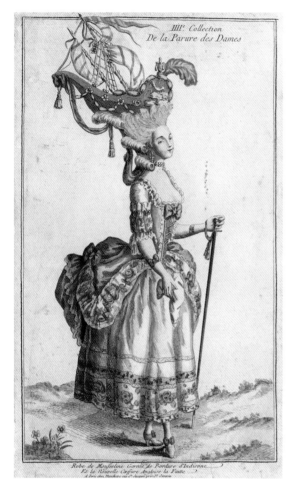

Fig. 2. French fashion plate illustrating a *pouf* headdress from *III^e Collection de la parure des dames*, c. 1775. Bibliothèque Nationale, Paris.

Because strict laws of etiquette prevented Bertin from being present in the queen's bedchamber during her morning *levée*, or rising, when she was ceremonially dressed by her ladies-in-waiting, Marie-Antoinette discontinued the practice and began to dress in a small, inner chamber, where Bertin could join her.[10]

As Marie-Antoinette's preferred *marchande de modes*, Bertin was well positioned to capitalize on the queen's popularity. Add to this her obvious talent and shrewd business sense, and she was virtually unstoppable. Bertin brought fashion up to the very minute with the cooperation of the malleable young queen and the emerging fashion press. By creating fashions named for current events, she ensured that they would go out of style as quickly as they had come in—sometimes from one day to the next. The *pouf* headdress was symbolic of fashion's new relevance. Bertin invented, for example, the *pouf à l'inoculation* to commemorate Louis XVI's inoculation against smallpox in 1774. *Poufs* might pay tribute to political scandals, popular plays, or public figures, whether explicitly or allegorically (fig. 2). Marie-Antoinette wore *poufs* representing "English gardens, mountains, parterres, and forests."[11]

These headdresses rose to such heights, one observer reported, that "women could not find carriages high enough to admit them; and they were often seen either stooping, or holding their heads out at the windows. Others knelt down in order to manage these elevated objects of ridicule with the less danger."[12] The price of feathers, an integral element of many *poufs*, skyrocketed. When Marie-Antoinette's mother, the Austrian empress Maria-Theresa, scolded her daughter for wearing feathered *poufs* "thirty-six inches high," her daughter did not deny the charge but protested: "Everyone wears them, and it would seem extraordinary not to wear them"[13] (fig. 3).

Madame de Genlis, with the virtue of hindsight, dismissed the fashions of the eighteenth century as "quite ridiculous" but admitted that

> the women were much more decorated then than they can be today; because formal dress, thanks to large hoops, was a dazzling display. It is impossible to give an idea of the splendour of a circle composed of thirty well-dressed women, sitting side by side. Their enormous hoops formed a rich lattice, artfully covered in flowers, pearls, silver, gold, colored sequins and jewels. The effect of all these brilliant *parures* together cannot be described. In those days, one wore not only flowers, but fruits, cherries, currants, strawberries with their flowers, etc. Art imitated these fruits so well that it was impossible to tell the difference. Some women wore vegetables; one saw those who were coiffed with artichokes and little turnips, but this was more a peculiarity than a fashion.[14]

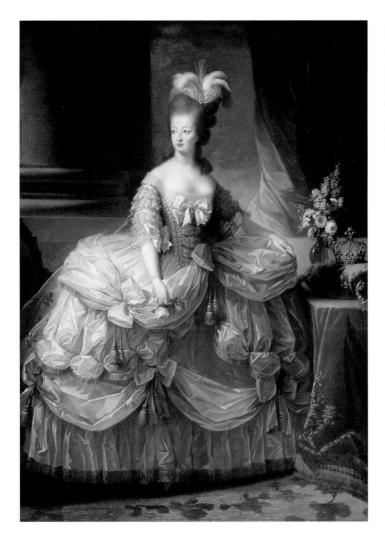

Fig. 3. Elisabeth-Louise Vigée Le Brun, *Marie-Antoinette in Her Court Robe*, 1779. Oil on canvas. Châteaux de Versailles et de Trianon, Versailles. Réunion des Musées Nationaux/Art Resource, New York.

Vast hoops and mountains of false hair provided the blank canvas for the *marchande de modes'* art.

As her thirtieth birthday approached, Marie-Antoinette tried to simplify her wardrobe, trading silk gowns for muslin and feathered *poufs* for straw hats, turbans, and flat velvet toques. But her new style was just as influential, expensive, and damaging as her old one had been. As Madame Campan recalled:

> The taste for dress, which the queen had indulged during the first years of her reign, had given way to a love of simplicity, carried even to an impolitic extent, the splendour and magnificence of the throne being in France, to a certain degree, inseparable from the interests of the nation.[15]

Elisabeth-Louise Vigée Le Brun's portrait of the queen in a plain white muslin gown created a scandal at the salon of 1783; the gown was thought to resemble a *chemise*, or undergarment. Nevertheless, variations on the so-called *chemise à la reine* soon appeared in the newly invented fashion magazines, and other ladies of the court rushed to be painted in them (fig. 4). When the marquise de La Tour du Pin married in 1787, there was "not a single silk dress" in her trousseau—everything was muslin.[16] And, in 1803, Vigée Le Brun could truthfully declare that she had not painted any lace for fifteen years.[17] Once again, Rose Bertin was one step ahead of changing tastes.

The relationship between fashion and art in eighteenth-century France was symbiotic. Painters such as Sébastien Jacques Le Clerc, Jean-Michel Moreau le Jeune, and François-Louis-Joseph Watteau contributed fashion plates of exquisite artistry to fashion magazines (fig. 5). Others took a more active role, designing coiffures and costumes.[18] In June 1781 the *Mémoires secrets* reported: "Fashions are more than ever the object of the inventive genius of our artists in diverse genres; those who concern themselves with the dress of women exercise the same taste as the *élégantes*, the *agréables*, the *petite-maîtresses* of the court."[19] Bowing to the dictates of fashion was not just good business sense, it was a legitimate form of artistic expression.

But fashion's attempts to penetrate the fine arts were more problematic. Bertin was the first fashion dealer to charge as much for her talent as for her materials. Previously, labor had represented only a fraction of the cost of a garment; carefully itemized sums for fine fabrics and trimmings comprised the bulk of the price.[20] "Does one pay Vernet for his canvas and paints alone?" Bertin once asked a customer who dared to complain about her high prices.[21] By comparing herself with Claude-Joseph Vernet, the celebrated landscape artist—whose son, Carle, would famously chronicle the extreme Directoire fashions of the *incroyables* and *merveilleuses*—Bertin claimed the skills and social status of an artist. It was a claim echoed a century later by Charles Frederick Worth, who went so far as to adopt the bohemian dress worn by artists of his generation.[22]

Fig. 4. Elisabeth-Louise Vigée Le Brun, *Duchess de Polignac*, 1783. Oil on canvas. The National Trust, Waddesdon Manor.

Fig. 5. Sébastien Jacques Le Clerc, *Dress for the Queen*, fashion plate from *29ᵉ Cahier de costume français*, 18th century. Musée de Louvre, Paris. Réunion des Musées Nationaux/Art Resource, New York.

Chemise à la Reine à manches attachées, la gorge garnis d'une fraize, Chapeau à la Malboroug entouré d'un ruban large rayé noir et de couleur.

A Paris chez Esnauts et Rapilly, Rue St. Jacques à la Ville de Coutances.

It was no coincidence that Bertin's clients were almost exclusively among the upper echelons of French court society—the same wealthy aristocrats, heiresses, and courtesans who patronized artists such as Vernet, Vigée Le Brun, and the sculptor Le Gradeur (who, in turn, patronized Bertin). Bertin was something of a connoisseur herself, decorating her *magasin de modes* with portraits of the many crowned heads of Europe who honored her with their custom.[23] (In addition to Marie-Antoinette, Bertin dressed the queens of Spain and Sweden, the comtesse de Provence, and the grand duchess Maria Federovna of Russia, along with a host of minor royals, ambassadresses, courtiers, and celebrities.) The posthumous inventory of her belongings includes an extensive collection of paintings, miniatures, portrait busts, and medals.

Given her unprecedented success at court, it is perhaps not surprising that Bertin developed what might be called an artistic temperament. The baronesse d'Oberkirch called her "a singular person, inflated by her importance, treating princesses as equals."[24] A rival *marchand de modes* complained that Bertin "assumed the airs of a duchess, and was not even a *bourgeoise*."[25] Like a *grande dame*, Bertin traveled in a "fine carriage" and dressed her servants in green livery with gold braid.[26] The *Correspondance secrète* described her stretched out on a chaise longue in her *magasin de modes*, greeting her noble patrons with a "very slight" inclination of her head.[27]

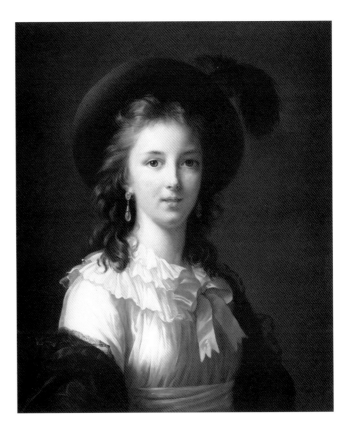

Fig. 6. Elisabeth-Louise Vigée Le Brun, *Self-portrait*, about 1781. Oil on canvas. Kimball Art Museum, Fort Worth, Texas.

This attitude did not endear her to those she sought to emulate. Bertin is conspicuous by her absence in Elisabeth-Louise Vigée Le Brun's memoirs, though the two women shared several clients (including Marie-Antoinette) and could not have avoided becoming acquainted during their frequent visits to Versailles. Vigée Le Brun made no secret of her "horror of the current fashion,"[28] as she put it, probably with Bertin's creations in mind. She discouraged her sitters from wearing hair powder, and she herself was instrumental in popularizing the simple, classically inspired styles adopted during the Revolution, which can be seen in her many self-portraits[29] (fig. 6).

But other artists were inspired by Bertin. The poet Jacques Delille praised her talents in verse, and the playwright Prévot caricatured her as "Madame du Costume" in *Le Public Vengé*, performed at the Theatre Italien in 1782.[30] It is a tribute to her immense fame and fortune that Bertin had her portrait painted by Louis-Rolland Trinquesse, who also painted Marie-Antoinette; most *marchandes de modes* could not expect to be immortalized in this way. The portrait was subsequently engraved by Jean-François Janinet, indicating that it was intended for mass consumption (fig. 7). By dressing the most famous women in the world, Bertin became a celebrity herself.

Her achievement was a victory for all *marchandes de modes*, and for women in general. With a few notable exceptions, such as Vigée Le Brun, eighteenth-century women were excluded from the fine arts and most other professions. Fashion was

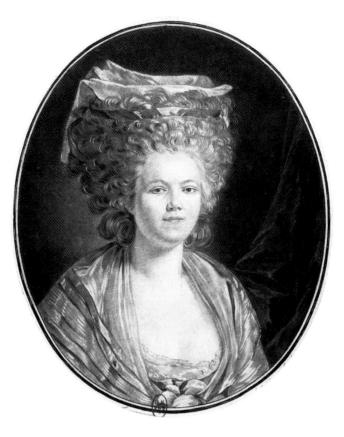

one legitimate outlet for the expression of female creativity and industry. As Mercier put it: "They cannot distinguish themselves in the law, nor in the church, nor in the military. . . . What remains for them? Dress, adornment. That is what constitutes their joy and their glory. Why envy them that moment of brilliance and happiness?"[31]

This artwork was by definition ephemeral. The *marchandes de modes* left no signatures on their art; the designer label would not appear until the nineteenth century, and it is difficult, if not impossible, to match those few eighteenth-century garments that survive today to individual *marchandes de modes*. Fashionable clothing had a finite life span in the eighteenth century; after it went out of fashion, it would be passed on to a servant or a secondhand clothes dealer, who might alter or update the garment. This cycle of redistribution would continue until the garment was not just outmoded but threadbare. Sadly, the French Revolution wiped out much of the tangible legacy of Louis XVI and his court. The total destruction of the royal family's wardrobe during the sack of the château de Tuileries on August 10, 1792, is well documented. Many of Bertin's exquisite creations ended up in the bloodstained hands of the *sans-culottes*.[32] As a result, we must rely on visual and documentary records for a true picture of French style in this period.

The French Revolution did not bring a total change in dress but formalized trends several years in the making. Nearly a decade before the Revolution condemned luxurious dress, the most fashionable Frenchwomen had already renounced it. During the Revolution, however, luxury became synonymous with tyranny and treason. Though muslin gowns were deemed acceptably "classical" or "democratic," the little luxuries that had been the bread and butter of the *marchandes de modes* were proscribed; Bertin was reduced to selling tricolor cockades and gilt models of the Bastille in order to survive.[33] The Revolution had catastrophic consequences for

the French fashion industry, which indirectly employed an estimated 25,000 people in Paris alone.[34] Many fashion workers emigrated because they could no longer make a living in France. Dress was no longer an aesthetic question but a philosophical one, the province of intellectuals and politically minded artists; Jacques-Louis David, Jean-Baptiste Isabey, and Moreau le Jeune all designed uniforms for the new revolutionary government (fig. 8).

Though the aristocracy saw Bertin as an upstart, to the *sans-culottes* she was no better than an aristocrat herself. And royalists and republicans alike blamed Bertin for encouraging Marie-Antoinette's excesses, which she continued to do right up until the queen's imprisonment. Unlike her royal muse, however, Bertin managed to survive the Revolution unscathed, waiting out the Reign of Terror in émigré havens such as London, Brussels, Frankfurt, and possibly even St. Petersburg, where she continued to dress fashionable foreigners and expatriate Frenchwomen. Although Bertin was twice put on the government's émigré list, both times she managed to prove that she had left France on legitimate business.

By the time Bertin returned to Paris in 1795, she was out of danger but also out of style. She shut the doors of her *magasin de modes* and retired to her country house at Épinay. It would be an exaggeration to say she lived happily ever after. Perhaps it was enough, in those dangerous times, that she lived at all. But the Revolution had cut her career short, and she died without seeing the restoration of the monarchy in all its magnificence in 1814. Upon reclaiming the throne, Louis XVIII, who had known Bertin before the Revolution, asked for the former minister of fashion, "and hearing that she had been dead for six months, publicly expressed his regret."[35]

Undoubtedly, if she had lived, Rose Bertin could have made a comeback, just as Coco Chanel did after finding herself on the wrong side of the political fence during World War II. French society had changed forever, but change is the essence of fashion, and Bertin had always thrived on it. Her remarkably long reign at the top of her profession testifies to a talent for reinvention. Fashions came and went, but Rose Bertin was timeless.

Kimberly Chrisman Campbell is a graduate of the MA program in History of Dress at the Courtauld Institute of Art and the author of a doctoral dissertation on the life and work of Rose Bertin.

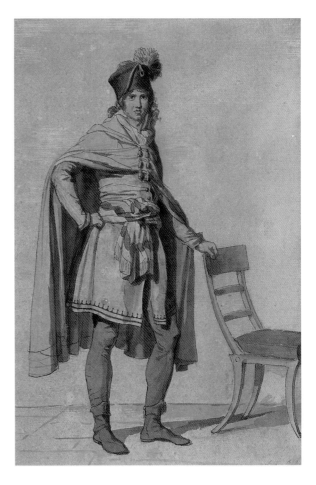

Fig. 8. Jacques-Louis David, *Costume of a French Citizen*, from The Civic Costumes Project, 1793. Watercolor. Châteaux de Versailles et de Trianon, Versailles. Réunion des Musées Nationaux/Art Resource, New York.

1. Louis-Sébastien Mercier, *Le tableau de Paris*, ed. Jean-Claude Bonnet (Paris: Mercure de France, 1994), 1:1481.

2. The term was coined by Imbert, Métra, et al., in the *Correspondance secrète, politique & littéraire, ou Mémoires pour servir à l'histoire des cours, des sociétés & de la littérature en France, depuis la mort de Louis XV*, April 1778, 6:148.

3. Marquis de Bombelles, *Journal d'un ambassadeur de France au Portugal, 1786–1788*, ed. Roger Kann (Paris: Presses Universitaires de France, 1979), 205.

4. *The World of Fashion and Continental Feuilletons* (London) 2, no. 8 (January 1, 1825): 27; Madame Campan, *Memoirs of the Court of Marie Antoinette, Queen of France*, ed. F. Barrière (London: Henry Colburn, 1843), 1:92.

5. Campan, *Memoirs*, 1:286.

6. Ibid., 1:286.

7. Ibid., 1:92–93.

8. Vicomtesse de Fars, *Mémoires sur Charles X* (Paris: Lecointe & Pougin, 1831), 173.

9. Campan, *Memoirs*, 1:97.

10. Ibid., 1:309–10.

11. Jean-Louis Soulavie, *Mémoires historiques et politiques du regne de Louis XVI*, ed. F. Barrière (Paris, 1801), 75.

12. Campan, *Memoirs*, 1:93.

13. Olivier Bernier, *Imperial Mother, Royal Daughter: The Correspondence of Marie Antoinette and Maria Theresa* (London: Sidgwick & Jackson, 1986), 159–60.

14. Stéphanie Felicité Brulart de Sillery, Comtesse de Genlis, *Dictionnaire critique et raisonné des étiquettes de la cour, et des usages du monde* (Paris, 1818), 2:40–41.

15. Campan, *Memoirs*, 2:421.

16. Marquise de La Tour du Pin, *Recollections of the Revolution and the Empire from the French of the "Journal d'une femme de cinquante ans,"* ed. and trans. Walter Greer (London: Jonathan Cape, 1921), 42.

17. Elisabeth-Louise Vigée Le Brun, *The Memoirs of Elisabeth Vigée Le Brun*, trans. Sián Evans (London: Camden Press, 1898), 255.

18. Louis Petit de Bachaumont, *Mémoires secrets pour servir à la histoire de la république des lettres en France* (London: John Adamson, 1780), 3 December 1777, 10:299.

19. Ibid., 3 June 1781, 17:226.

20. Madeleine Delpierre, *Dress in France in the Eighteenth Century*, trans. Caroline Beamish (London: Yale University Press, 1997), 137–41.

21. *Mélanges extraits des manuscrits de Madame Necker* (Paris: Charles Pougens, 1798), 3:142.

22. Diana de Marly, *Worth: Father of Haute Couture* (London: Holmes & Meier, 1990), 110.

23. *Mémoires de la Baronne d'Oberkirch*, ed. Le Comte de Montbrison (Paris: Charpentier, 1853), 2:62.

24. Ibid., 1:181.

25. Ibid., 2:73.

26. Chevalier d'Eon papers, Brotherton Library, University of Leeds; Fars, *Mémoires*, 173–74.

27. *Correspondance secrète*, April 1778, 6:146.

28. Vigée Le Brun, *Memoirs*, 27.

29. Ibid.

30. Grimm, Diderot, Raynal, Meister et al., *Correspondance littéraire, philosophique, et critique*, ed. Maurice Tourneux (Paris: Garnier Frères, 1880; Liechtenstein: Kraus Reprint, 1968), April 1782, 12:116.

31. Mercier, *Le tableau de Paris*, 1:496–97.

32. M. Cléry, *A Journal of the Occurrences at the Temple, during the Confinement of Louis XVI, King of France*, trans. R. C. Dallas (London: Baylis, 1798), 72.

33. Fondation Jacques Doucet, Rose Bertin, MS 1, dossier III, no. 298, p. 2841; MS 1, dossier IV, no. 306, p. 3028; MS 1, dossier VII, no. 716.

34. Daniel Roche, *The Culture of Clothing*, trans. Jean Birrell (Cambridge, U.K.: Cambridge University Press, 1994), 279.

35. Godard, justice of the peace of the Tenth Ward of Paris, to Comte de Lieautaud, 26 July 1816, quoted in Emile Langlade, *Rose Bertin: The Creator of Fashion at the Court of Marie Antoinette*, trans. A. S. Rappoport (London: John Long, 1913), 305.

Using Art in Pursuit of Fashion

Melissa Leventon

Fashion has . . . battened on art, especially in France.[1]

Fashion designers, especially those in the world of haute couture, have been strongly influenced by both historic and contemporary art. Not surprisingly, representational art—paintings, prints, photographs, sculpture, even pottery—has been a natural source of design inspiration. Some fashion designers have come under the sway of specific art movements, such as surrealism or minimalism. But intentionally or not, art also has been a shrewd marketing tool. Leaving aside the tired question of whether or not fashion *is* art, this essay will look briefly at several of the ways early French couturiers employed art in pursuit of fashion.

Charles Frederick Worth (1825–1895) is often termed the father of haute couture. He was arguably not the first couturier, but his several key innovations have shaped couture to this day. Most notable are his "collection" system, based around a vocabulary of interchangeable parts, and his practice of dictating the style of a dress to a client rather than collaborating with her, as had previously been the custom. Moreover, Worth was a skilled and dedicated self-promoter, so much so that the Second Empire period, when he first came to prominence, is often known as the Age of Worth—and not as the age of any of his equally gifted contemporaries. Art was important to his designs, his marketing, and his personal image.

Worth was a leading proponent of the historic revivalism that informed many fashions of the last thirty years of the nineteenth century, and it was in this vein that he produced fashions recognizably grounded in the art of the past. He cannot be credited with creating the vogue for revival styles, but historicism did become a house trademark, beginning in the early 1870s. Worth's early success had been founded upon royal patronage; he and his partner Otto Bobergh opened Worth & Bobergh in 1858, and by 1860 Worth had managed to attract the interest of Empress Eugénie, wife of Napoleon III, and her court. They seem to have accounted for a goodly share of Worth's business, and wealthy foreigners traveling to Paris did for much of the rest. With the fall of his regime in the Franco-Prussian War of 1870–71, Napoleon III and Eugénie fled; Worth must have worried that his business would be hard hit. Is it significant that his use of historical elements drawn from Old Master paintings and print sources began shortly thereafter? It is tempting to conclude that having lost his royal patronage, Worth consciously decided to use artistic references as a means of continued distinction, but there is no direct evidence that he did so.

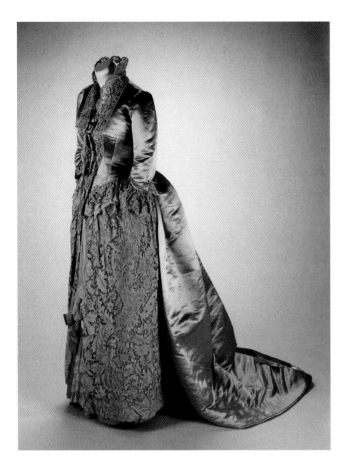
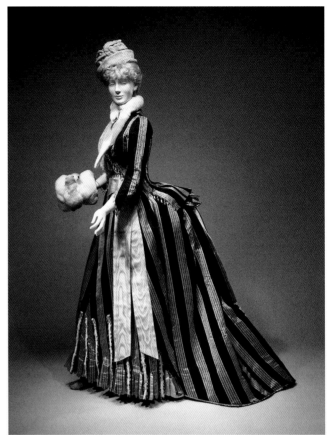

Fig. 1. Charles Frederick Worth, *Dinner dress*, c. 1885. Oyster silk satin with silk georgette and ecru needle lace. The Fine Arts Museums of San Francisco, gift of Mrs. William G. Parrott, Jr.

Fig 2. Charles Frederick Worth, *Walking dress*, c. 1885. Striped silk satin and faille; moire ribbon and passementerie trim. The Brooklyn Museum, gift of Mrs. C. M. Andrews.

But he must have been looking for ways to maintain his position in the wake of the political and economic upheaval brought by the war, and using art to distinguish his creations may have seemed an appealing option.

Worth is known to have used specific artists and paintings in public and private collections as source material, and Worth's son and creative heir, Jean-Philippe, followed his example enthusiastically. Paul Poiret, who worked briefly for the younger Worth around the turn of the twentieth century recalled, "He worked after the pictures of the old masters, and I have seen him derive magnificent ideas from the canvases of Nattier and Largillièrre."[2] In addition to Nattier and Largillièrre, both Worths were thought to have consulted paintings by Titian, Rembrandt, Reynolds, van Dyck, and Gainsborough; they also had access to plates and drawings from eighteenth- and nineteenth-century fashion journals.[3] Worth did not, however, create slavish reproductions of period styles; instead, as is usual with revival style, he selected elements from different sources, and often different periods, and fused them together into new and contemporary garments. Both women's and men's styles of the past were fair game. Worth was especially fond of seventeenth- and eighteenth-century styling, and his revivalist dresses sport details like wired, rufflike collars, puffy slashed sleeves, and antique-style (or sometimes genuinely antique) lace (fig. 1); many also suggest the silhouette or garment styles of an earlier era.

Elizabeth Ann Coleman, in her thorough study on Worth noted that, except for two instances of fancy dress, no direct correlation has been established between an extant Worth garment and a specific work of art.[4] However, a circa 1885 walking dress of black-and-white striped silk satin and faille, in the collection of the

Brooklyn Museum (fig. 2), bears so strong a resemblance to Rose Adélaïde Ducreux's *Self-portrait with a Harp* (fig. 3) of a century earlier that it is tempting to see the painting as the model for the dress.[5] Maison Worth was unusual in that the house had many of its textile designs custom-woven, and paintings are known to have served as models for these. Jean-Philippe Worth claimed, for instance, that the first textile his father had custom-woven for the house was based on the cloak portrayed in a favorite Gheeraerts painting of Queen Elizabeth I from about 1600.[6] In this way, Worth could match not only the embroidery or trim of a dress with its revival style, he could make sure the design of the textile fostered the historical illusion. Perhaps the most striking such garment extant is a full-length opera coat from about 1900, also in the Brooklyn Museum's collection (fig. 4). It was designed by Jean-Philippe to suggest a late-sixteenth-century overgown and made in black and white velvet voided in a Tudor rose motif.

What was the appeal of art in the context of couture? The use and appreciation of art in fashion imparts to both designers and consumers an aura of cultural and intellectual distinction. In the baldest terms, the designer distinguishes himself by his knowledge of art and references to it in his clothes; it implies that he himself is an artist and his work is art, too. This has the side benefit of making it easier to command high prices; one can charge more for a work of art than for a mere dress (Worth was famously expensive). The client, by understanding and appreciating the artistic references, cloaks herself in an aura of cultural superiority. This may also

Fig. 3. Rose Adélaïde Ducreux, *Self-portrait with a Harp.* Oil on canvas. The Metropolitan Museum of Art, New York, bequest of Susan Dwight Bliss, 1967 (67.55.1). Photograph © 1983 The Metropolitan Museum of Art.

Fig. 4. Jean-Philippe Worth, *Opera coat,* c. 1900. Black and white voided velvet, black velvet, white silk chiffon, and black Chantilly lace. The Brooklyn Museum, gift of Mrs. William E. Griswold.

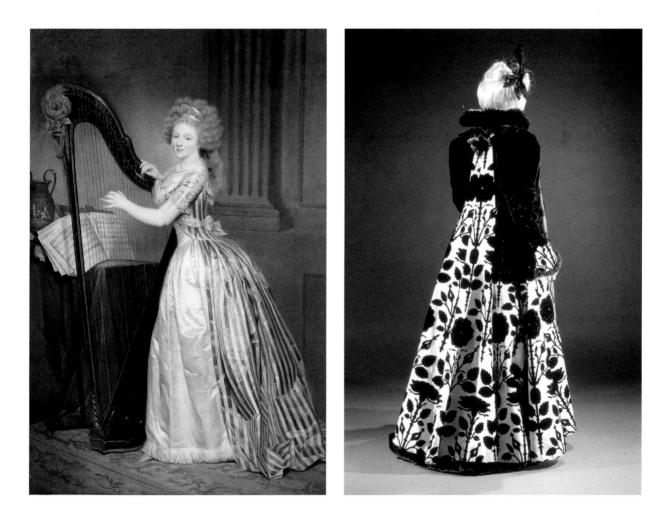

be one of the reasons Worth was so popular with Americans. The late nineteenth century was a time of unbridled capitalism in the United States, and many newly rich families sought to establish themselves socially by acquiring substantial collections of European art. In the same way that tapestries, suits of armor, and paintings by famous artists could help to legitimize a family's social pretensions, a seventeenth-century-style Worth inspired by a masterwork would connect its wearer to an aristocratic and cultured European past.

Even in his own time Worth was not the only couturier to plumb art as source material—similar styles appear in the work of a number of his competitors, including Doucet, Laferrière, Pingat, and Paquin. But Worth was also famous for his exploitation of what Valerie Steele has described as "the 'genius' theory of fashion,"[7] which he did in part by dressing and behaving like an artist, implying that he considered himself on a par with the Old Masters he studied. His eccentric dress and behavior attracted a lot of attention; one result, as Steele and others have pointed out, is that he is far better remembered than virtually all his contemporaries even though he was arguably no more talented than they. So for Worth, art was also a means of self-promotion.

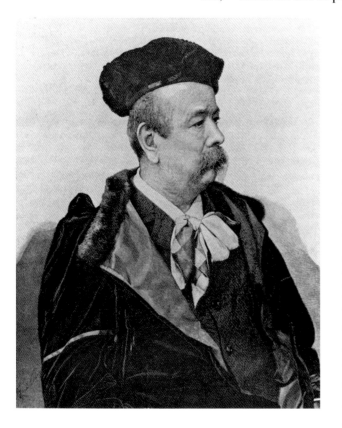

Fig. 5. Charles Frederick Worth, from an engraving based on a photograph by Felix Nadar of early 1892.

The idea of fashion designers as artists was current at the time, promoted by the fashion press and by chroniclers such as Octave Uzanne and the poet Charles Baudelaire.[8] The idea of artists as aristocrats is also largely a nineteenth-century construct, developed as the traditional, landed aristocracy receded under the combined assaults of revolution and the rising financial power of an urban bourgeoisie. Culture is the vehicle by which the French convinced both themselves and everyone else of their superiority, and artists, as primary cultural contributors, enjoyed higher status than did tradesmen. So to be considered an artist would have been far more desirable than to be considered a dressmaker, and Worth played the role to the hilt. He dressed the part: when receiving established clients, he generally wore a dressing gown over a smock and baggy trousers, with a cap or beret perched on his head. This is the kind of undress in which artists, especially of the seventeenth and eighteenth centuries, traditionally portrayed themselves, but it was most unlike the correct business attire commonly worn by a merchant in the nineteenth century.

Worth had himself photographed in 1892 by Felix Nadar wearing his "artistic" clothes and "striking a Rembrandt-like pose"[9] (fig. 5). He also adopted a persona befitting artistic genius; Worth was renowned for both his affectations and his sartorially dictatorial behavior toward his wealthy clients. In particular, Worth was famous for requiring his clients to report to him before attending a state ball so that he might inspect—and if necessary correct—their attire.[10] Not only did Worth dress and behave like an artist, he lived, to the greatest degree possible, like an aristocrat. He built a country mansion, which he staffed with liveried servants and where he entertained many of his aristocratic clientele, something that would have been

unheard-of a generation earlier. Worth's house was also crammed with art, although Worth was known more for the quantity than the quality of his collections.[11]

Art has remained important to fashion in the twentieth century, though early modern designers used it differently than had their Victorian predecessors. Rather than draw specific garment styles from painted masterworks, designers such as Madeleine Vionnet, one of the most modern of twentieth-century couturiers, embraced certain philosophies of art that came to imbue their work. Like Worth, Vionnet explored public art collections as source material for design ideas. In the 1920s she designed a number of dresses inspired by Greek pots in the Louvre; in an interview given in 1935 she commented that she drew inspiration both from the clothes depicted on Greek vases and from the lines of the vases themselves. Vionnet adapted the methods of drapery found on Greek originals for her completely modern draped clothing of the teens, twenties, and early thirties. In her monograph on Vionnet, Betty Kirke notes: "She used the jabotlike fall of the loose ends of the chlamys [a short, draped mantle, pinned or knotted on one shoulder, worn by men in ancient Greece] in every size possible to enhance, at different times, almost every part of the body."[12] Vionnet looked to classical art, in part, as a way to escape the imprint of fashion—a time-honored practice among artists.[13] Vionnet also looked to Greek vases for surface design ideas, such as the Grecian horses motif, designed in 1924 (fig. 6). Not only did the figure of the horse derive from a Greek vase, it was executed on the dress in the style of Greek red-figure pottery—the figure was outlined and only the negative areas were embroidered. And the proportions of Greek vases contributed to Vionnet's understanding of satisfying proportions of dress on the body.[14]

During the period between the two world wars, the spheres of fine art and high fashion often intersected, and fashion designers and artists worked together on clothing and textiles. Probably the best-known collaboration was that between Elsa Schiaparelli and the surrealists—Jean Cocteau and Salvador Dalí in particular—which produced garments such as a chest-of-drawers suit and the famous lamb-chop hat. As Richard Martin amply demonstrated in *Cubism and Fashion*, Vionnet's work—geometrically grounded garments of intellectual rigor and deceptive simplicity—is both indebted to and reflective of the imagery and philosophy of cubism.[15] But the most important artistic influence on Vionnet was probably futurism, as propounded by the Italian artist Thayaht (Ernesto Michelles), whom she likely met during her visit to Rome in 1914. Thayaht was one of the few futurists who also designed clothing professionally; like Vionnet, he was concerned with issues of movement and the human body. Thayaht moved to Paris for a time after the First World War, and until 1924 he and Vionnet often worked closely together.

Thayaht likely introduced Vionnet to the futurist theory of dynamic symmetry, which, like cubism, envisioned the world in terms of shifting planes: "Everything moves, everything runs, everything turns swiftly. The figure in front of us never is still, but ceaselessly appears and disappears. Owing to the persistence of images on the retina, objects in motion are multiplied and distorted, following one another like waves through space."[16] Futurism focused especially on spirals and diagonals, perfect for a couturier who worked by draping muslin on an artist's lay figure mounted on a revolving piano stool. Vionnet had already begun using geometric shapes as devices to engineer or enhance fit in her garments, but her work with Thayaht inspired her to move toward a more philosophical employment of dynamic

Fig. 6. Madeleine Vionnet, *Grecian horses dress* (detail), 1924. Silk georgette embroidered with silvered bugle beads and gold thread. The Fine Arts Museums of San Francisco, Roscoe and Margaret Oakes Collection. The dress was originally shown in red silk embroidered in blue beads to better mimic the effect of red-figure vases.

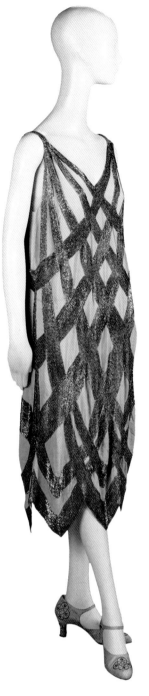

symmetry as part of the fundamental visualization of a garment, and as real or conceptual extensions of the garment beyond the body. This view is expressed in many of the fashion plates Thayaht drew of Vionnet's clothes for the *Gazette du bon ton*, where movement is expressed as linear extensions of the geometry of each dress into the space around it. Vionnet is fortunate to have had an illustrator so in tune with her ideas, and Thayaht to have had such a like-minded subject.

Thayaht and Vionnet also collaborated on specific garments. He designed a woman's version of the futurist's man's *tuta*—a garment intended to be "simple, handy, and hygienic"[17]—for her. Kirke comments that it sold reasonably well but was not, in fact, up to Vionnet's standards.[18] Drawings still in the possession of his family also suggest that Thayaht collaborated with her on the design of an evening dress which definitely is up to her standards; of flesh-pink silk crepe embroidered in opalescent glass bugle beads, it is dominated by a dynamic, expanding diamond grid that extends from shoulder to jagged hemline (fig. 7). Although little other direct documentation of collaboration between Thayaht and Vionnet on garment designs exists, there were undoubtedly other instances.

Art and fashion, though not, perhaps, the same, are both concerned with creating images of the human body. Designers have repeatedly conferred distinction on fashions by drawing on art as an encyclopedia of historic styles or by embracing art's specific modes of representation. Couturiers have also relied on the status of art to promote fashion, using it to lend desirability to their work, and by envisioning and presenting themselves as artists and patrons of the arts. Artists and couturiers have collaborated directly on the design of fashions and textiles. And fashion has been immeasurably enriched.

Melissa Leventon is a principal with Curatrix Group consultants in textiles, costumes, and interiors. From 1986 to 2002 she was successively assistant, associate, and finally curator in charge of the Department of Textiles at the Fine Arts Museums of San Francisco.

Fig. 7. Madeleine Vionnet, *Evening dress*, c. 1922. Silk crepe embroidered with glass bugle beads; underdress of matching silk crepe de chine. The Fine Arts Museums of San Francisco, gift of Mr. and Mrs. Alfred E. Wilsey.

NOTES

1. Ernestine Carter, *The Changing World of Fashion 1900 to the Present* (New York: Putnam, 1977), 104, quoted in Valerie Steele, *Paris Fashion: A Cultural History* (New York: Oxford University Press, 1988), 232.

2. Paul Poiret, *King of Fashion: The Autobiography of Paul Poiret*, trans. by S. H. Guest (Philadelphia and London, 1931), 66.

3. Elizabeth Ann Coleman, *The Opulent Era: Fashions of Worth, Doucet and Pingat* (New York: The Brooklyn Museum and Thames and Hudson, 1989), 62.

4. Ibid. Fancy dress has always made use of historical portraiture; masquerade balls were frequently populated by kings, queens, and other attractive personages copied from well-known paintings or prints. Mary Queen of Scots was a perennial favorite, as was Peter Paul Rubens's second wife, Helena Fourment.

5. This painting, now in the Metropolitan Museum of Art, New York, was in the collection of the marquis de Saffray in Paris until 1897.

6. Coleman, *The Opulent Era*, 69. Coleman commented that the pattern was copied incorrectly when it was first woven, and it wasn't until Maison Worth revived the pattern and had the silk rewoven ten or fifteen years later that Worth got the textile he wanted.

7. Steele, *Paris Fashion*, 246.

8. See ibid., especially chaps. 4 and 5.

9. Coleman, *The Opulent Era*, 25.

10. Diana de Marly, *The History of Haute Couture* (London: Batsford, 1980), 22.

11. Jacques Doucet, however, built important collections of eighteenth-century and twentieth-century art and devoted himself to the literary and artistic world in Paris. Though he was one of Worth's most successful competitors, contemporaries commented that he would by far rather be known as a connoisseur of art than as a couturier. As Elizabeth Ann Coleman put it, "The Worths were committed to the art of dressmaking, Jacques Doucet to art"; see ibid., 53, and Coleman, *The Opulent Era*, 149–52.

12. Betty Kirke, *Madeleine Vionnet* (San Francisco: Chronicle, 1998), 41.

13. Perhaps the best-known exemplar of this practice was the eighteenth-century British artist Sir Joshua Reynolds, who clothed his female sitters in classically inspired draperies specifically because he felt (erroneously) they would not date the portraits the way fashionable dress would. An exemplar in fashion would be Mariano Fortuny, whose classically inspired Delphos dresses went virtually unchanged for the forty years they were manufactured, yet have rarely been out of fashion.

14. Kirke, *Madeleine Vionnet*, 116.

15. Richard Martin, *Cubism and Fashion* (New York: Metropolitan Museum of Art, distributed by Harry N. Abrams), 1998.

16. Helen Gardner, *Art through the Ages*, rev. Horst de Lacroix and Richard Garners (New York: Harcourt Brace Jovanovich, 1920); quoted in ibid., 64.

17. Kirke, *Madeleine Vionnet*, 115.

18. Ibid.

Addressing the Body

Sean M. Ulmer

The Union of Contemporary
French Art and Fashion

Art and fashion. Fashion and art. Until recently, both practitioners and the general public in the United States perceived these two arenas as distinct and unrelated. This separation can be attributed in part to the role the United States has played in each sphere and the different trajectory of its influence in each. Around the time of World War II, the United States eclipsed Paris as the center of the art world as European artists emigrated to New York to escape political unrest just before the war. It was much later, however, that the United States played a significant role in fashion. The distinction between art and fashion, however, is not so pronounced in other countries, and no place are they less separate than in France. Perhaps because the French have long held positions of primacy in both worlds, they have viewed them in tandem. Whereas in the United States these two worlds have collided only of late, they have enjoyed a more fluid interaction in France. High art and high fashion inform each other and are collaterally valued by their audiences.

This situation has altered recently in the United States. New York, the undisputed leader of the art world for the past fifty years, has witnessed many artistic styles and trends. Abstract expressionism, pop art, op art, and minimalism are only a few of the many artistic expressions explored by artists in the city in the past half-century. This pluralism of styles is one of the hallmarks of twentieth-century art in much of the Western world. In the past twenty years, the art world has opened up and become more global in its outlook, embracing a wide variety of issues and styles. During this same time, especially in the 1980s, artists developed a strong interest in the exploration of the body and various territories surrounding it. Representation of the figure is a long-standing tradition in the history of art, dating back to the first stick figures in cave paintings. More recently, however, representation of the figure has taken on newer meanings, less associated with depictions of the body than with issues surrounding it, or body politics. Some artists chose to re-present the body, in various forms and styles, to call attention to ideas about the human condition. Others removed the body completely and referred to it only in the abstract; it was present by its overt absence. Several artists explored this "new" territory by employing clothing in their work. Clothing, intimately associated with the corporeal forms that wear it, inherently references the body.

Clothing also brings with it all sorts of associations other than those relating to the body of the wearer. Clothing originated as a means to remain warm or to protect oneself from the elements. The earliest man wore skins of animals for this reason. These rudimentary garments evolved, over time, into togas and later into ermine-lined robes. Indeed, the history of art, from ancient Roman statuary to medieval manuscripts to nineteenth-century canvases, displays the full range of clothing through the ages. In this progression, however, the clothing became more than a means of warmth and protection. Very early, clothing became associated with status. The Roman senator was not attired identically to the slave, nor did the lord dress the same as the serf. The wealthy person did not wear the same apparel as the poor. The same distinctions continue to this day. A tailored Versace tuxedo does not bear the same associations as a sports jacket and khakis. A designer gown carries a different message than a skirt and blouse. Status, class, distinction, power, and identity are all wrapped up in what people wear. Often the ways in which people wish to be perceived or perceive themselves are manifested in their choices of clothing. The progression, from clothing as protection to clothing as statement, is a long and fascinating one but beyond the scope of what can be accomplished in this essay.

Many artists have recognized the important role clothing plays in today's society. Beginning primarily in the 1960s, artists have referenced or incorporated clothing in their work to a variety of ends. Joseph Beuys's *Felt Suit* of 1970 has often been cited as an early manifestation of an interest in and use of "clothing" as art and in art, but more accurately it should be seen as one example among many artistic explorations of the various associations attached to clothing. In the past two decades, however, the art world has witnessed a proliferation of artists employing clothing—and its allusion to the absent body—in their work. These works of the 1980s and 1990s address a number of disparate points, many concerned with the body, a subject of particular fascination during this time. Building upon the groundwork laid in the 1960s and 1970s, artists such as Kiki Smith and Robert Gober explored body politics. Especially in the 1990s many artists took issues surrounding the body in innovative directions by incorporating references to clothing or by actually using it in their work. During this period artists both built upon and departed from issues strictly related to the body to touch on wider aspects of race, gender, sexual orientation, politics, religion, social injustice, and other concerns.

Although in recent years much attention has been focused on artists working along these lines in the United States, a careful analysis of this material reveals that it is truly an international phenomenon. It is not difficult to list artists from Africa, South America, Asia, and Europe who have been investigating these same topics. French artists, for example, have demonstrated the same evolution of interest in using clothing as a referent to the body in their art. One artist, Annette Messager, was the subject of much critical attention throughout the 1980s and 1990s, and has been linked to artists such as Louise Bourgeois, Robert Gober, Rona Pondick, and Kiki Smith. For her *Histoire des robes* series of 1988–92, Messager positioned dresses within glass-faced, shallow boxes and attached photographs to them. Each dress tells its own story, not only through the photographs but through the dress itself, referencing the wearer as well as the potential occasion or event. The dresses have the feeling of a *memento mori*—a memorial—similar to the way in which cherished items were contained within bell jars in the nineteenth century.

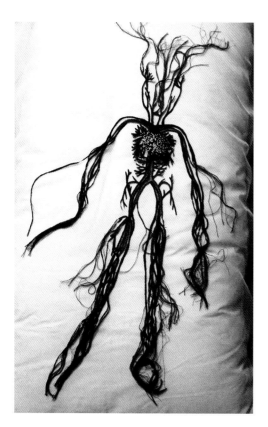

Fig. 1. Annette Messager, *Pénétration*, 1996. Silk thread and tulle. Collection of the artist, Paris (cat. no. 108).

In a different vein, both literally and figuratively, is Messager's *Pénétration* (fig. 1), in which the artist worked with a master lace maker to create a work from *dentelle aux fuseaux*, or bobbin lace. Depicted is the body, but not a corporeal one. Instead, the viewer is confronted with an image of the human arterial and venal systems. In delicate red and blue lace, the network of arteries and veins is laid out for the viewer to contemplate. The form, while clearly humanlike in shape, is ethereal and surreal, with its extended limbs and the hairlike diffusion of the veins and arteries of the head. To extend the reference to dissection, Messager incorporated straight pins of the type frequently found in dissection labs. Here, however, the mass of pins is accumulated around the heart, conjuring up associations of the pains and the trials of life. This piece, delicate and labor intensive, alludes also to the great delicacy and fragility of the body, a form much more complicated than it might seem from the outside. By extension, this is also true of the makeup of the individual person, whose complicated and elaborately interwoven characteristics make him or her unique.

Similarly, Marie-Ange Guilleminot's creations cause the viewer to think differently about clothing and the body (fig. 2). For the 1997 Venice Biennale she installed a "transformation parlor," in which viewers were invited, with video instruction from the artist, to transform a pair of panty hose or women's tights into a backpack or other wearable device, such as a head wrap or brassiere. Fragile and yet strong, these backpacks took the form of whatever was placed into them, thereby creating unique objects—much as each individual is the unique product of what is "put in" him or her. Similarly interactive and transformative is Guilleminot's series *Chapeau-Vie*. These rolled-up Lycra forms can be worn on the head as a hat or unrolled to form a body sheath. When rolled, they look like large navels, nipples, or condoms. In the process of unrolling, they become tubular, like a tunnel or symbolic passageway, somewhat penile in shape. This action, similar to unrolling a condom, ends in the entire envelopment

Fig. 2. Marie-Ange Guilleminot's *Dress on Wheels* in use (cat. no. 109).

of the body within the sheath. This blending of aspects of the body and clothing has been a constant in Guilleminot's work. *Chapeau-Vie* echoes a project she created in 1992 in which she fabricated a series of dresses, all from the same pattern but differentiated, following the natural design of her own skin, by individualized beauty marks or belly buttons. This series celebrates the variation that exists in what may seem to be the same: all women—all people—are not the same. In all her works Guilleminot explores the individual's relationship to others as well as to oneself.

Often occurring in public spaces, the art of Christian Lacroix uses elements of performance to comment upon the diversity found within and among people. Best known as a fashion designer of both haute couture and prêt-à-porter, Lacroix has, in the past few years, expanded his vision beyond high fashion; he is truly an artist who transcends the distinctions between art and fashion. In a project for La Beauté, an art festival in Avignon held in summer 2000, Lacroix ambitiously attempted to "dress" the city, thereby creating a link between the exhibitions scattered throughout the city. In *Souvenir pieu (Le piétinement de la croix)*, also from 2000 (cat. no. 107), Lacroix created, with the help of a master lace maker, a camisole in *dentelle aux fuseaux* and *maille* knit. This intricate and highly laborious work, while taking a traditional halter form, is anything but the average camisole. Composed of a fastidious merging of lace patterns, the piece is a study of the many different elements brought together in the creation of a single complicated item. It mirrors many such compilations in the world, from individual members of a team, who come together to form a single unit, to the many different components within each person that combine to create one finished whole. Lacroix's concerns echo some of the issues and techniques of interest to both Messager and Guilleminot.

Several contemporary French artists besides Guilleminot and Lacroix have employed an interactive quality in work that deals with the body and clothing. One is Jean-Michel Othoniel, an artist who received some attention during the 1990s. Although he has made more traditional, clothing-based objects, such as his fragile and erotic glass harnesses modeled on leather and metal-ring counterparts, Othoniel has been expansive in his approach to art making. For example, he created a series of oversized glass bead necklaces with the help of Murano glassblowers. The large, globular beads of these necklaces, which are sometimes eight feet in length, were modeled on designs Othoniel made in terra-cotta. Once formed, these enormous beads were strung into necklaces not with wire but with a lighted cord so that, as night descends, the necklaces begin to glow from within. Just as each viewer is a unique form, like an irregular bead, he or she too has an inner quality that is made evident when one looks past the exterior. Othoniel took this work one step farther when he brought 750 red-bead necklaces of normal size from Murano to the 1997 gay pride rally in Paris. He gave them all away, exchanging each one for a photograph he took of the recipient wearing the necklace. In a real way, this interactive project celebrates the diversity of all the people who wear things, even identical things. For another, theatrical piece, Othoniel created scenery composed of dresses dipped in wax and hung from above like bellpulls. On the darkened stage, dancers in flint-paper costumes struck matches off each other, shedding the only light for the performance. This sensual piece is completed only through the interaction of the individuals. Like many of Othoniel's works, this performance transcends genres and genders while focusing on the individual.

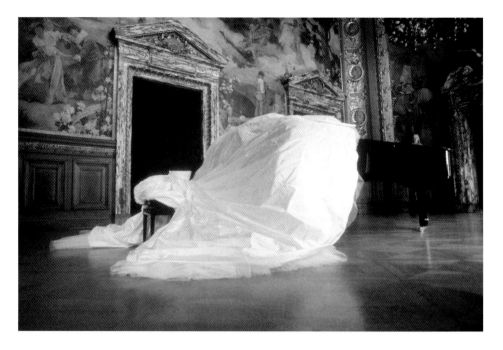

Somewhat different is a body of work by Gotscho. Throughout the 1990s Gotscho collaborated with artists and fashion designers, often creating a final product that merged their two realms. In 1996 he exhibited a series of pieces created with photographer Nan Goldin in which images she took of Gotscho's bodybuilder back were combined with haute couture dresses that cascaded to the floor. Surprising and surreal, these works combined elements thought to be antithetical. Visually stunning, and yet humorous, the mixed-media collages cause viewers to question stereotypes and to think about issues of identity. In these and other works, Gotscho is interested in how people identify themselves and what "labels" they wear. In other creations Gotscho invites the viewer into fantasy realms in his pursuit of *the* shirt, *the* pant. Equally fantastic are his furniture/fashion combinations, from his "pregnant" Louis XVI–style chair (1992), with an immensely overstuffed seat, or his black leather jacket stitched to a bar stool. *Solo GOTSCHO/UNGARO* (fig. 3) confronts the viewer with one of these fashion/furniture constructions. Here, an Ungaro gown is wed to a grand piano. The missing element, the human who would have worn the gown, is defined by the glamorous trappings, by her role at the piano. We can picture the absent person, much in the same way we can visualize the wearer of the leather jacket sitting on the bar stool. Gotscho questions how people define themselves by their clothing, their settings, and the stereotypes and expectations of others.

Another arena in which clothing more strictly functions to identify the wearer is that of the uniform. Just as the female concert pianist in Gotscho's work is defined by her glamorous gown, so uniforms of daily life identify the wearer, both for the onlooker and the wearer. For example, the bullfighter's toreador costume or the nun's habit are both uniforms whose distinctive characteristics make the wearer's particular profession immediately understood. The same is true of sanitation workers, flight attendants, and a host of other professionals whose uniforms are identified in the public's mind with a particular function or industry. One profession whose uniforms have been exploited by artists is the military. While demonstrating differences

between various branches and levels within each branch, the military uniform possesses immediately recognizable characteristics, which the artist Bernadette Genée has referenced. Her *Décorations civiles et militaires* (2000; cat. no. 110) somewhat upends the viewer's expectations by presenting just one-half of a military jacket. It is an object for visual consumption, not to be worn, to which Genée has added new embellishments that incorporate allusions to the military and civilian worlds. These new insignia, created with the help of the École de broderie bretonne Pascal Jaouen in Quimper, incorporate new and unusual imagery such as peacock feathers and curled forms. The drawing together of the military and the civilian undermines the established authority associated with military costume, while suggesting that all people wear some sort of "military" costume—or put up defenses—in their daily lives and interactions with others.

Another type of uniform, especially popular in Europe, is that worn for soccer. Like sports uniforms worldwide, it has immediate associations for the onlooker, who, as spectator cum fanatic, assumes a vital role in the completion of the event. In his 1994 *World Cup*, Matthieu Manche created a suite of team uniforms with black and striped parts (fig. 4). As in other of his clothing-based works, such as the 1998 *Show Room* of slick silicone and latex vestments, Manche confronts the viewer with the unexpected. In the case of *World Cup*, the team uniforms are surreal, à la Salvador Dalí. Some are short and stubby, some are elongated and spill onto the floor, some have conjoined arms, while others have too many sleeves. The total effect is a spectacle of variation. Beneath the surface lies the notion that sports are a competition of aggression, which affects both children and adults, and perhaps receive a distorted importance in Western society. What dynamics are established on the sporting field and how do they influence the ways in which people interact off the field? These distorted soccer uniforms, while strange and somewhat humorous, at the same time fundamentally question our obsession with sports.

Fig. 4. Matthieu Manche, *World Cup*, 1994. Installation. Collection of the artist (cat. no. 106).

In all these works, many of which are collaborations with makers of traditional materials, the artists have departed from conventional expectations to investigate individual themes and ideas. In each case, the artist has utilized clothing, and the associations brought to it by the viewer, to explore new ideas and issues. Whether commenting on themes of identity or social stereotypes and expectations, or confronting the viewer with new and innovative ways of thinking about clothing and its functions, these contemporary artists push the boundaries not only of the art world but the fashion world. In their hands, these worlds collide, and the outcome is a meditation about how these worlds coexist and inform each other. The works engage, amuse, and provoke the viewer to see new and dynamic possibilities in art and fashion.

Sean M. Ulmer is curator of Modern and Contemporary Art at the University of Michigan Museum of Art, Ann Arbor.

Frivolity, Folly, and the French Royal Court

The eighteenth century dawned amid the full baroque grandeur of the court of Louis XIV, the self-anointed Sun King. Typified in portraits by sitters swathed in luxurious swags of the most expensive silks and brocades, the change in taste to the initially light and airy style of the rococo grew more and more lavish, culminating in extravagant designs of lace, frills, and bows. The emphasis on decoration played out similarly in highly ornamental works of art. Louis XIV's reign, from 1643 to 1715, saw the building of the grand palace of Versailles but also the increasingly unjust taxation of those who could least afford it. Louis XIV financed the exploration and early settlement of the Louisiana Territory, of which Mobile was the first capital. Almost without exception, Louis XIV's ventures, whether successes or failures, were insistent drains on governmental coffers.

Louis XIV survived his son, grandson, and eldest great-grandson to be succeeded by the five-year-old Louis XV. For the most part well intentioned, Louis XV made many strategic errors in dealings with the church and in the conduct of wars abroad which clouded his reign and that of his successor. Court life thrived, however, as the king's mistresses, Madame de Pompadour and, later, Madame du Barry, demonstrated a great sympathy to artists, musicians, and writers. Indeed, as in other European royal courts, such patronage encouraged a multidisciplinary approach. In service to the king, court artists not only produced great works of art but also designed fashions and regalia, and even, in some instances, costumes and set designs for palace entertainments.

Madame de Pompadour was particularly supportive of the philosopher Denis Diderot, who questioned why society had lost its honesty and simplicity, and of Voltaire, proponent of free thought. These men came to represent the Age of Enlightenment, which set forth the ideals that gave birth to new social and political systems. Despite their innate idealism, such philosophies contrived some of the greatest violence in the history of France. Increasingly unapologetic displays of wealth and arrogance by the aristocracy spurred the working classes to question with indignation their circumstances and, eventually, the very structure of the nation.

_____ 1

Jean-Baptiste Jouvenet
(French, 1649–1717)

Antoine LeMoyne de Chateaugue,
c. 1703

Oil on canvas, 36 × 30 in.
The Museum of Mobile, Alabama, 4426

*J*ean-Baptiste Jouvenet was born in Rouen to a family whose work as painters dates back to 1548. Jouvenet went to Paris in 1661, where he worked with the painter Charles Le Brun on a number of prestigious commissions to decorate royal palaces including the Tuileries and Versailles. His greatest achievement may be the painted decorations for the Hall of Mars at Versailles. He was known for his straightforward depictions of bourgeois and religious clerks, whom he painted without the allegorical allusion so common in the work of his contemporaries. At the age of seventy, Jouvenet, inflicted with paralysis in his right hand, taught himself to paint with his left. Despite his infirmity, he subsequently was awarded a number of important commissions, including the decoration of the choir at the cathedral of Notre Dame, Paris.

Although Mobile Bay was probably first mapped by the Italian navigator Amerigo Vespucci, and visited by the Spanish explorer Hernando de Soto, it was the Frenchman Robert La Salle who secured the area at the mouth of the Mississippi for France in 1682 and convinced Louis XIV to fund its settlement. Antoine LeMoyne de Chateaugue joined his brother Pierre LeMoyne, sieur d'Iberville, when he was sent to establish the territory for the French. Iberville secured Fort Louis de Maubile (today, Mobile at 27-Mile Bluff) as the capitol of French Louisiana, which came under the leadership of Chateaugue's other brother, Jean-Baptiste LeMoyne, sieur de Bienville. Chateaugue returned to France in 1698–99 and then again for a shorter period in 1703 to raise a regiment. It was probably during one of these visits that the painting was executed. Chateaugue was a trusted and invaluable supporter of his brother's efforts to settle Mobile Bay, and among his achievements were the peace negotiations between the Chickasaw and Choctaw tribes. Around 1716–17 LeMoyne was named commander of the land and sea forces in Mobile. He later was appointed a number of governorships in French-Caribbean colonies before returning to France, where he died in 1747.

LeMoyne's attire is consistent with men's dress of the baroque period. Of special interest is the high collar, on top of which a large lace jabot is worn. The width and length of jabots eventually grew to extremes, sometimes becoming so wide that they covered both arms. During this era men for the first time took to wearing wigs; LeMoyne's is arranged in a long, curled hairstyle.

—————2

Nicolas de Largillièrre
(French, 1656–1746)

Portrait of Marguerite de Sève, 1729

Oil on canvas, 54⅝ × 41⅞ in.
Timken Museum of Art, The Putnam
Foundation, San Diego, 1973:001.A

*I*n the course of his long life, Nicolas de Largillièrre, who died at ninety, was both well respected and well remunerated for his paintings. Although he produced many landscapes, still lifes, and religious works, he is regarded first and foremost as a portraitist, one of the most important of the eighteenth century.

In 1729 Marguerite de Sève and her husband, B. Jean-Claude Pupil, president of the Cour des Monnaies de Lyon, posed for a pair of pendant portraits by Largillièrre. He skillfully merged the portrait conventions of the court, which leaned toward allegory, and the more individualistic realism of the bourgeois portrait. Blending artifice with naturalism, his portraits are timeless in their visual beauty.

Largillièrre's mature works are noted for their brilliant coloration. The Timken painting demonstrates this in the color contrasts established between the sitter's ivory flesh tone, the luxuriant fabric of the gown, and the blue cut velvet of the upholstered chair and wallpaper.

De Sève's dome-shaped skirt is consistent with a style, popular until about 1730, which grew more oval in shape. A petticoat reinforced the skirt, with hooped whalebones lending further structure. Ending at about the knee, the petticoat would have made a gentle, graceful motion as the wearer moved. The bodice, which clearly reflects the lining of the cape, was made from unusual materials, either metal or silk cut on the bias and mounted on a molded buckram (a coarse cotton fabric sized with glue, commonly used for stiffening garments and bookbindings).

Largillièrre was above all an allegorist. The page of music Madame de Sève turns is actually a popular drinking song of the time, indicating perhaps the sitter's joviality or prowess as a hostess rather than a great interest in art and music.

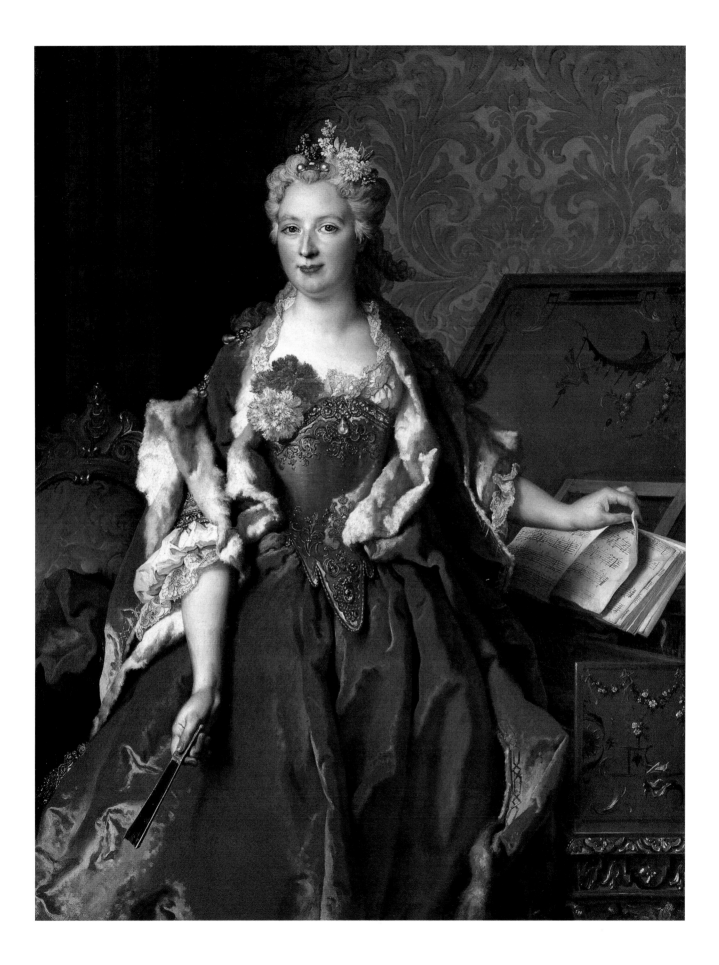

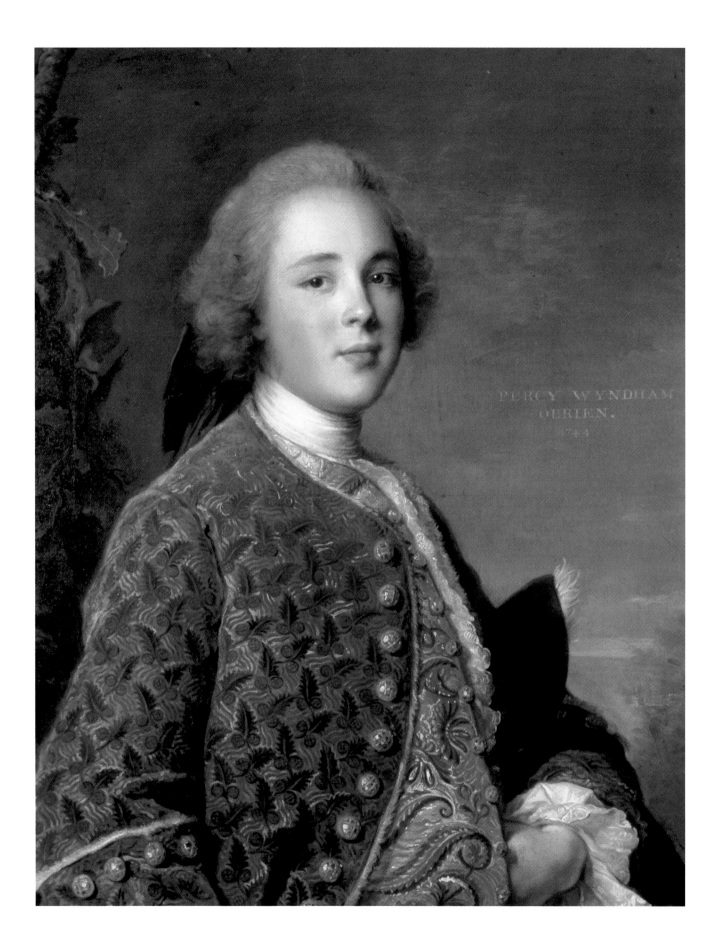

_____3

Jean-Marc Nattier
(French, 1685–1766)

Percy Wyndham O'Brien, 1744

Oil on canvas, 31⅛ × 24¾ in.
Columbia Museum of Art, South
Carolina, museum purchase through
a gift of the Charles Ulrich and
Josephine Bay Foundation, 1960.23

Jean-Marc Nattier was born into an artistic family, and probably first studied under his father, Marc Nattier, and the artist Jean-Baptiste Jouvenet (see cat. no. 1). His own son also became an artist and his two daughters both married artists, Louis Tocqué (see cat. no. 4) and François-Hubert Drouais (cat. no. 7). A leading artist at the court of Louis XV, Nattier was famous for posing his sitters in the aspect of mythological figures. He painted the king's daughter Adélaïde, for example, in guises including the goddesses Diana and Flora.

Nattier's sitter in this portrait, the Londoner Percy Wyndham O'Brien (1723–1774), was the ninth earl of Thomond. Coats during this period were designed without collars so as not to obstruct the ponytail worn by men, as does O'Brien, a style that remained fashionable well into the 1770s. Also indicative of the period are the full-buttoned cuffs, which in only a few years would be outmoded. Typically, for the period, the waistcoat (known as a *gilet*) is the most highly decorated element of O'Brien's dress. The front is lavishly embroidered, but the back and other unseen parts of the waistcoat would have been unadorned and probably made of a less expensive material. Although the coat is not fully visible in the painting, its line and cuff suggest that it flared, although less fully, in the style of the *justaucorps*, a coat highly fashionable since the 1720s.

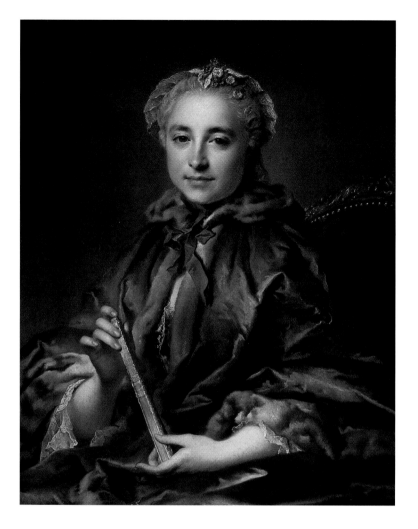

————4

Louis Tocqué
(French, 1696–1772)

Madame de Livry, 1750

Oil on canvas, 33¾ × 26½ in.
Birmingham Museum of Art, Eugenia
Woodward Hitt Collection, 1991.246.1

Louis Tocqué was a pupil of the history painter Nicolas Bertin but was also greatly influenced by his father-in-law, the portraitist Jean-Marc Nattier (see cat. no. 3). Tocqué was renowned for his ability to present natural and simple poses.

Madame de Livry, who died in 1769, was the wife of Jean de la Inte de Livry, a patron of Tocqué and a close friend of Madame de Pompadour, the influential mistress of Louis XV. Tocqué also painted de Livry's father-in-law and produced a portrait bust of her husband.

Although Madame de Livry wears a hooded, fur-lined cape over her dress, it most likely was not meant for the out-of-doors. Such capes were worn inside, especially in winter, in cold, drafty places.

Folding fans such as the one Madame de Livry holds originated in China and Japan, where they were regarded as status symbols. The montures forming the fan's infrastructure of sticks and guards were made of various materials, including ivory and mother-of-pearl, and in some instances were ornamented with jewels. The leaves were then painted, often with *fête champêtre* scenes (see cat. nos. 13 and 14). By the eighteenth century, many were made in Europe, but imported fans were still highly prized. Madame de Livry's cold-weather attire suggests that the closed fan was included in the picture as a sign of status; it also acts as a compositional device for the positioning of the sitter's hands.

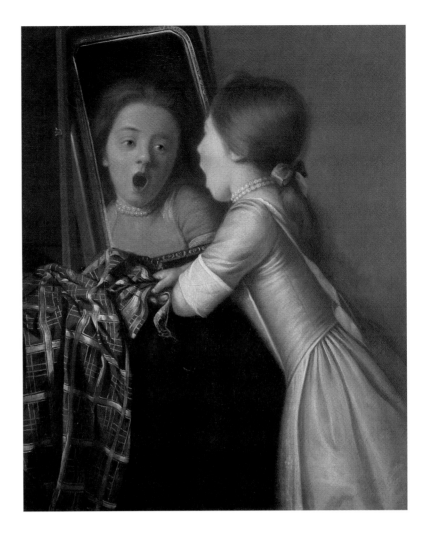

—————5

Jean-Étienne Liotard
(born Switzerland, worked in France,
1702–1789)

Young Girl Singing into a Mirror,
1730–38

Oil on canvas, 30 × 25 in.
Museum of Fine Arts, Springfield,
Massachusetts, James Philip Gray
Collection, 44.01

Two elements of this charming young girl's dress help place this hitherto undated work to about 1730–40. Both the plain, deep sleeve cuff and the separate stomacher panel were the prevailing style in that decade (Bradfield 1981). The artist, Jean-Étienne Liotard, is known to have traveled to Constantinople between 1738 and 1742, allowing us to further refine the date to 1730–38.

After his return from Turkey, Liotard adopted clothing in the Turkish style and grew a long beard. His unconventional dress is thought to have been a purposeful effort to establish his credentials as a connoisseur of exotic taste.

The plaid textile, a corner of which the subject grasps in her right hand, is probably a shawl or piece of fabric used as part of the girl's play. Until well into the nineteenth century, children's clothing was merely a miniature form of adult wear. The stiff, pointed bodice of the subject's dress illustrates the use of corsetry even for young girls' clothing.

_____ *6*

Jean-Baptiste Greuze
(French, 1725–1805)

Portrait of Madame Marie-Angélique Gougenot de Croissy, 1757

Oil on canvas, 31½ × 23¾ in.
New Orleans Museum of Art, museum purchase, Ella Freeman Foundation Fund, Women's Volunteer Committee Fund, and an anonymous gift to 1976 Acquisitions Fund Drive, 76.268

When Jean-Baptiste Greuze, a genre painter and a portraitist, enrolled at the Académie Royale in Paris, his talent was at first unappreciated. His goddaughter related, "When he went to draw at the Académie [in 1750], his talent was ignored, and he was given the worst place; his proud and sensitive soul rebelled against this injustice, and, taking his works in his hands, he went to see . . . [the] former drawing master to the royal children, who, astonished and delighted by his talents, ordered that Greuze be given a decent place" (Brookner 1972).

The artist's strict and prudent personal demeanor was in conflict with the luscious images he painted. Most disarming are the many depictions he made of women's heads in semi-ecstatic expressions, works with which he remains the most closely associated.

During a 1755 trip to Italy, Greuze met Louis Gougenot de Croissy, a wealthy Frenchman, who became one of his great patrons. Greuze painted a pendant portrait of Gougenot's brother, Georges Gougenot de Croissy, later *secretaire* to Louis XV (c. 1758, Musées Royaux des Beaux-Arts de Belgique, Brussels), and his wife, Madame Marie-Angélique Gougenot de Croissy, born in Varennes in 1737 and the daughter of an equerry to the king.

Madame Gougenot de Croissy's clothing, replete with a fur choker matching the trim of her blue mantle, is extremely luxurious and befits a woman of her stature. The deceptively alluring ribbons decorating the front of her bodice were a popular ornament at the height of the rococo era. Greuze's adeptness at rendering lace—the sleeves are most likely separate and detachable pieces known as *engageantes*—is evident.

Madame Gougenot de Croissy holds in her left hand an ornamented spindlelike device known as a *navette*. Made of precious materials like the gold one seen here, it was used by women in public settings who kept their fingers busy by knotting thread and wrapping it about the *navette*. The pursuit had no real purpose except to demonstrate an abhorrence of idle hands.

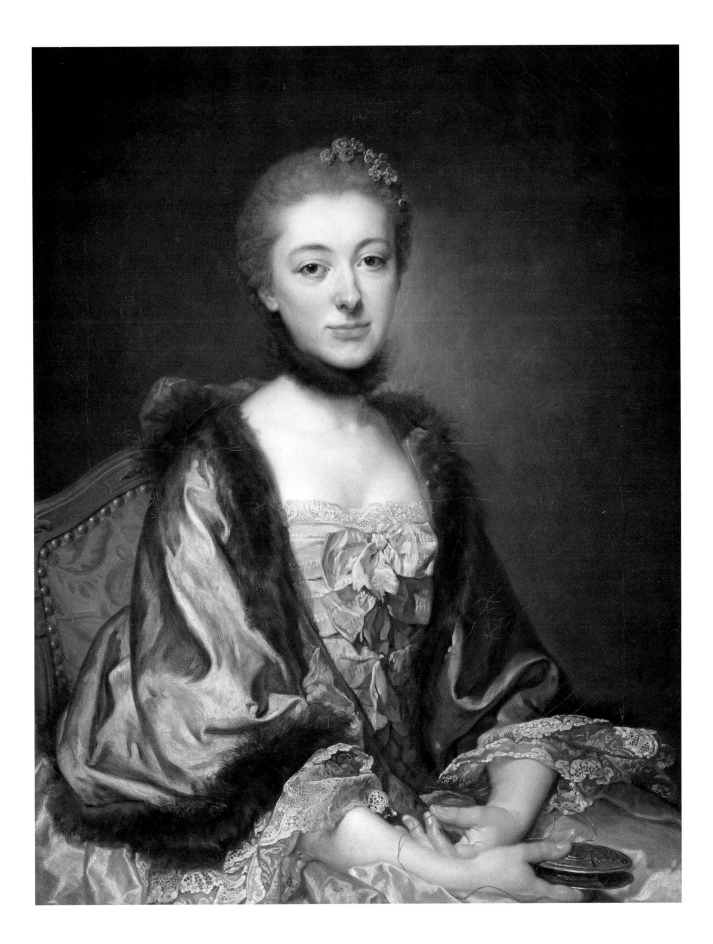

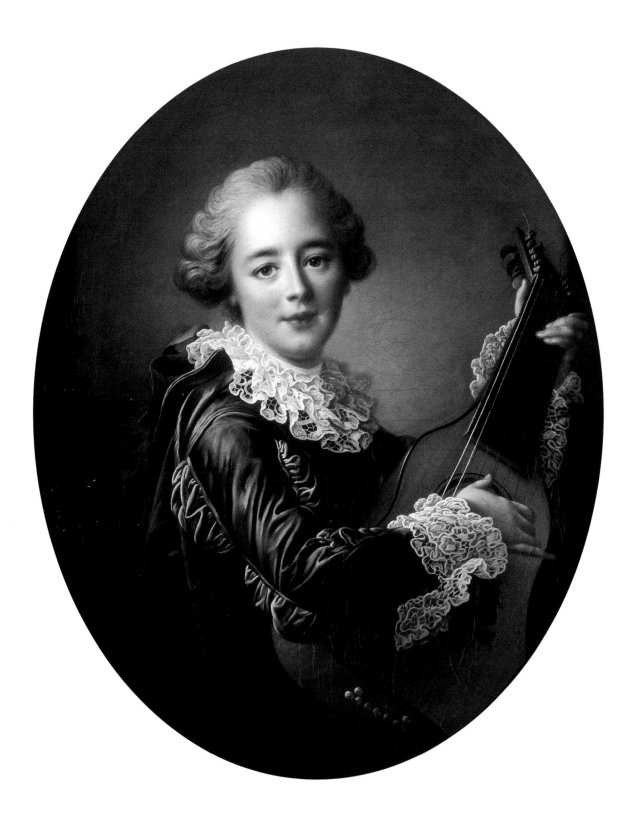

François-Hubert Drouais
(French, 1727–1775)

Madame du Barry Playing the Guitar,
1765

Oil on canvas, 28½ × 23¾ in.
Birmingham Museum of Art, Eugenia
Woodward Hitt Collection, 1991.252

François-Hubert Drouais was a follower of the important rococo artist François Boucher and the son-in-law of Jean-Marc Nattier (see cat. no. 3). Drouais was especially adept at portraying the texture of fabric, a skill that established him as one of the leading portraitists of the day and a most sought-after artist at the royal court.

Drouais's subject was born Jeanne Bécu in 1743 but is better known as Madame du Barry. She worked briefly as a shopgirl in the Paris fashion house Labille's, and while there she began a liaison with Jean du Barry, a nobleman. Many artists, including Drouais, frequented the shop to borrow trimmings to use in portraits. It is possible that du Barry, who already enjoyed a reputation as a great beauty, first made the acquaintance of the artist at Labille's. She eventually married her lover's brother, becoming the comtesse du Barry in 1769, but the marriage was only one of convenience. Madame du Barry's new aristocratic status enabled her to become the official mistress of King Louis XV, whose attention she had attracted the previous year. Although adored by the king, she did not have the same political impact on him as her predecessor, Madame de Pompadour. Du Barry was a great patron of artists, including Drouais and Elisabeth-Louise Vigée Le Brun (see cat. no. 19), and she was a good friend of the author and philosopher Voltaire.

The flounces at her collar and cuffs are probably alençon, a highly prized lace associated with winter wear. The ruching at the sleeves is in contrasting shades of blue-green. Drouais portrayed du Barry with a stringed instrument to symbolically indicate her skill in and appreciation of the musical arts, one of the many areas in which a woman of her standing would be expected to excel. The painting, previously titled *Portrait of Madame du Barry Dressed as a Page*, was made before her elevation as the king's mistress. Indeed, she would not be introduced to the king for another three years. Her depiction in the guise of a male page and player of a stringed instrument reflects, therefore, not the taste of the court, but most likely that of Jean du Barry. Drouais portrayed her similarly in *Portrait of Madame du Barry in Male Costume* (1769, Bibliothèque Nationale, Paris). Of Drouais's several paintings and drawings of du Barry in existence, the Birmingham work is the earliest.

Briefly banished to a convent after Louis XV's death in 1774, du Barry later formed her own court of admirers separate from Versailles. Her indisputable connection to the royal court, and her ongoing communication with French émigrés living in London, precipitated her condemnation by the Revolutionary Tribunal. She died at the guillotine on December 7, 1793.

Robe à la française, c. 1760s

English or French
Silk faille
Kent State University Art Museum,
Ohio, Silverman/Rodgers Collection,
1983.1.8 a, b
Photographs © David M. Thum

*T*he distinctive attributes of the *robe à la française* are the deep box pleats that begin at the shoulder and fall to the floor or, as in this gown, are gathered toward the bottom of a full skirt. The artist Jean-Antoine Watteau (see cat. no. 15) was nearly obsessed with the graceful movement of this type of pleats, an interest borne out by his many studies of women in *robes à la française* in various poses. They are, in fact, most commonly referred to as "Watteau pleats."

In the 1770s and 1780s the rigorous style of the *robe à la française* led to its wear only at court or other formal events. For less grand occasions, two dress styles emerged: the *robe à l'anglaise* and the *robe à la polonaise*. The *robe à l'anglaise* lacked back box pleats but was otherwise very similar to the *robe à la française*, especially in the skirt shape. The *robe à la polonaise* had a slightly raised hemline created by drawing up the overskirt with pull-cords in a swaglike effect that often revealed the wearer's shoes.

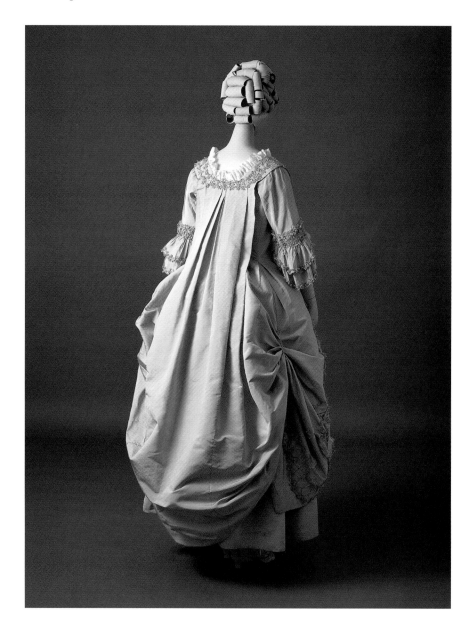

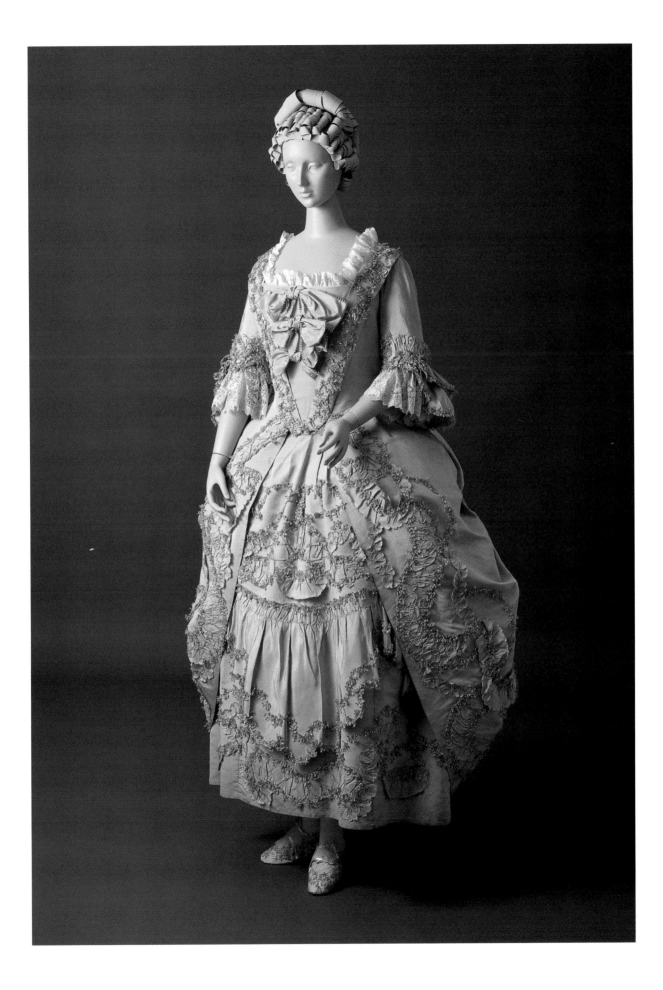

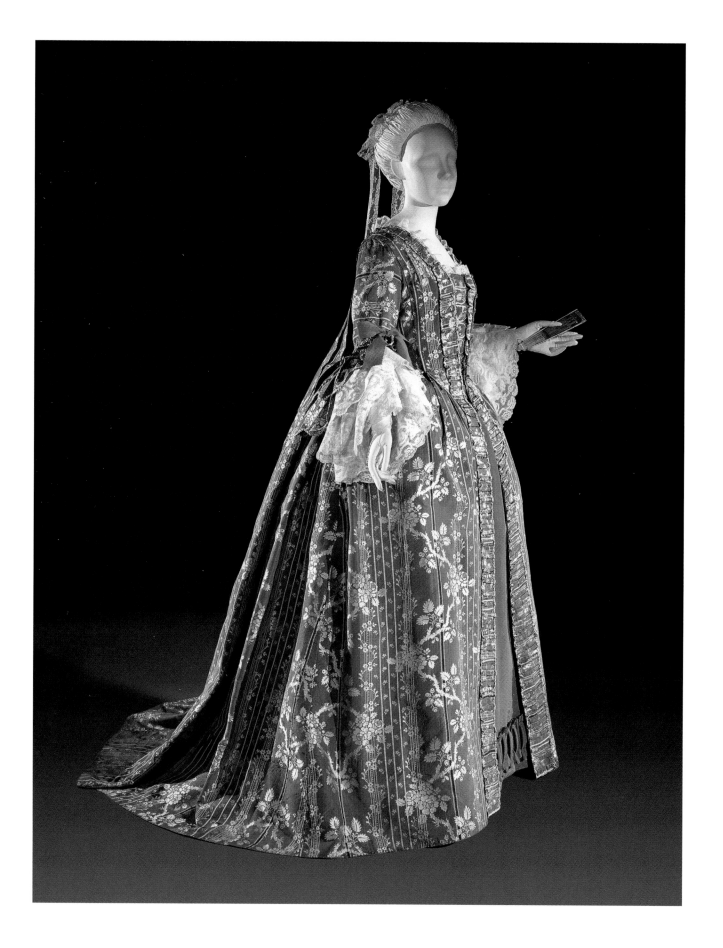

—————9

Robe à la française with attached stomacher, 1760s

Brocaded silk taffeta
Philadelphia Museum of Art, the Fiske and Marie Kimball Fund and the Edgar V. Seeler Fund, 1981-9-1

The dress is another variation of the *robe à la française*, with an open front and attached stomacher panels. The stomacher, usually in a V-shape, was stiffened with boning and formed the central part of the bodice. The striped floral decoration was the preferred textile design for such gowns and can be seen worn in many women's portraits of the day. The shape of the broad skirt, flattened at the back and front, was achieved with a panier, a set of oval hoops sewn into the petticoat or attached with fabric tape. At its height, the panier became so wide that its wearer was forced to turn sideways to pass through a doorway. Later versions of the panier were more flexible, allowing the woman to compress the hoops either by holding her arms at her sides or by sliding her hands into small pockets sewn into the sides of the skirt.

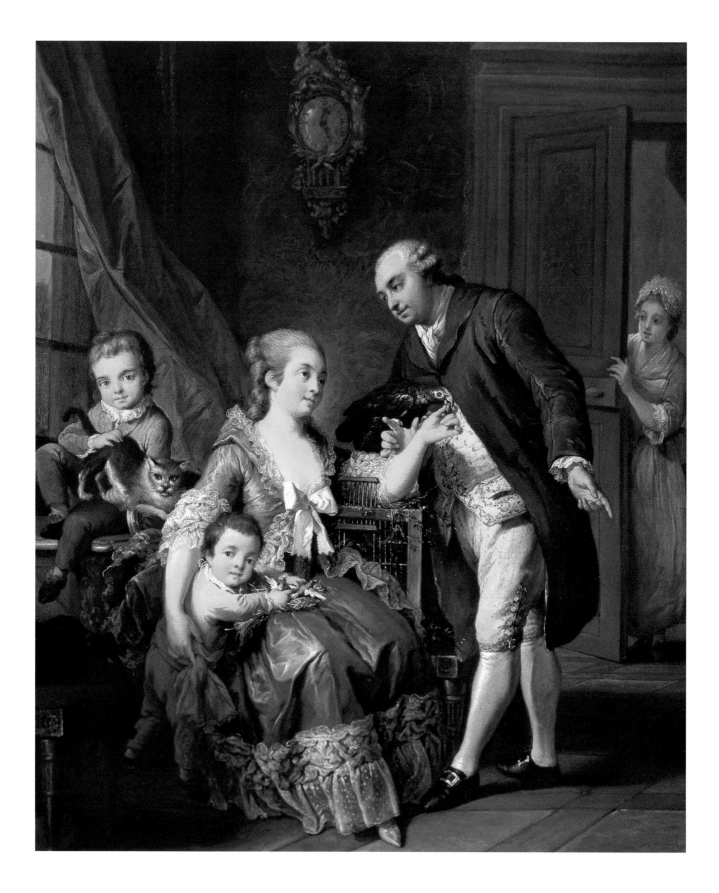

_____ *10*

Jean-Baptiste Charpentier
(French, 1728–1806)

The Duke of Orléans and His Family,
c. 1743–59

Oil on canvas, 24½ × 20 in.
The Speed Art Museum, Louisville,
Kentucky, bequest of Alice Speed Stoll,
1998.6.1

*L*ouis-Philippe, duc d'Orléans, was born at Versailles in 1725 and married Princess Louise-Henriette de Bourbon-Conti in 1743. She died in 1759, and the duke later married Charlotte Bérault de la Haye. He is here most likely pictured with his first wife, and the painting probably predates the princess's death, a supposition consistent with the clothing styles represented. Of special interest are the duke's breeches, which in the style of the period, fit tightly just below the knee. Although the waistcoat, traditionally the most embellished article in a man's outfit, demonstrates rich embroidery, its overall subdued color is an indication that the duke is attired for homelife and not for court, for which grander costumes were prescribed.

Louis-Philippe's grandson, Louis-Philippe I, became king of a restored French monarchy in 1830, due in great part to support from the rising bourgeois classes, who would make a significant impact on French society throughout the nineteenth century.

The artist, Jean-Baptiste Charpentier, was born in Paris and was a well-regarded professor at the Académie Saint-Luc. He also received the patronage of the duc de Penthièvre.

Adélaïde Labille-Guiard
(French, 1749–1803)

Portrait of Madame Adélaïde of France, Daughter of Louis XV, c. 1781

Oil on canvas, 11¾ × 84⅜ in. (framed) The Speed Art Museum, Louisville, Kentucky, gift of Mrs. Berry V. Stoll, 1982.21

*B*y 1774 Adélaïde Labille, the daughter of a Parisian haberdasher, was a pupil of the master pastelist Maurice-Quentin de la Tour (1704–1788), whose attention to detail in costume is consistently evinced in her work. Labille-Guiard was a direct contemporary of Elisabeth-Louise Vigée Le Brun (see cat. no. 19); the two women were even admitted to the Académie Royale on the same day. They were also rivals in competition at the royal court; Labille-Guiard was favored by Louis XVI, while Vigée Le Brun painted many portraits of his wife, Marie-Antoinette, and her circle.

Labille-Guiard's portrait of Madame Adélaïde, the daughter of Louis XV, depicts the subject among a complex of biographical references. She stands before a silhouette portrait of her father, mother, and brother, indicating her artistry as well as her nobility; she is surrounded by ornate furnishings, which she collected; and she is dressed in the sumptuous attire of a fashionable woman. As described by Madame de Boigne, an aristocrat at court, the princess was "very taken with her toilette, and . . . greatly disposed to coquettishness" (Passez 1973). The architectural plans shown at the lower left were for a convent the princess was financing, a demonstration of the attitude of goodwill the royal family wished to convey.

The style of Adélaïde's gown, a type of sack dress, came into fashion after 1775. A decidedly more comfortable manner of women's dress, it did not necessitate the wearing of a panier, or hoop framework. The fullness of the skirt, accentuated in the back, and the train was achieved primarily by a bustle. The red velvet, embroidered in gold, the amazing flounces of bows forming a lattice trimming at the bodice, and the pearl-gray silk skirt, also embroidered in gold, not to mention the fine lace, demonstrate the sitter's access to the finest and most luxurious of materials.

Adélaïde's large, wide coiffure, usually achieved by pulling the hair over pads, is stylistically consistent with the 1780s, as is the equally broad lace headpiece.

Adélaïde was born the third, much-loved daughter of Louis XV at Versailles. Although unmarried, she and her sisters were referred to as "madame," a sign of respect even greater than the title of "princess."

With the arrival of the king's mistress Madame du Barry (see cat. no. 7), Adélaïde lost the great influence she had had upon her father. She retreated from court with her sister Victoire. The two princesses made a harrowing escape at the onset of the Revolution to Trieste, Italy, where Adélaïde died in 1800. Her remains were returned to France in 1817 and interred at the cathedral of Saint-Denis with her many royal ancestors.

Unlike Vigée Le Brun, who continued to paint the aristocracy in exile, Labille-Guiard chose revolutionary figures and adopted the neoclassical style. She waited out the Terror in her country home with her tutor, François Elie Vincent, whom she married in 1800.

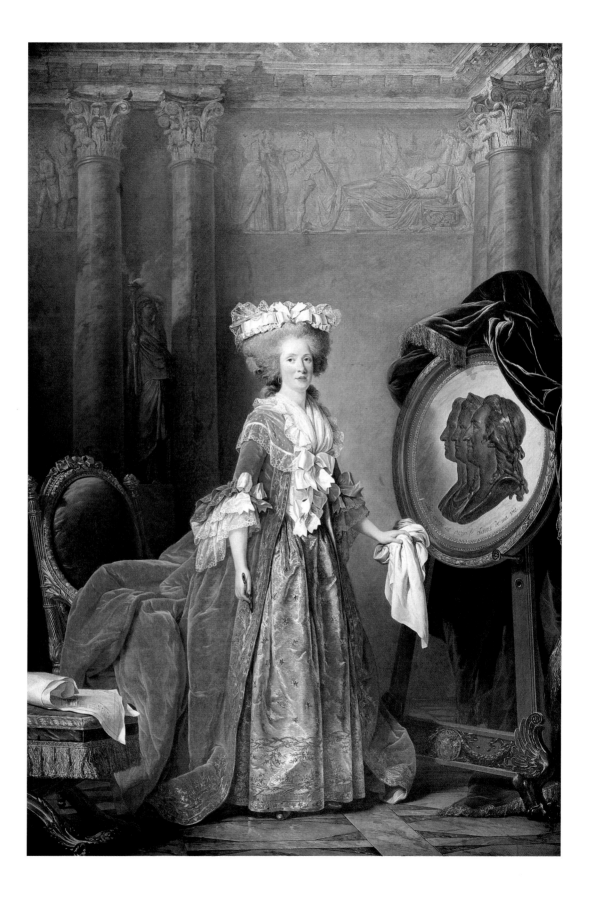

_____ *12*

Marie-Victoire Lemoine
(French, 1754–1820)

Portrait of a Young Girl, c. 1790

Oil on canvas, 17½ × 14 in.
The Speed Art Museum, Louisville,
Kentucky, bequest of Alice Speed Stoll,
1998.6.5

*M*arie-Victoire Lemoine was born in Paris, and although probably not a pupil of Elisabeth-Louise Vigée Le Brun (see cat. no. 19), she was greatly influenced by her. The esteem in which Lemoine held the artist is revealed in a portrait of Vigée Le Brun (c. 1796, Metropolitan Museum of Art, New York) in which she is depicted as nothing less than a priestess to women artists.

Lemoine's painting of the 1790s demonstrates the change in fashion, even before the Revolution, to simpler designs and less adornment. Muslin and printed cotton, for instance, replaced silk fabrics. The gown in this painting shows signs of the shift in style, with a slightly higher waist and less decoration at the neck and sleeves. Around her neck the young girl wears a lace scarf, which is tucked into the top of her bodice. Known as a fichu, its traditional purpose was for modesty, but depending on its arrangement, the fichu could be worn tantalizing low and open, accentuating, rather than covering, a woman's décolleté.

The oval format and pose of the sitter relate very closely with Lemoine's *Mademoiselle d'Holbach*, c. 1785–95, in the collection of the Ball State University Museum of Art.

_____13

Bonaventure Debarre
(De Bar; French, 1700–1729)

Fête Champêtre, late 1720s

Oil on canvas, 7 × 11½ in.
The Sarah Campbell Blaffer
Foundation, Houston, 1988.2

The fête champêtre, or pastoral, genre made its first appearance in the paintings of Venetian Renaissance artists such as Titian and Giorgione. In the eighteenth century the theme is associated with the French rococo and bucolic, festive scenes such as this, in which young men and women gather in an arcadian setting. Typically the revelers engage in the amorous activities of courting, dancing, and picnicking. Musicians, sometimes dressed as *commedia dell'arte* figures, usually accompany the festivities.

The standing male figure seen from the rear wears a red *justaucorps*, a knee-length jacket with flared skirts and deep cuffs reaching almost to the elbows, which was standard attire for a gentleman of the period. Although it is not fully visible, his hat, from the look of its long flat back, appears to be a tricorne, or three-cornered hat, a design nearly synonymous with French style. The other men are dressed similarly, if less grandly, with breeches extending just beyond the knees.

The central female figure is in a state of partial undress, with undone bodice lacings reaching almost to her waist. Around her head she holds—more for flirtation than protection from the elements—a scarf or possibly some discarded clothing. The two other women, on the left and right of the painting, are dressed more modestly in full, structured skirts and restricted bodices, a style seen since the seventeenth century.

Bonaventure Debarre devoted the body of his work to the *fête champêtre* (another example is in the Louvre, Paris), but his promising career was cut short by his early death.

Nicholas Lancret
(French, 1690–1743)

The Bourbon-Conti Family, 1737

Oil on canvas, 19⅜ × 26¼ in.
Krannert Art Museum and Kinkead
Pavilion, University of Illinois, Urbana-
Champaign, gift of Mrs. Elinora D.
Krannert, 1967-3-5

Nicholas Lancret began his career as an engraver, but by 1700 he was studying painting at the Académie Royale. He also studied under Claude Gillot, the teacher of Jean-Antoine Watteau, and it was probably from Gillot that both Lancret and Watteau developed their interest in the pastoral or rural scenes known as *fêtes champêtres*. From 1730 until 1743, Louis XV was Lancret's primary patron.

The attire of the figures in the painting dates from slightly earlier than the painting itself, a consistent phenomenon in the *fêtes champêtres* of Lancret and Watteau. The figure at the right of the standing group illustrates the *contouche*-style dress, an early variation of the box or Watteau pleat. Also evident is the practice of dressing children in smaller versions of adult clothing, unaltered in design from the adult fashion in decoration, materials, or even the use of corseted bodices.

The Bourbon-Contis were direct descendants of Armand de Bourbon (1629–1666), at whose birth the title of prince of Conti was revived. The family represented in the painting is probably that of Louis-François, prince de Conti (1717–1776), who served the French military with distinction in Germany and the Netherlands. Because he often disagreed with Louis XV on political matters, however, Louis-François earned the disfavor of the highly influential Madame de Pompadour. The Bourbon-Conti line existed until 1814.

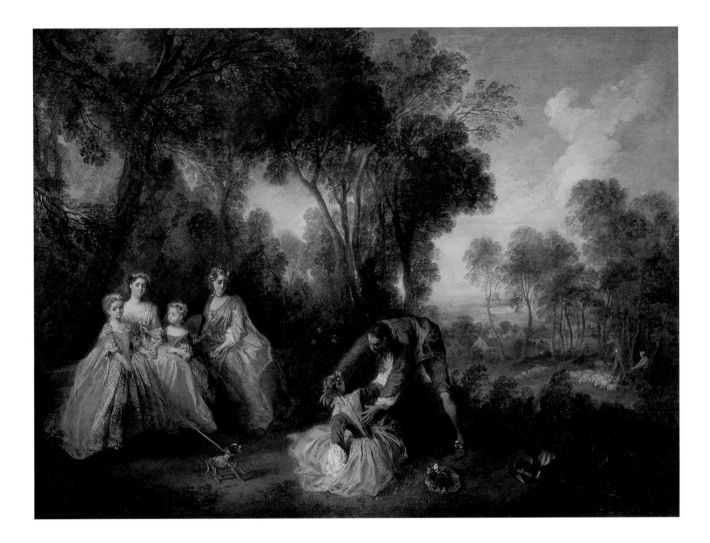

15

**Attributed to
Jean-Antoine Watteau
(French, 1684–1721)**

A Lute Player, undated

Crayon on paper, 9½ × 6½ in.
The Santa Barbara Museum of Art,
gift of Mrs. Sterling Morton, 64.9

Jean-Antoine Watteau studied in Paris from 1704 to 1708 under Claude Gillot, an artist renowned for his theatrical designs. It may have been while under Gillot that Watteau gravitated toward theatrical characters and settings. Musicians, especially lute players, appear in much of Watteau's subsequent work.

Attributed to Watteau, the drawing is stylistically consistent with his work, and the figure resembles Nicolas Vleughels (1668–1737), an artist and Watteau's roommate, who often modeled for him. Watteau is credited with the invention of fantastical views of people in fancy dress mingling in arcadian settings with strolling *commedia dell'arte* musicians. To distinguish this particular genre, the Académie Royale named them *fêtes galantes*.

Men's jackets of the first two decades of the eighteenth century were in the style of full-skirted *justaucorps* with back pleats. The deep, buttoned cuffs were also the trend in men's wear until 1745–50.

Watteau suffered much of his life from consumption, eventually dying of tuberculosis at age thirty-seven years. After Watteau's death, his patron and supporter Jean de Jullienne commissioned a series of engravings of the artist's paintings and drawings. It was through these engravings that Watteau's influence was disseminated to future generations of artists and designers.

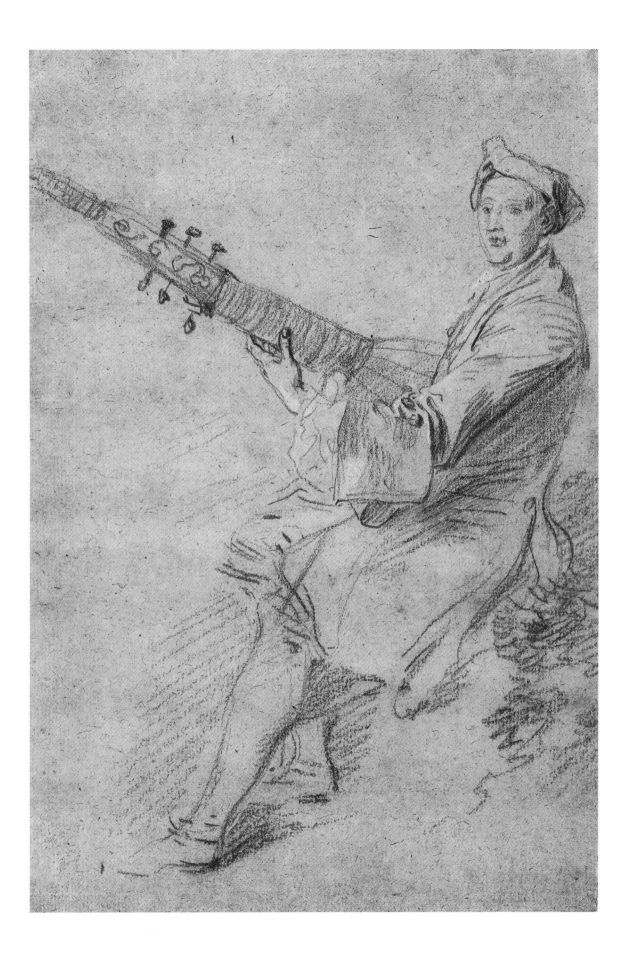

Man's suit, c. 1775–80

Patterned silk and metallic sequins
Kent State University Art Museum, lent by the
Allen Memorial Art Museum, Oberlin College,
Ohio, R. T. Miller Jr. Fund, 1948, 48.173a–c
Photograph © David M. Thum

During the time of this suit, men's dress
consisted of three primary pieces: the coat,
waistcoat, and breeches. Although exqui-
sitely embroidered with sequins and metal-
lic thread, this suit shows the shift toward
more restrained decoration that began in
the 1760s and lasted until the Revolution.
In shape, the coat is a slimmer version
of the *justaucorps*, a man's coat from the
earlier part of the century.

At the time of the Revolution, fashion
was a highly symbolic statement of a per-
son's status and political leanings. For in-
stance, the short breeches long associated
with the aristocracy disappeared in favor
of long trousers, which were evocative of
the working class.

—————*17*

Officer's epaulettes, c. 1780

Cloth and silver thread
The Stewart Museum at the Fort,
Île Sainte-Hélène, Montreal,
inv. 1965.3

*E*paulettes, whose name derives from the French word *épaule* (meaning "shoulder"), were originally a sign of military rank. The duc de Choiseul introduced them to the French army in 1762. The class and rank of an officer were distinguished by the color and thickness of the fringe.

By the 1780s epaulettes had become elaborate decorations, often made of gold and silver thread. They have enjoyed subsequent popularity in civilian dress, both in men's and women's fashion, and were particularly fashionable in the mid-1980s.

Antoine-François Callet
(French, 1741–1823)

Portrait of Louis XVI, c. 1782–83

Oil on canvas, 64 × 51½ in.
New Orleans Museum of Art,
museum purchase in honor of
the 75th Anniversary, 86.90

Antoine-François Callet first achieved artistic success at the court as a painter of royal portraits. Despite this, he survived the Revolution to become one of the first proponents of neoclassical painting, setting a precedent for artists such as Jacques-Louis David (see cat. no. 22), whose work would become synonymous with the style. Callet's portrait of Louis XVI is relatively restrained, in marked contrast to the highly decorative depictions by the previous generation of rococo artists.

The fur yoke and lining of the king's robe come from the ermine, a type of weasel whose fur turns white in winter. Ermine is closely associated with royal regalia and was reserved for royal use. On the front of the robe, on a background of lush purple velvet, is the fleur-de-lis, the heraldic symbol of the Bourbon dynasty of the ruling house of France. The origin of the fleur-de-lis probably dates from the mid-fourteenth century. It is most commonly read as a stylized flower, possibly a lily, or, with its three points, as a symbol of the Holy Trinity. Iconographically, the fleur-de-lis remains symbolic of French history and culture even to the present day.

Born at Versailles in 1754, Louis XVI became heir to the throne at the age of eleven. At sixteen he married Marie-Antoinette, daughter of the Austrian emperor, and became king of France four years later, in 1774. Unfortunately, with the crown he also inherited his predecessor's debt, which was on the verge of bankrupting France.

At the lower left of the painting is a molded hand in the gesture of a "royal wave." When he traveled by carriage through the streets of Paris, the monarch, by merely moving the stick back and forth, would be saved the physical exertion of actually waving to his subjects as he passed by. Such artifice in communicating to the French citizenry would have great resonance in the history about to unfold, which would bring to an end both the king's monarchy and his life.

Another painting of Louis XVI by Callet hangs in the Apollo state room at the palace of Versailles.

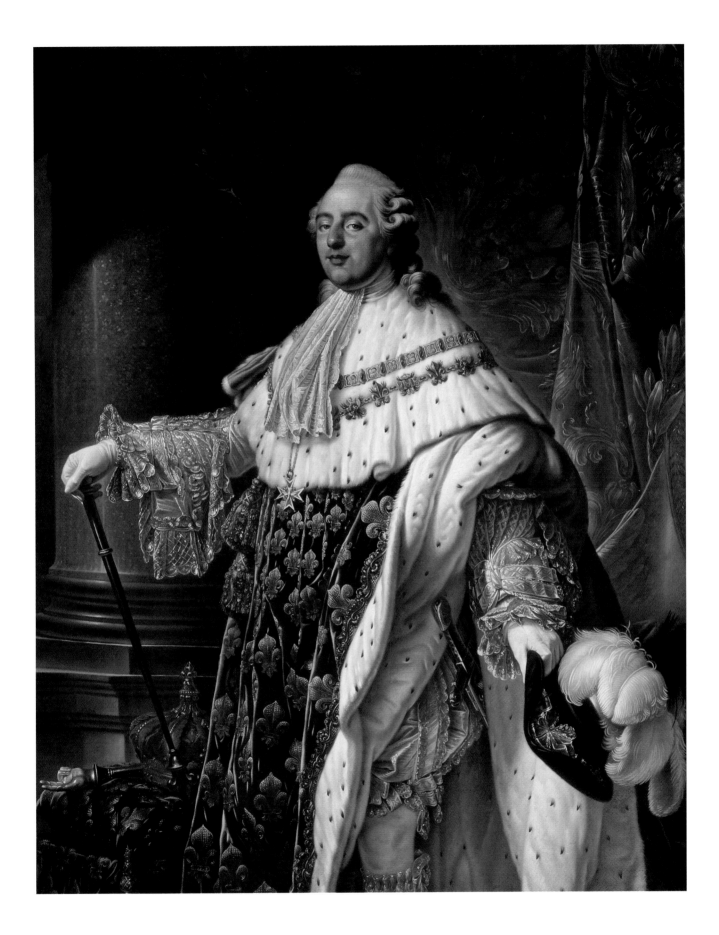

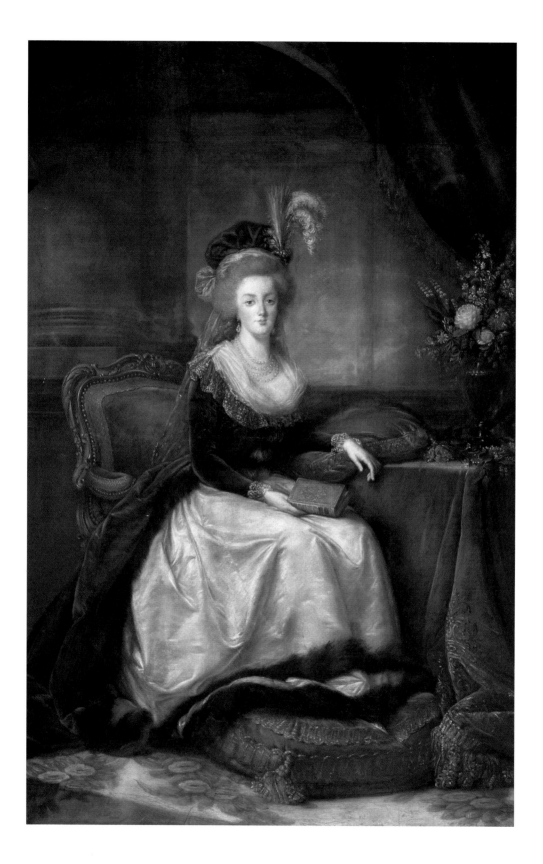

Elisabeth-Louise Vigée Le Brun
(French, 1755–1842)

Marie-Antoinette, c. 1788–89

Oil on canvas, 100 × 67 in.
The Sarah Campbell Blaffer
Foundation, Houston

Elisabeth-Louise Vigée Le Brun was tutored in art by her father, the painter Louis Vigée. After his death, Vigée Le Brun, while still a teenager, supported her family with her earnings as an artist. At the prodding of her mother, she married the art dealer and painter Jean-Baptiste-Pierre Le Brun.

Vigée Le Brun's highly flattering portraits no doubt contributed to her demand as an artist at court; throughout the course of her association with Marie-Antoinette, she painted the queen twenty times. Vigée Le Brun painted her first portrait of Marie-Antoinette in 1788.

Born in Vienna, November 2, 1755, Marie-Antoinette was the daughter of the Austrian emperor Francis I and Empress Maria-Theresa. At the age of fifteen, Marie-Antoinette married the future Louis XVI. The young queen cultivated a taste for fine things at the French court, and her spending, including large bills from the *marchande de modes* Rose Bertin (see Campbell essay, above), caused great public outcry. The headpiece in this work is consistent with the style of Bertin's creations; however, her design books from this period have not survived to offer confirmation. Perceived as a frivolous spendthrift, Marie-Antoinette contributed to the unrest that ended in the French citizens' revolt. She was imprisoned after the storming of Versailles in 1789 and executed by guillotine on October 16, 1793.

Vigée Le Brun fled France at the time of the Revolution, settling in Italy and later Russia, where she remained for several years, often painting fellow expatriates. She returned to France in 1802 and published her memoirs in 1835.

Revolution and Empire: The Politics of Fashion

The downfall of the Bourbon dynasty, already crippled by debt and its callous disregard for the poor and starving, seemed inevitable when Louis XVI inherited the throne in 1774. The spendthrift ways of Queen Marie-Antoinette—most notably the complicated intrigue known as the Affair of the Necklace in 1785—exacerbated the ire of the populace. In 1789 rebels stormed the grim Bastille prison, long a symbol of autocratic oppression. Versailles was similarly overtaken the following October, and the king and queen removed to Paris. The king, found guilty of treason, was guillotined in 1793. Nine months later Marie-Antoinette suffered the same fate. The death of the monarch was only the beginning of a bloodbath known as the Reign of Terror, during which aristocrats and anyone else suspected of colluding with foreign enemies were systematically executed.

The Revolution's violent reordering of the ruling class required a visual disassociation from recent history. Jacques-Louis David, for example, was called upon to suggest a new style of dress that would signify the new age and make an absolute break with the past. Although David's vision of toga-garbed citizens was never realized, it inspired others to begin a reinterpretation of the antique. Additionally, design elements previously restricted to uniforms or the working class, such as a coachman's jacket or full-length trouser legs, were assumed in a conscious attempt to celebrate functionality. Painting styles abruptly became more austere and simplified, often incorporating elements of the antique in the dress and interiors depicted.

Ongoing political and social unrest created an opportunity for a young Corsican to seize the leadership of France. Napoleon Bonaparte had demonstrated his military genius in early successful campaigns in Italy and Egypt, and he would eventually bring most of the Continent, and beyond, under French domination. He was the first non-royal to rule France. Cognizant of his unprecedented (and possibly tenuous) political position, Napoleon further embraced neoclassicism as a means of invoking parallels between the republic of France and that of ancient Rome and, through the power of propaganda in art and fashion, suggested himself as a leader in the tradition of Julius Caesar.

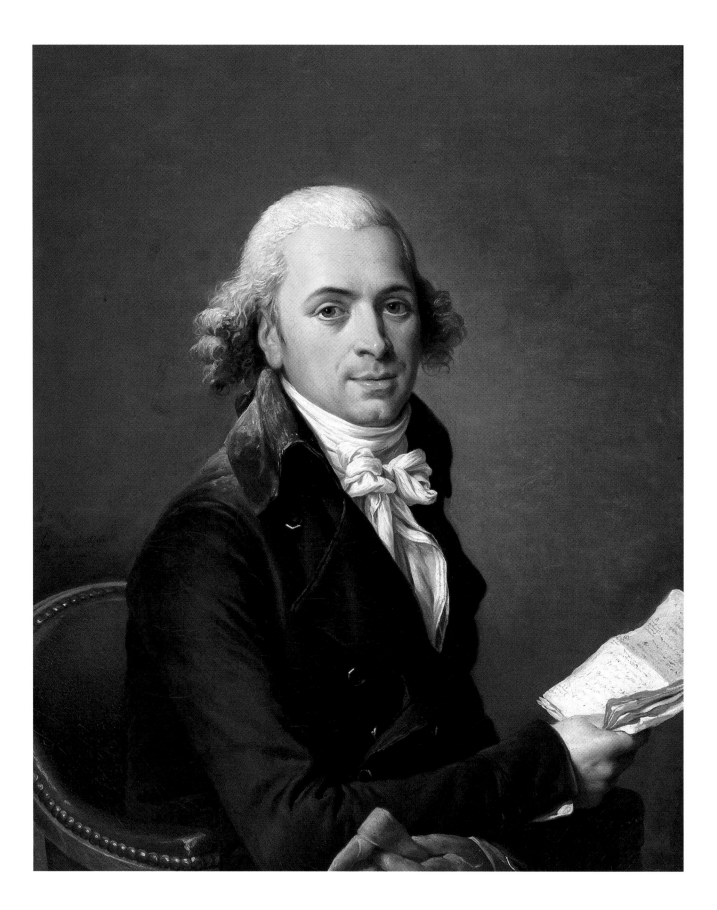

_____20

Adélaïde Labille-Guiard
(French, 1749–1803)

Portrait of Monsieur Meunier, 1798

Oil on canvas, 29 × 23½ in.
Honolulu Academy of Arts, purchase,
1962 (3067.1)

Adélaïde Labille-Guiard demonstrated her female independence by hyphenating her maiden and married names upon her marriage to Louis-Nicolas Guiard in 1769. They separated after ten years.

Little is known of the sitter, Monsieur Meunier, although the pages he holds, of which he is most likely the author, perhaps provide clues to his achievements.

The painting stands in contrast to earlier works by Labille-Guiard (see cat. no. 11) for the French royals and aristocracy. With a plain background, the painting shows the influence of David and neoclassicism in its decided restraint.

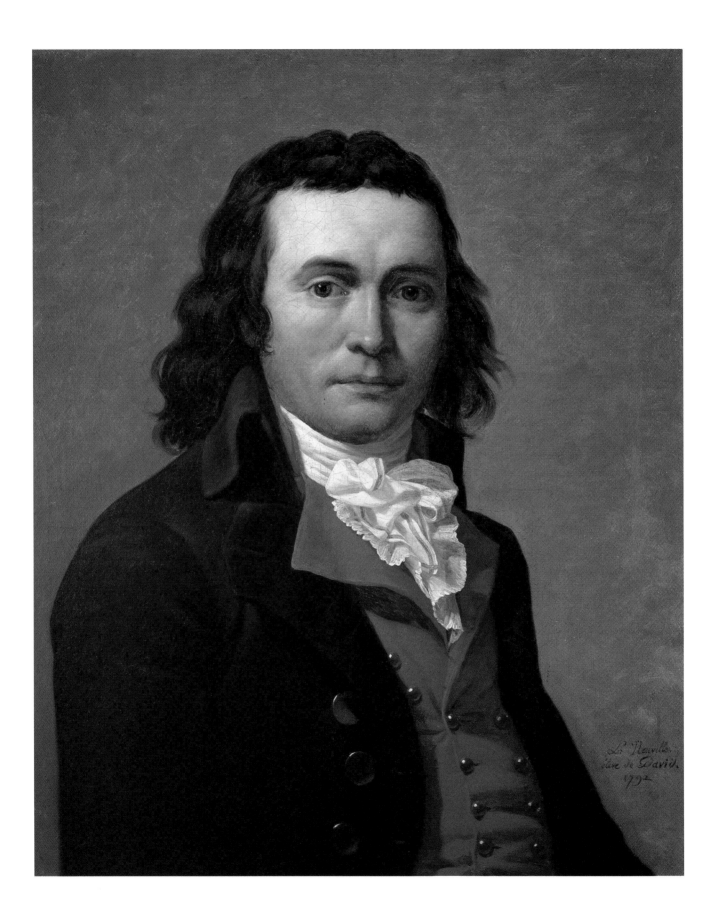

21

Jean-Louis Laneuville
(French, 1748–1826)

Portrait of Ruamps de Surgères, 1792

Oil on canvas, 25½ × 21½ in.
Joslyn Art Museum, Omaha, museum
purchase, 1960.268

Jean-Louis Laneuville was a direct contemporary and pupil of Jacques-Louis David. The monochromatic background of the portrait is consistent with much of Laneuville's work, as is the figure's pose, seated with head turned toward the viewer. Many of Laneuville's portraits emphasize in crisp detail the fashion worn—in this work, the masterly folds and knots of the sitter's cravat, and the slight stress of his torso upon the vest buttons.

A highly significant period in men's fashion, the 1790s in many ways changed men's dress permanently. Fashion no longer looked to the royal court for inspiration but to the political assembly, whose members wore plain clothing, usually in black.

Ruamps de Surgères was a revolutionary convention delegate, one of many whom Laneuville painted during this tumultuous period. A passionate proponent of the king's execution, and known for his occasional temper, de Surgères nonetheless opposed the mass executions of the Terror. For expressing his resistance, he was briefly imprisoned. After his release, de Surgères returned to the country and farmed until his death.

The Revolution, and the Reign of Terror in particular, precipitated a restrained manner of dress as a means of distancing oneself, no matter the degree of one's personal wealth, from the excesses of the aristocracy. This austerity, however, ran counter to the French taste for individuality and a distinctive style among the upper class.

Studio of Jacques-Louis David
(French, 1748–1825)

Self-portrait, c. 1790–1800

Oil on canvas, 19 × 15 in.
North Carolina Museum of Art, Raleigh,
purchased with funds from the State of
North Carolina, 52.9.122

The neoclassical artist Jacques-Louis David served as a deputy of the National Convention during the Revolution and voted for Louis XVI's execution despite the fact that he, like his colleague Jean-Baptiste Isabey, had enjoyed the king's patronage and court life at Versailles.

The original painting on which this studio copy was based probably predates David's arrest in 1794, during the time of political upheaval. In later self-portraits, David showed himself at work, with the accoutrements of an artist such as paintbrushes and paints, and often wearing a housecoat or more informal attire. But in this painting, a smaller version of the original (1794, Uffizi Gallery, Florence), David is clearly identified as a citizen and revolutionary rather than an artist.

The association of modes of dress with class distinctions and political leanings is evinced by the *sans-culottes*, the revolutionaries who stormed the Bastille and supported the Reign of Terror. Trousers were associated with the common workingman, and breeches with the aristocracy.

The uprising of the working class against the monarchy brought to France a new form of idealism that celebrated the commoner. Clothing designed for utilitarian rather than decorative purposes became the fashion. In this picture the artist wears a simple, unadorned brown coat inspired by those worn by carriagemen. The shoulder flaps allowed horse riders and drivers to have free arm movement. The riding coat adapted as a jacket style, called the redingote, was also popular in women's fashion.

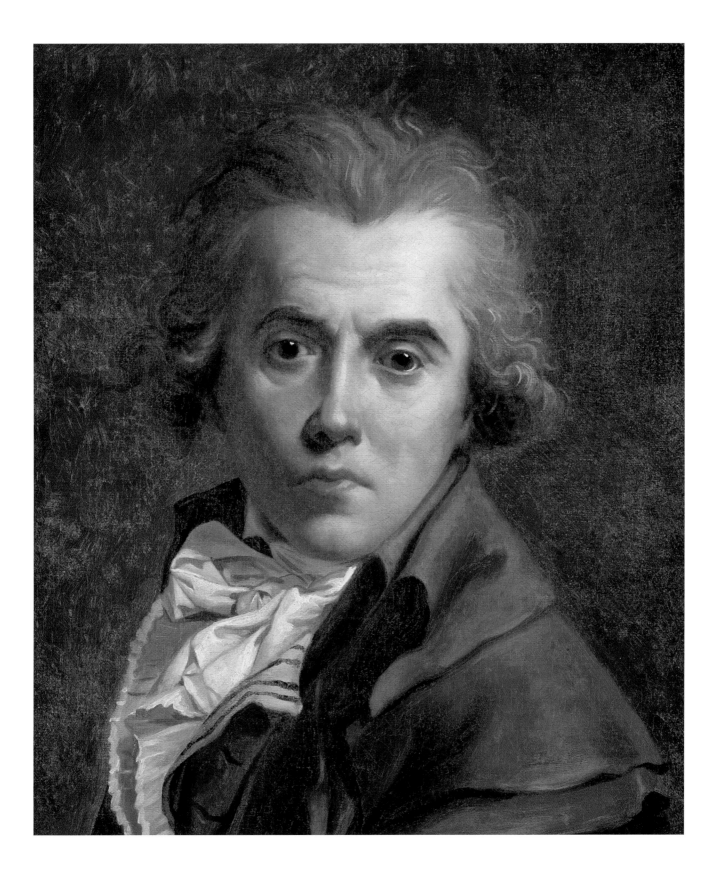

**Unknown artist, after
Jacques-Louis David
(French, 1748–1825)**

Madame de Servan, after 1800

Oil on canvas, 57½ × 44½ in.
Museum of Fine Arts, Springfield,
Massachusetts, James Philip Gray
Collection, 33.09

*M*adame de Servan wears a costume *à la grecque*, highly fashionable about 1800. The long shawl draped around her arms was an essential element of a woman's ensemble of the period. Napoleon's campaigns in faraway lands, such as Egypt in 1798, stirred the imagination of the upper classes who mass-ordered the shawls, usually made of cashmere, from French importers. Commonly a deep red, the shawls were often decorated in black stylized designs of classical forms, such as scrolling vines or palmettes.

The classicized dress so often worn by portrait sitters during this period was meant to convey the subject's knowledge of the classical world and to present them as both fashionable and learned. Street dress, inspired by, yet distinctive from this style, adapted classical elements of color and simplicity but retained Western forms. The interest in the classical world stemmed from archaeological discoveries at Herculaneum, first excavated in 1709, although the major findings were not disseminated until the end of the century.

Madame de Servan was the wife of the minister of war, Joseph-Marie Servan, or Servan de Gerbey (1741–1808), who was briefly arrested during the Terror.

The dress and interior are almost directly quoted from David's *Madame Raymond de Verninac* (1799, Louvre, Paris); the only differences are the sitters' heads and the red turban Madame de Servan wears.

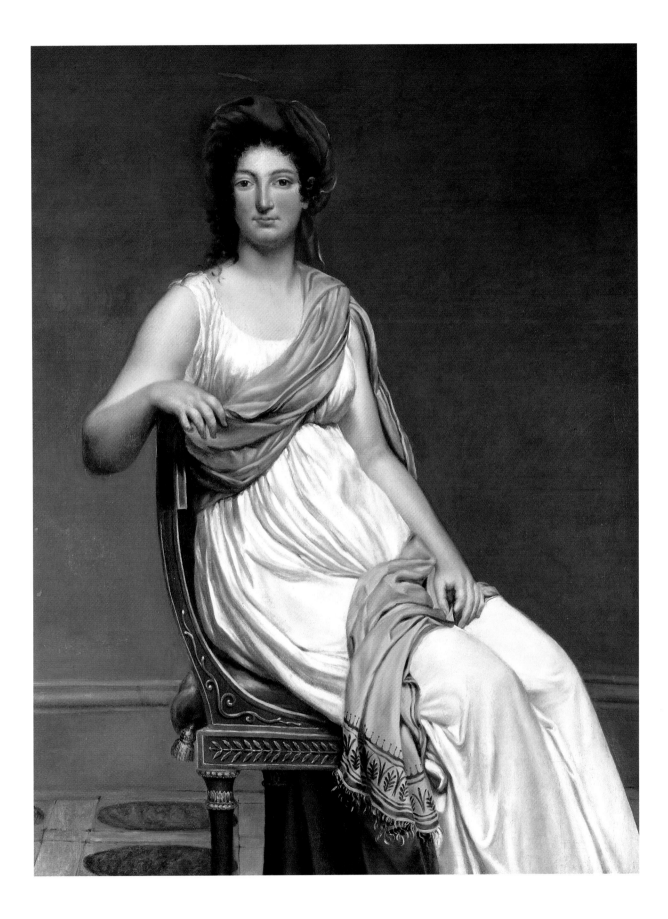

Jean-Baptiste Isabey
(French, 1767–1855)

Portrait of Elisa Bonaparte, c. 1810

Watercolor on ivory, gold, and enamel,
3⅛ × 1⅝ in.
Hillwood Museum and Gardens,
Washington, D.C., 53.6
above, left

*E*lisa Bonaparte was regarded as the least pretty of Napoleon's three sisters. She was also considered the smartest and most cultured of his siblings and, by most accounts, the emperor's favorite. Born in Bonaparte's native Corsica, she was known to her family as Marie-Anne. A great patron of the arts, she befriended David, Gros, and Isabey and commissioned works from them. She married Félix Pascal Bacciochi in Marseille in 1797, and received many titles from her brother, including princess of France and grand duchess of Tuscany.

The gown worn by Elisa Bonaparte in the miniature is almost archetypal of the Empire style, so closely associated with her family and the period of her brother's rule. The white muslin, while extravagantly expensive, had a plain, soft appearance as opposed to the lavish brocades and silks of the previous century of French fashion. The high waistline and short sleeves were meant to evoke the dress of the ancients. The uncorseted style was more scandalous than previous fashions.

_____ 25

Jean-Baptiste Isabey
(French, 1767–1855)

Portrait of the Empress Josephine,
c. 1805

Watercolor on ivory, 1⁷⁄₈ × 1³⁄₈ in.
The Philbrook Museum of Art, Tulsa,
gift of the Starr Foundation, Inc.,
1958.17.26

opposite, right

Jean-Baptiste Isabey arrived in Paris in 1785. He first studied under the miniature painter François Dumont and supplemented his income by painting decorative boxes and buttons.

Appointed first painter to Empress Josephine in 1805, Isabey is associated almost exclusively with his neoclassical work at the Napoleonic court. Yet he first achieved success as an artist at the royal court of Versailles and was a favorite of Marie-Antoinette, for whom, like Josephine, he designed gowns. There are accounts of Isabey dressing the queen, her ladies-in-waiting, and even himself in flamboyant costumes for masquerade balls. Isabey was granted his own apartments at Versailles and became the pupil of Jacques-Louis David, who at the time also enjoyed the privileges of court life.

Isabey came to the attention of Napoleon through Josephine, whose daughter Hortense he tutored in art. Isabey is credited with suggesting that Josephine purchase Malmaison, the beautiful château where she took refuge after her divorce and where she died in 1814.

Although of noble birth, Josephine, née Rose Tascher, spent an impoverished childhood on the island of Martinique. Her humble beginnings contributed to her being described as provincial throughout her life. Barely escaping the guillotine that claimed the life of her first husband, Vicomte Alexandre de Beauharnais, Josephine spent the first years after the Revolution establishing her independence and accumulating great wealth (by some accounts through nefarious methods). A tall and striking woman, Josephine captivated the young Napoleon, whose military career was just ascending. Although she did not return his affection with as deep an ardor, she had a great influence on the emperor. Their marriage was annulled in 1809 due to her adulterous affairs and inability to provide an heir.

The tiny red straps discernable at Josephine's shoulders suggest that she is wearing royal robes, possibly for her coronation. Isabey was responsible for the overall design of the coronation ceremony, including the gowns and robes of its officiates and participants. The dress and jewels pictured here are consistent with Isabey's designs for the empress's coronation, now in the collection of the Bibliothèque Nationale, Paris.

Jean-Baptiste Isabey
(French, 1767–1855)
Ceremonial jacket [fragments],
c. 1805–10

Embroidered silk velvet
The Costume Institute, The Metropolitan
Museum of Art, gift of Mary Tavener Holmes,
1984 (1984.591)
Photograph © The Metropolitan Museum
of Art

*S*urviving prints of Isabey's designs
for ceremonial dress at the Napoleonic
court demonstrate the frequent use of
acanthus-leaf and gold-embroidered
motifs as decoration. This unconstructed
man's ceremonial jacket exists in fifteen
fragments, including front, side, and back
panels, cuffs, collars, and a waistcoat.
Sumptuous embroidery (see cat. no. 29)
was revived during this period upon
Napoleon's order as a means of stimu-
lating the garment industry, which had
suffered greatly after the Revolution
with the absence of a royal court.

The neoclassical period saw the re-
vival of many antique motifs by artists
and designers, who often stylized organic
forms, such as the palm, husk, waterleaf,
or acanthus. Notably, even Napoleon's
imperial crown was designed as a wreath
of golden leaves. The intended wearer of
the suit and the reason for its unassem-
bled state are unknown.

———27

Antoine-Denis Chaudet
(French, 1763–1810)

The Emperor Napoleon as a Roman Consul,
c. 1806

Bronze, h. 24 in.
The Nelson-Atkins Museum of Art, Kansas
City, Missouri, gift of Michael Hall Fine
Arts, Inc., New York, 66-26/7

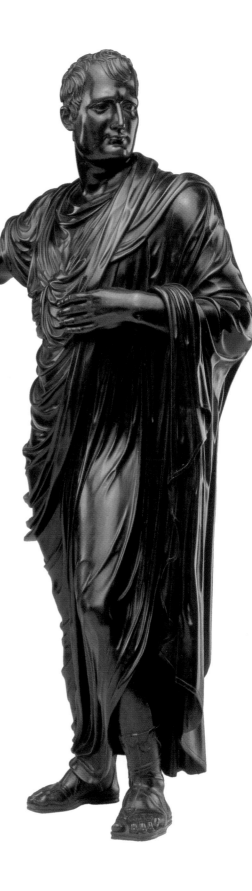

A sculptor and painter, Antoine-Denis Chaudet created many
likenesses of Napoleon; perhaps the most famous was the full-
length sculpture depicting Napoleon in a Roman toga that stood
atop the column of the Place Vendôme in Paris from 1810 to 1814.
This sculpture may be a study for the Place Vendôme figure,
which was melted down after Napoleon's defeat but replaced with
a figure of Napoleon dressed in full military uniform. Napoleon III
later had a replica of Chaudet's original placed on the column.
During the Paris Commune the column was brought down, but it
was restored in 1873 to its present state.

Napoleon III was keenly aware of the political importance of
civic design, and political motivation was also behind the decora-
tion used in Napoleon I's court, which emphasized the antique
and symbols of the ancient world. (The Place Vendôme column
itself was modeled on the antique precedent of Trajan's column in
Rome.) As the first major French ruler since Louis XVI, Napoleon
asserted his right to rule with militaristic strength and justified his
leadership by evoking the Roman Republic. Dressed in a Roman
toga, Napoleon I is portrayed as a "Caesar" of a new age, and a
leader of unquestioned authority.

Merry-Joseph Blondel
(French, 1781–1853)

Portrait of Madame Houbigant, born
Nicole Dechamps, c. 1807

Oil on canvas, 42 × 33¼ in.
The Speed Art Museum, Louisville,
Kentucky, gift of Mrs. Hattie Bishop
Speed, by exchange, 1993.17

*M*erry-Joseph Blondel apprenticed at the Dihl and Guerhard porcelain factory before switching in 1802 to the study of painting in Jean-Baptiste Regnault's atelier. In the course of his career he received several prestigious commissions such as the Galerie d'Apollon at the Louvre and the Galerie de Diane at Fontainebleau.

The ostrich-feather cap and red Kashmir shawl worn by Madame Houbigant reflect the height of fashion in 1807, and the color and silhouette of her dress show the influence of the *à la grecque* style. This particular ensemble, however, is more representative of what would be worn in everyday life than the toga-inspired costumes seen in other portraiture. The white color and high waistline remained in fashion throughout the first decade of the nineteenth century. Although Madame Houbigant wears a corset, it is much smaller and less obtrusive than those of the eighteenth century. Fuller corsets with longer boning would not return to fashion until the mid-1820s, when waistlines dropped to a more natural position on the body. The tight-fitting cap of pleated fabric with flamboyant ostrich feathers came into vogue as a flattering counterpoint to the short, classically inspired hairstyles of the period. In addition to the clothing, the design of the chair and the wall scrollwork show the influence of classical designs uncovered in archaeological excavations.

The sitter married into the Houbigant family, whose perfume business was founded in 1775 by Jean-François Houbigant in Paris. Houbigant enjoyed the patronage of important customers, including Marie-Antoinette and Napoleon. Empress Josephine, who favored musk, inspired a group called the "Muscardins" to frequent Houbigant's store and order new musk concoctions. Today Houbigant, a major conglomerate, produces dozens of popular perfumes.

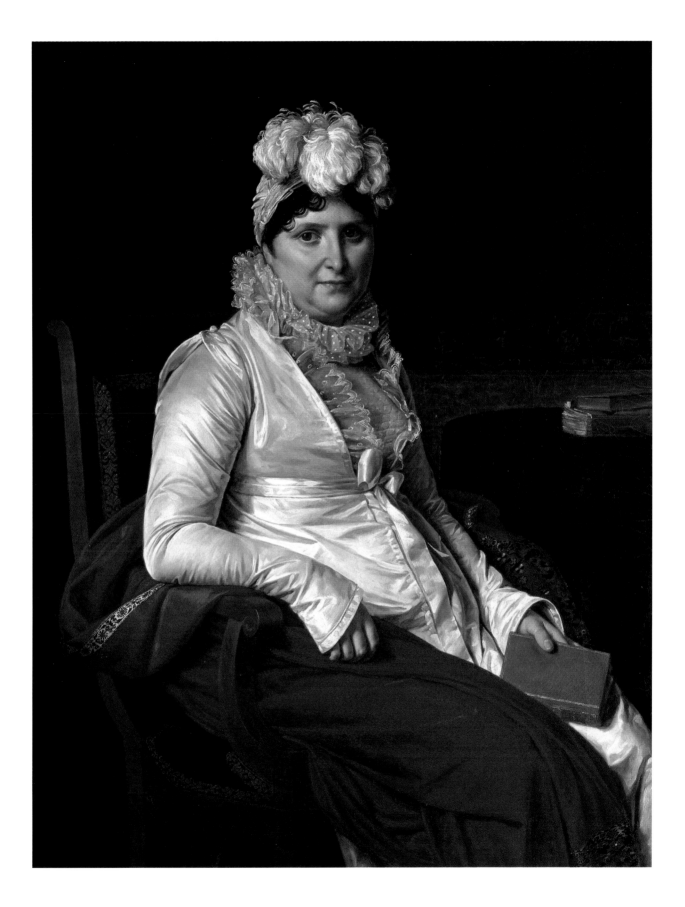

_____29

Waistcoat and suit jacket, c. 1800

Silk and metallic thread
The Stewart Museum at the Fort,
Île Sainte-Hélène, Montreal,
inv. 1982.72

Although sumptuary excessiveness was one grievance of the French citizenry, even after the Revolution fashion retained many luxurious materials. Ironically, postrevolutionary restraint in clothing was dependant upon color choice (black and white predominantly) and ornamentation, both of which were dictated more by stylistic taste than cost.

This suit demonstrates a subdued appearance in its limited palette, although the embroidery is intricate in detail and made of luxurious, expensive thread. While more subtle in presentation than its rococo predecessors, the suit illustrates the appreciation for high style that was never fully relinquished even after the Revolution.

Mules, c. 1805

Velvet and gold thread
The Stewart Museum at the Fort,
Île Sainte-Hélène, Montreal,
inv. 1970.100.71

*T*his pair of mules is encrusted with embroidered bees, the heraldic symbol of the Bonaparte dynasty, and monogrammed with the initials EB, suggesting that the shoes were the property of Emperor Napoleon's stepson, Eugène de Beauharnais.

De Beauharnais was the only son of vicomte Alexandre and Josephine de Beauharnais. Two years after his father's execution by guillotine in 1794, his mother married the young French general Napoleon Bonaparte. A loyal supporter of his stepfather, de Beauharnais was adopted by Napoleon in 1806. Among the many titles the emperor bestowed upon him were prince of Venice and viceroy of Italy. In Napoleon's government de Beauharnais stabilized public finance and reformed the country's legal system.

This style of low-heeled shoe replaced the court shoes featuring higher, curved heels and worn by both men and women. Heel height dropped from the 1790s until about 1800, when shoes became completely flat.

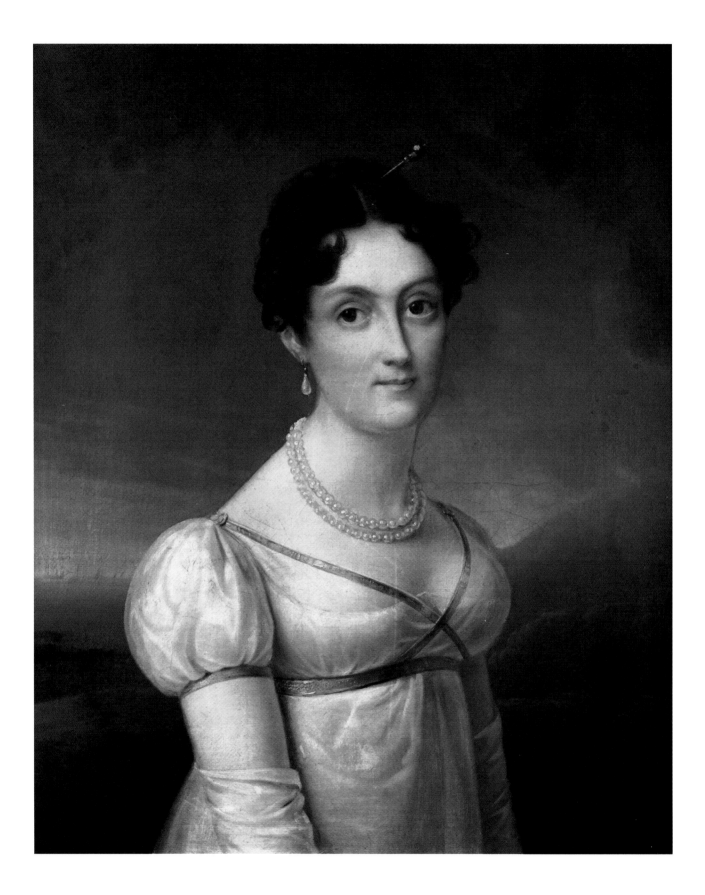

_____32

François-Joseph Kinson
(Flemish, worked in France,
1771–1839)

Elizabeth Patterson Bonaparte, 1817

Oil on canvas, 25½ × 21 in.
The Maryland Historical Society,
Baltimore, xx5.72

François-Joseph Kinson was the official court painter to Jerome Bonaparte (1784–1860), the king of Westphalia, Napoleon's younger brother, and husband of the sitter, Elizabeth Patterson Bonaparte. Kinson was born in Bruges, but went to France to paint, becoming a fashionable society portraitist.

Elizabeth (Betsy) Patterson (1785–1879) was the daughter of an Irish gunrunner who became one of the wealthiest men in Baltimore, Maryland. She met Jerome Bonaparte at a local party, and they fell almost instantly in love, marrying two months later at Baltimore Cathedral. The marriage did not suit Napoleon's plans to marry off his sibling for his own political advantage, and he arranged for a swift annulment. Although Patterson was denied entry into France and spent the rest of her life in the United States, one of her grandsons, Jerome Napoleon (1830–1893), a West Point graduate, became a colonel in Napoleon III's army. Despite Patterson's efforts, she and her son were never granted any title or even recognized by the emperor as Bonapartes.

Patterson was an extremely stylish and well-dressed woman, befitting her beauty and wealth. The gown she wears in this painting, with its deep décolletage, high waist, and short sleeves, evokes the quintessential Empire style, so identifiable with the period of her brother-in-law's reign.

Kinson painted other Bonapartes, including Napoleon's sister Paulina (1808, Museo Napoleonico, Rome).

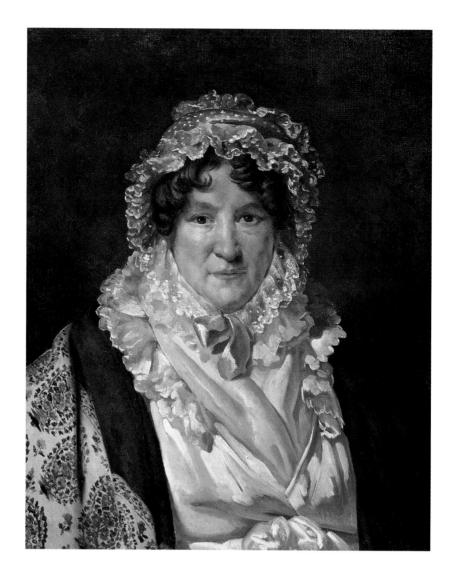

_____33

Ary Scheffer
(Dutch, worked in France,
1795–1858)

Portrait of the Comtesse de Tracy, 1818

Oil on canvas, 25½ × 21¼ in.
Palmer Museum of Art, The Pennsyl-
vania State University, University Park,
75.94

Johann-Bernhard and Cornelia Scheffer, both artists, encouraged their
son's study of art at the Amsterdam Teeken-Academie from an early age. In
Paris Scheffer studied under Pierre-Paul Prud'hon while attending the École
des Beaux-Arts. He exhibited at the Salons for most of his career, from 1812
to 1846. Although he was trained in the neoclassical tradition, Scheffer later
adopted the looser, more romantic style that dominated painting and sculpture
in subsequent decades. An early work by the artist, the Palmer painting shows
in its crisp attention to detail the influence of Prud'hon and Ingres.

Comtesse de Tracy's open, three-quarter-length coat was a style worn for
extra warmth as an alternative to large shawls or stoles. Between 1810 and
1820, a greater variety of fabrics came into fashion, especially heavy silks
with somber-colored designs, as seen in the comtesse's coat. The look of many
ruffles around the head and neck, also in vogue, was probably influenced by
English taste. Her bonnet, made of specked tulle or chiffon, was referred to
as a "coronet," as it emphasized the crown of the head.

Scheffer became a French citizen in 1850. A respected history painter, he
also painted many portraits. He was known for his pleasant, amiable character,
and had many friends who were musicians, including Liszt and Chopin, as
well as political figures like Lafayette.

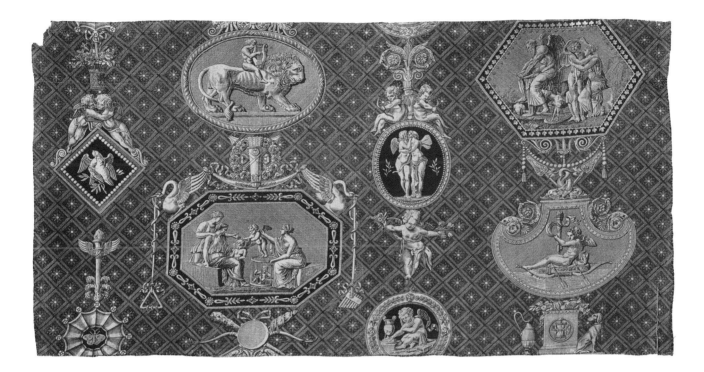

_____34

Louis-Hippolyte Lebas
(French, 1782–1867), after Pierre-
Paul Prud'hon (French, 1758–1823)

La marchande d'amour, 1817

Printed cotton, 20½ × 39¾ in.
Philadelphia Museum of Art, purchased
with the Darley Fund, 1925, 25-9-3

*L*ouis-Hippolyte Lebas was a respected designer of architecture, furniture, and decorative art. He made several trips to Italy, and those visits no doubt inspired the classical motifs in his work. Etruscan and Pompeiian funerary artifacts especially are seen in many works dating after 1816.

Lebas provided designs for many important decorative arts factories, including the Sèvres porcelain and Jouy textile manufactories. The so-called *toiles de Jouy* (cloths of Jouy) took their name from the French village Jouy-en-Josa, near Versailles, where these textiles had been made since 1760. *Toiles de Jouys* usually showed pastoral or classical scenes inspired by the works of French artists. This particular textile illustrates Pierre-Paul Prud'hon's version of *La marchande d'amour* (The Seller of Love), a subject that had been recently discovered in Pompeiian fresco.

Christophe-Philippe Oberkampf, the founder of Jouy, also commissioned architectural plans from Lebas. A leading teacher of architecture, Lebas was elected to the Académie des Beaux-Arts (1825) and became the official architect of the Institut de France in 1832.

**Jean-Auguste-Dominique Ingres
(French, 1780–1867)**

Study for "Jésus au milieu des docteurs,"
c. 1842

Pencil on paper, 16⅛ × 10½ in.
The Speed Art Museum, Louisville,
Kentucky, purchase, 63.22

Jean-Auguste-Dominique Ingres produced this study for a painting commissioned in 1842 by King Louis-Philippe and intended for a chapel at the château of Bizy. The project was eventually abandoned, although the artist completed the subject twenty years later (1862, Musée Ingres, Montauban).

Since the early Renaissance, artists have produced drapery studies, which demonstrate the difficulty of depicting not only dress but also a convincing representation of a body beneath clothing. The artist's interest in fashion detail, evinced by so much of his work, is no less evident in this artistic precedent. Ingres's brilliant technique in contrasting the bold modeling of the drapery folds with the more delicate, linear delineation of the subject's head and hands suggests an artist at ease in portraying the integration of body and dress.

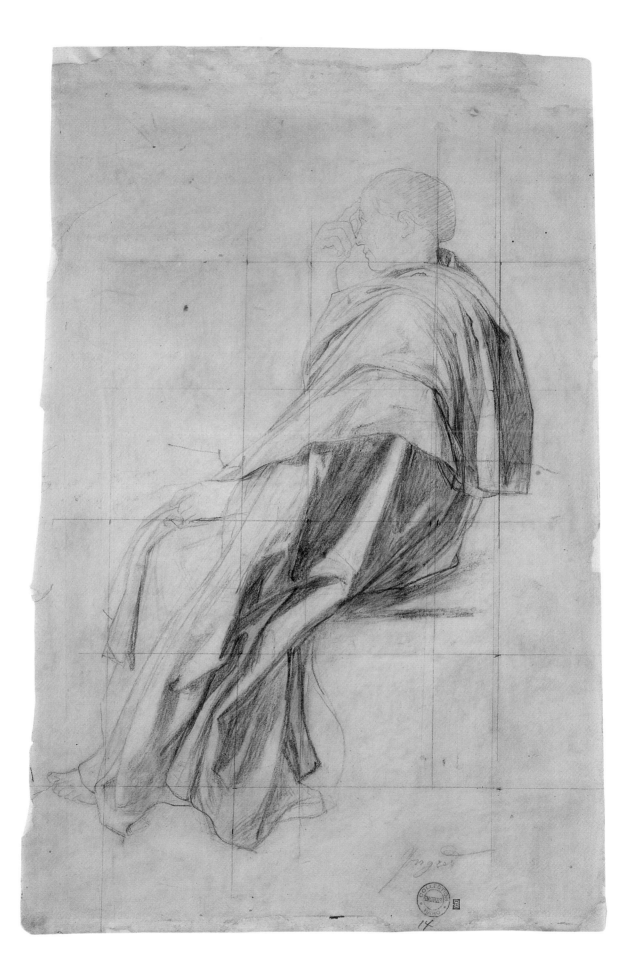

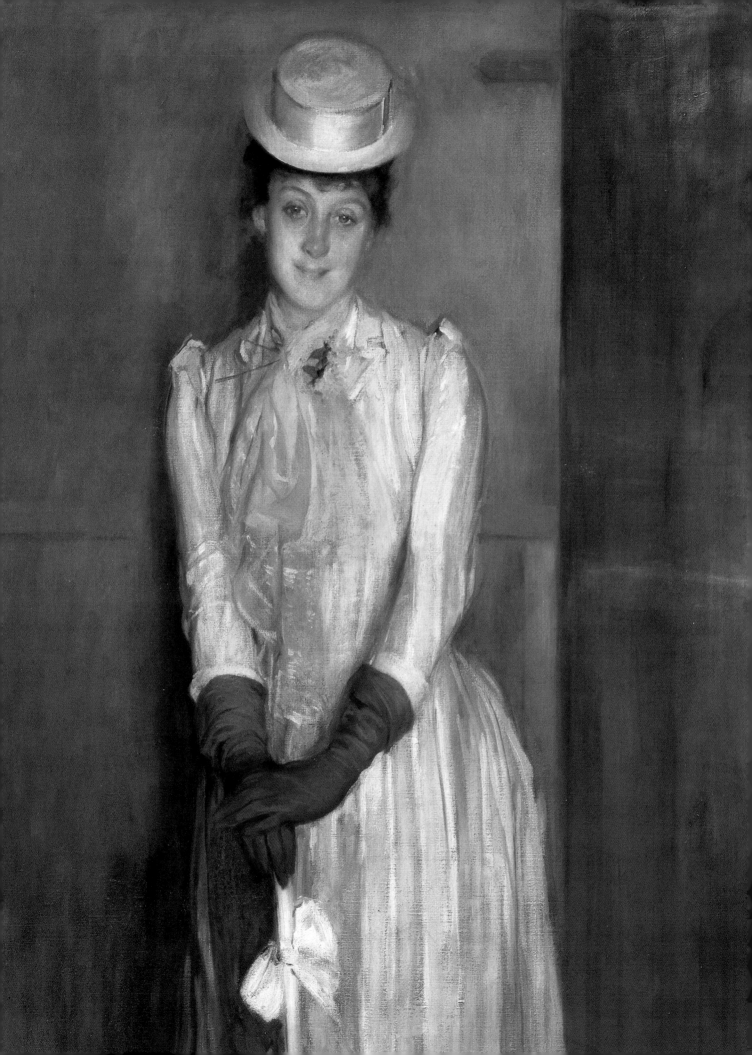

The Bourgeois Rule

Napoleon's obsessive desire to conquer Russia and Great Britain brought him colossal defeats and led to his final exile in 1815 to the island of Saint Helena. Although the monarchy was restored, to Louis XVIII, the younger brother of Louis XVI, it was greatly altered by constitutional reforms. The profile of the French population had also changed dramatically, most notably in the rising middle or bourgeois class, which had achieved greater social prominence and a comfortable economic status.

The Bourbons, however, continued to flounder upon the throne. Promising to abide by the nation's constitution, Louis-Philippe, duc d'Orleans, was granted the throne in 1830. Known as the bourgeois king, Louis-Philippe often walked the city streets, having symbolically replaced the sword carried by former monarchs with an umbrella. His eighteen-year rule, known as the July Monarchy, practiced rigidly codified manners and indulged in conspicuous material consumption, which would continue throughout the century.

French colonialism extended to the far corners of the world, further buffeting the domestic economy. Unusual and precious imports, like the Kashmir shawl, elevated interest, particularly among the bourgeois, in the "exotic." A general term often interchanged with "orientalism," the exotic came to embody a variety of cultures and peoples, from Italy to the Middle East and Asia. Embraced but often misinterpreted, the exotic fed the creative imaginations of artists and fashion designers, and elements of its influence would linger long after colonialism receded.

By 1852 Louis Bonaparte, previously elected president of the French republic, was granted dictatorial powers under a new constitution and became Napoleon III. His despotic rule coincided with the era of great economic prosperity embodied in the fashions of Empress Eugènie, an early patron of the first modern couturier, Charles Frederick Worth. The emperor's failures in foreign affairs brought about his downfall, and he was deposed in 1870 and fled with his family to England. The next year, civil disorder erupted between the political left (the Commune) and the right (the Third Republic), bringing more death and mayhem to the streets of Paris.

A similar dialectic emerged from the 1870s between the establishment, embodied by the traditional and conservative art academy, and the avant-garde. These mostly young artists, such as the impressionists, whom the academy had rejected, sought other outlets for the exploration and appreciation of their art. With their flouting of established art practices and principles, a new revolution began, one which called artists and designers to challenge the possibilities of their respective crafts.

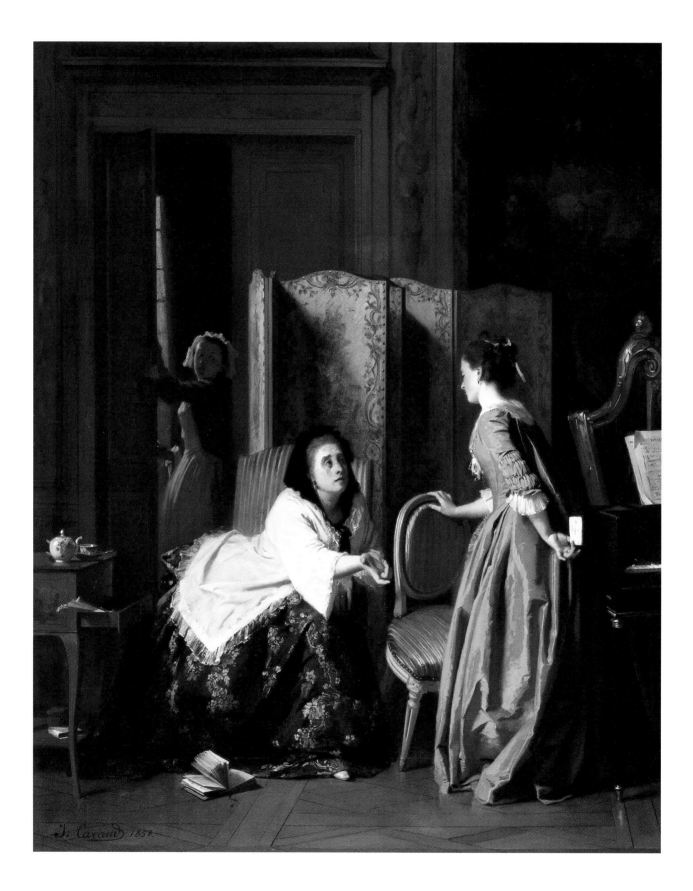

Joseph Caraud
(French, 1821–1905)

The Message, 1858

Oil on canvas, 30 × 24 in.
Lauren Rogers Museum of Art,
Laurel, Mississippi, 83.74

Joseph Caraud studied at the École des Beaux-Arts in Paris and established himself as a painter of domestic scenes. Responding to the current taste for romanticizing France's lost monarchy, Caraud often set his works in mid-seventeenth-century venues.

In this work Caraud evoked the earlier period through the blue *robe à la française* dress (see cat. no. 8). The artist most likely knew the style of dress and its "Watteau pleats" (pleats that fell from shoulders to floor) from reproductions on fans and textiles of *fêtes champêtres*, the bucolic scenes associated with Watteau. Although Caraud invoked the costume of an earlier era, he painted very much in the style of the mid-nineteenth century, when genre scenes with strong narratives gained popularity.

————37

Honoré Daumier
(French, 1808–1879)

The Bon Vivant, undated, model
Probably after 1860

Bronze, h. 6½ in.
Museum of Fine Arts, Springfield,
Massachusetts, The Robert J. Freedman
Memorial Collection, 73.S05

The Visitor, c. 1840–62, cast after 1930

Bronze, h. 6⅝ in.
Hirshhorn Museum and Sculpture
Garden, Smithsonian Institution,
Washington, D.C., gift of Joseph H.
Hirshhorn, 1966, 66.1064

The Elder: The Orator, c. 1840–62,
cast 1929–30

Bronze, h. 5⅝ in.
Hirshhorn Museum and Sculpture
Garden, Smithsonian Institution,
Washington, D.C., gift of Joseph H.
Hirshhorn, 1966, 66.1072

*H*onoré Daumier's greatest interests—drawing and politics—fueled his many studies and caricaturizations of contemporary society. He was particularly critical of King Louis-Philippe's constitutional monarchy, which strengthened the power of the French middle-class. Newspapers such as the antimonarchist *La caricature* created an outlet for many of Daumier's political drawings and lithographs.

These three sculptures represent a body of caricaturizing work that Daumier produced about French parliamentarians. Daumier stole into parliamentary meetings and sketched the individual politicians, whose features, and in some instances clothing elements, he exaggerated to illustrate their pomposity (or banality). Originally modeled in terra-cotta, the sculptures were cast in bronze after the artist's death. Daumier's criticism was so perceptive that Louis-Philippe reintroduced stricter censorship regulations, and Daumier was imprisoned for six months. These rules forced Daumier to focus on societal ills rather than specific individuals in the more general, socially concerned caricatures he continued to produce for satirical journals.

Daumier shrewdly used clothing—whether an exaggerated tied jabot, or the well-tailored, three-piece suit of a comfortable middle-class gentleman— in depicting his subjects and emphasized the styles favored by the bourgeoisie to create a symbol of the class he found complacent and callous. His modeling of clay was so adept that Honoré Balzac claimed Daumier had something of Michelangelo in him.

Dress, c. 1850–55

Silk
Philadelphia Museum of Art,
gift of Alice McFadden Eyre, 1926,
1926-58-1 a, b

*T*he most dominant feature of women's dress in the 1850s was an immense skirt supported by a complex structure of crinolines and hoops. The low and wide neckline, secured at the edge of the shoulders, indicates that this gown was made for evening wear. The pleated sleeves decorated with ribbons and fringe are in line with the period's taste for ornate decoration. Flounces, ruching, embroidery, and artificial flowers were common embellishments.

The fabric, made in Lyons, is Jacquard-woven silk. Its pattern, of a woman on a swing, is based on rococo paintings, most notably Jean-Honoré Fragonard's *The Swing* (1767, Wallace Collection, London) and works by Jean-Antoine Watteau (see cat. no. 15). During the eighteenth and nineteenth centuries, the swing theme was a commonly employed sexual metaphor. It was particularly apt for an evening dress and a night's flirtations. A revived interest in eighteenth-century French art, which this dress so clearly illustrates, had been present in France since the 1840s.

Stiffened crinoline petticoats, used to hold out the shapes of skirts, were worn layer upon layer as the fashion for fuller skirts grew. By the 1850s, however, even multitudes of layered crinolines could not achieve the desired effect, which advanced the introduction of whalebone hoops.

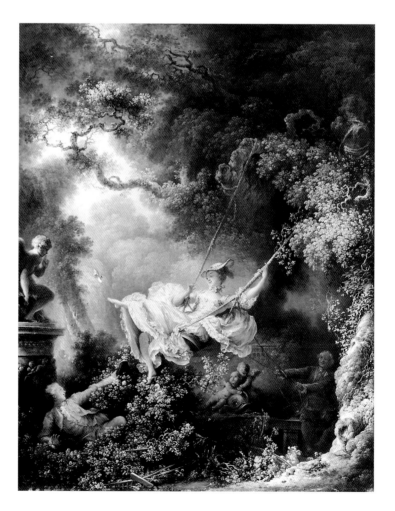

Jean-Honoré Fragonard (French, 1732–1806). *The Swing*, 1767. Oil on canvas. Courtesy of the Trustees of The Wallace Collection, London, inv. no. P430.

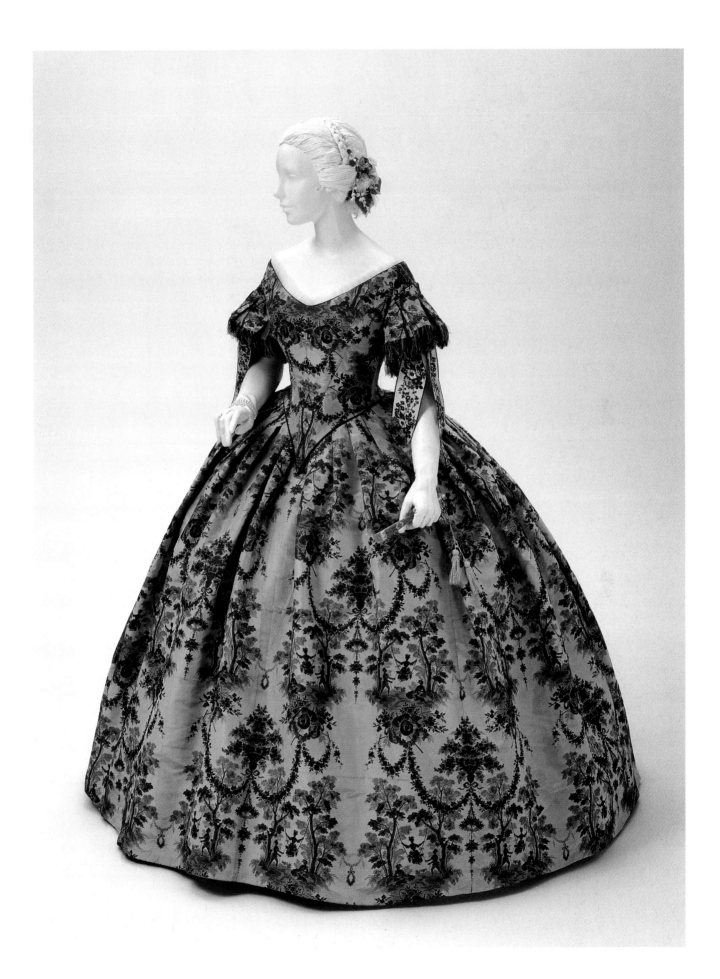

Jules-Adolphe Goupil
(French, 1839–1883)

Portrait of a Seated Lady, c. 1866

Oil on board, 12¾ × 9¼ in.
Palmer Museum of Art, The Pennsylvania State University, University Park, 73.5

The gown worn by the sitter captures an important moment in the changing silhouette of the skirt. The broad crinoline skirt dominated the 1850s and 1860s, but from 1865 its bulk slowly shifted toward the back of the garment. By the 1870s and 1880s, the wide circumferences of crinoline and hoop skirts had completely transformed into the bustle. The gathering along the length of the woman's sleeve, frequently trimmed in lace, was also in style about 1865–67. The low square neckline and the rich sheen of the gown indicate that it was made for evening wear.

Jules-Adolphe Goupil studied under Ary Scheffer (see cat. no. 33) at the École des Beaux-Arts and won several prizes at the Paris Salon in the 1870s. Later in his career, he received the rank of chevalier in the Legion of Honor. Goupil was much sought after for his portraits and historical compositions.

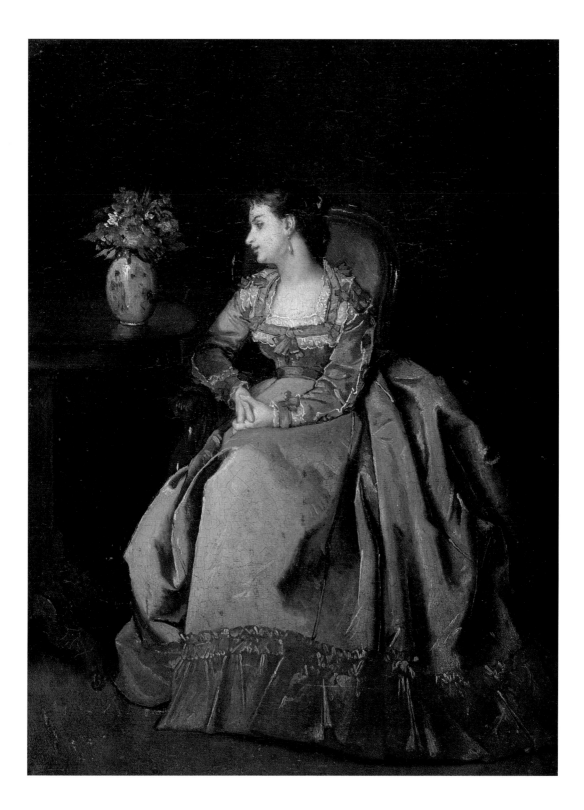

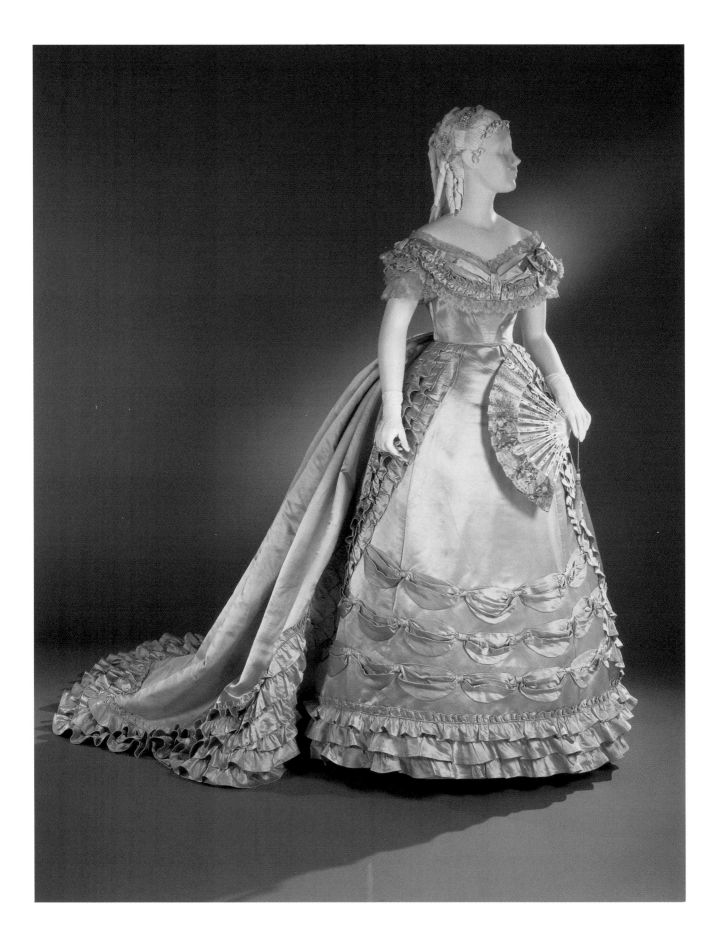

Charles Frederick Worth
(English, worked in France,
1825–1895)
Made by Worth & Bobergh, Paris
Bodice and skirt, c. 1867–70

Silk satin with lace and tulle
Philadelphia Museum of Art, gift of the
heirs of Charlotte Hope Binney Tyler
Montgomery, 1966, 1996-19-5

*B*orn and raised in Lincolnshire, England, Charles Frederick Worth descended upon the French capital in 1845 with little money and no knowledge of the language. Yet he flourished and, ironically, became a pioneer of Parisian haute couture. Years later he commented: "I owe everything to France. She enabled me to express myself, gave me every opportunity to succeed in the work I was fitted for; she has been everything to me" (Worth 1928).

One of the first places Worth found work was Gagelin, a fashion house on the rue de Richelieu. There he met a *demoiselle de magasin,* an in-house model, Marie-Augustine Vernet, who would later become his wife. Extremely elegant and a beauty, she was a great asset to her husband's business, wearing his designs to their best advantage and approaching important potential clients, including the empress Eugénie, wife of Napoleon III. Worth formed his own fashion house with Otto Gustav Bobergh (1821–1881) in 1857. They met with almost instant success and within a short time were the couturiers of many of the royal houses of Europe. Empress Eugénie was their first and most important patron, which allowed Worth & Bobergh to incorporate the imperial coat of arms on its label. (The Philadelphia gown bears this insignia.) Worth had an active interest in art and frequently sketched textiles and costume details at the National Gallery in London and the Louvre in Paris. He boasted, "I am a great artist; I have Delacroix's sense of color and I compose. A *toilette* is as good as a painting" (ibid.).

Although quite full, the skirt of this gown signifies the transition from hooped skirts to bustles. The flounces that adorn almost the entire dress, from the train to the edge of the bodice, evoke late-eighteenth-century designs. The gown is a study in simplicity in its use of only one predominant fabric, yet the overall silhouette and recollection of more excessive periods convey an intricateness in design for which Worth became renowned.

_____ *41*

Émile Auguste Carolus-Duran
(French, 1837–1917)

Merrymakers, 1870

Oil on canvas, 35½ × 55 in.
The Detroit Institute of Arts, Founders
Society Purchase, Robert H. Tannahill
Foundation Fund, 80.37

Carolus-Duran studied at the academy in his native Lille before moving in 1853 to Paris, where he resumed his studies at the Académie Suisse. He became a fashionable society portraitist and was friendly with a number of leading artists, including Édouard Manet and Claude Monet.

The models are likely the artist's wife, on the right, and his sister-in-law, the central figure, the famous stage actress Sophie Croisette. The small, disk-shaped hat Croisette wears was called a *Watteau*, or shepherdess hat. Usually made of straw and decorated with silk flowers and leaves, these hats frequently were worn with hair styled in ringlets. Watteau showed the hat style in his illustrations, encouraging its popularity. The woman at the left, likely a restaurant worker, is separated from her bourgeois patrons both compositionally and by her plain, utilitarian dress.

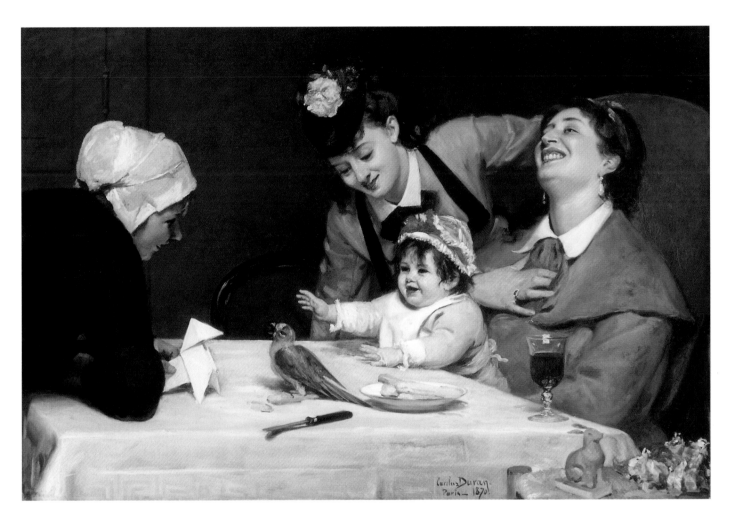

_____42

Auguste Rodin
(French, 1840–1917)

Balzac in Frock Coat, 1891–92
(later cast)

Bronze, h. 23½ in.
Iris and B. Gerald Cantor Center
for Visual Arts, Stanford University,
California, gift of the Iris and B. Gerald
Cantor Foundation, 1974.91

The Société des Gens de Lettres commissioned Rodin in 1891 to create a monument for the centenary of Balzac's birth, to be celebrated in 1899. By 1893, after numerous studio visits, members of the society already were expressing doubt that the work would be completed to their satisfaction in time. Rodin was so inspired to re-create a real sense of Balzac that he obsessively collected artifacts, photographs, and information about the great writer. To best convey the writer's physical likeness, he sought out Balzac's former tailor, Bion, and ordered trousers and a waistcoat based on Balzac's exact measurements.

Rodin worked on a number of versions of the monument, including Balzac in street dress of the 1830s; another, almost abstract representation; and Balzac in a Dominican robe. Rodin had learned that the writer often wore such a garment late at night while writing. Bion is believed to have made for Rodin a robe in Balzac's proportions which inspired one of the artist's more innovative versions, in which the robe is freestanding, without a wearer.

At the 1898 Salon Rodin exhibited a model of the final version which was greatly derided by the public and rejected by the Société. The piece was not cast in bronze until the 1930s.

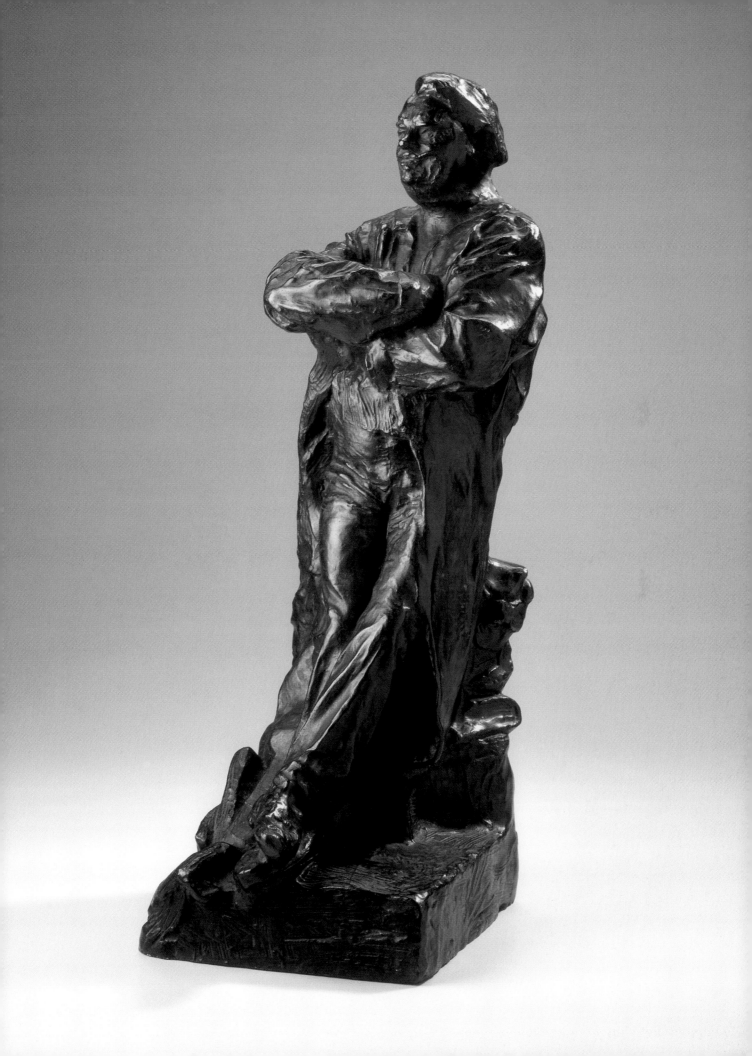

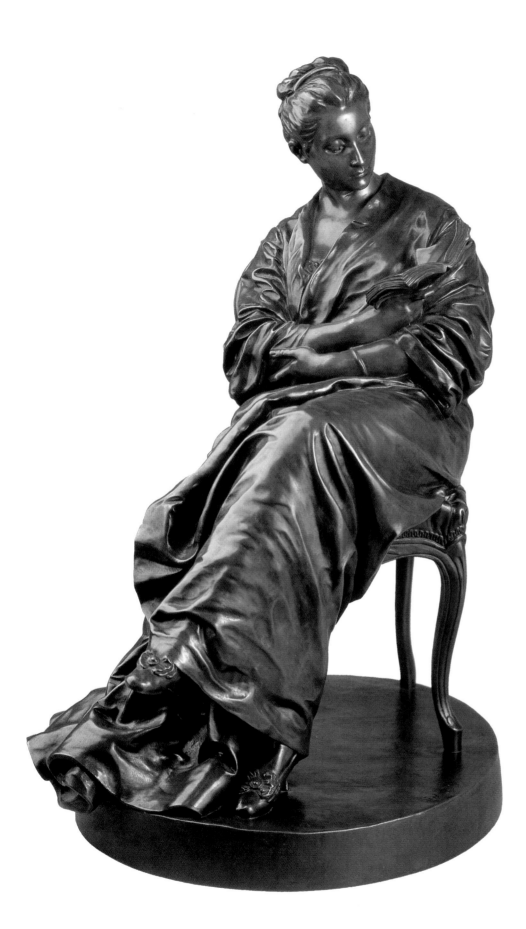

43

Jules Dalou
(French, 1838–1903)

Woman Reading, c. 1877

Bronze, h. 22 in.
The Toledo Museum of Art, Ohio,
purchased with funds from the Libbey
Endowment, gift of Edward Drummond
Libbey, 1963.35

A contemporary and sometime rival of Auguste Rodin, Jules Dalou studied with the sculptor while both were young men. Dalou routinely supplemented his income through goldsmithing, an experience that may have heightened his awareness of fashion and working with three-dimensional form.

After the collapse of Napoleon III's government (1870), Dalou, a social democrat, participated in the Paris Commune. When the Commune itself fell in 1871, Dalou fled to London, where he lived and worked until 1879. Dalou's sculptures of women in interiors accorded well with the Victorian taste for genre scenes, and he enjoyed great success. *Woman Reading* is typical of the simple, somewhat sentimental motifs that Dalou took from contemporary middle-class life. In other versions by Dalou of the sitter (most certainly his wife) in the same attire, the woman nurses an infant (e.g., *Maternal Joy*, 1871–72, Baltimore Museum of Art).

While in London, Dalou sculpted a prestigious commission for the Royal Stock Exchange, the marble *Charity* (1877–79). After this achievement, he lost interest in smaller, intimate subjects such as *Woman Reading*, making it one of the last of this type of work in his oeuvre.

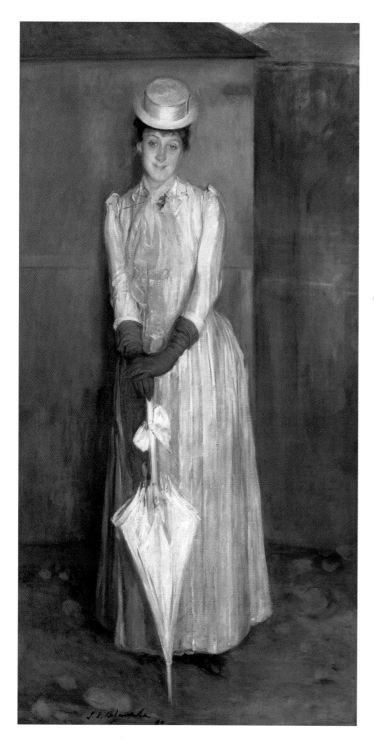

Jacques-Emile Blanche
(French, 1861–1942)
Portrait of Mrs. Holland, 1890

Oil on canvas, 91¾ × 51½ in.
Iris and B. Gerald Cantor Center for Visual Arts,
Stanford University, California, Committee for
Art Acquisitions Foundation, 1976.270

*J*acques-Emile Blanche had little formal training,
but his work was strongly influenced by James Tissot
and John Singer Sargent, artists who, like Blanche,
focused much of their art on the subject of fashion-
able women. Blanche was also an accomplished
writer.

Blanche visited London annually, and it was there
that he likely made the acquaintance of the English
Mrs. Holland. The setting of the painting, however, is
probably the French coastal town of Dieppe, where
Blanche spent most every summer, doing much to
promote the site as a popular artist's colony.

Mrs. Holland wears the type of ensemble that
fashionable women chose for leisure, particularly at
seaside resorts. The striped fabric and jaunty boater,
probably made of straw, were de rigueur in women's
sportswear, and seem oddly cumbersome and formal
by present standards. The raised sleeve, gathered at
the shoulder to accentuate arm length, came into
fashion just about 1890. Also discernable is a small
bustle, which accentuates the straight skirt line.
Gloves and a parasol to protect the skin from tan-
ning were also prerequisites. Tanned skin would
not become fashionable until later in the twentieth
century; Coco Chanel, an early proponent of a
bronzed appearance, ironically referred to it as
a "healthy" look.

Blanche was stung when his friend Marcel Proust
wrote that Blanche's "sole ambition was to be a
much sought-after man of the world" (Rouen 1997).
But Blanche supported Proust's assertion through
his eager cultivation of society figures, patrons, and
friends. He achieved much of his self-promotion
through his writings, most notably *Cahiers d'un
artiste* (1914–17) and *Propos de peintre* (1919–29).

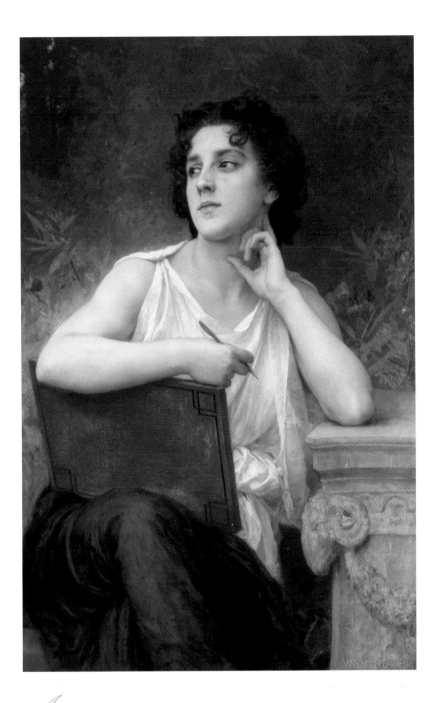

_____45

William Adolphe Bouguereau
(French, 1825–1905)

Inspiration, 1898

Oil on canvas, 39½ × 26 in.
The Columbus Museum, Georgia,
gift of Mrs. Richard Jennings, 55.3

A devoted realist, William Adolphe Bouguereau famously exhorted: "One has to seek Beauty and Truth, Sir!" Born in the French coastal town of La Rochelle, the artist studied at the École des Beaux-Arts in the studio of François-Édouard Picot in 1846. Bouguereau won the Prix de Rome in 1850 and stayed in Italy, studying the antique, until 1854.

Bouguereau favored dark-haired models, who were plentiful in the "model markets" of Paris, where artists could choose from a variety of physical types, generally immigrants of Italian or Jewish descent. Bouguereau dressed the model in classical garb to differentiate the work from a contemporary portrait and assert the figure's presence as a muse of "inspiration."

—— *46*

Alfred Stevens
(Belgian, worked in France,
1823–1906)

Memories and Regrets, c. 1875

Oil on canvas, 25⅛ × 18⅛ in.
Sterling and Francine Clark Art
Institute, Williamstown, Massachusetts,
acquired by Sterling and Francine
Clark, 1930, 1955.864

*T*he model in this painting, who also likely appears in Stevens's *Le bain*
(c. 1867, Musée National du Palais de Compiègne), has been proposed as
Victorine Meurent (1844–1927; Jiminez 2001). Meurent more famously posed
for Édouard Manet's *Olympia* (1863, Musée d'Orsay, Paris).

　　The woman's state of undress reveals the complex foundation necessary
to create the preferred silhouette of cinched torso and full skirt, created with
layers of crinoline. The garments and items she has casually discarded at the
right create a still life of contemporary fashion accessories. Realism is forsaken,
with the outermost garments placed over those that the woman would have
removed last.

Alfred Stevens
(Belgian, worked in France,
1823–1906)

Eva Gonzales at the Piano (formerly
The White Dress), 1879

Oil on panel, 21⅝ × 17⅞ in.
The John and Mable Ringling Museum
of Art, Sarasota, Florida, bequest of
John Ringling. SN438

*T*he focus of this painting is the stunning white dress worn by the sitter, Eva Gonzales. The use of white in painting requires considerable skill and excellent technique, which Stevens demonstrated with bravura, creating subtly pleasing gradations of color from the background wall to the folds and ruffles of the nearly all-white dress.

With Mary Cassatt and Berthe Morisot, Eva Gonzales was one of the leading women artists of impressionism. She was raised in an artistic milieu: her father was a novelist and her mother a musician. A pupil and frequent model of Édouard Manet, Gonzales often vied against Morisot for the artist's attention and approval. She was married to the engraver Henri Guerard and died in childbirth in 1883.

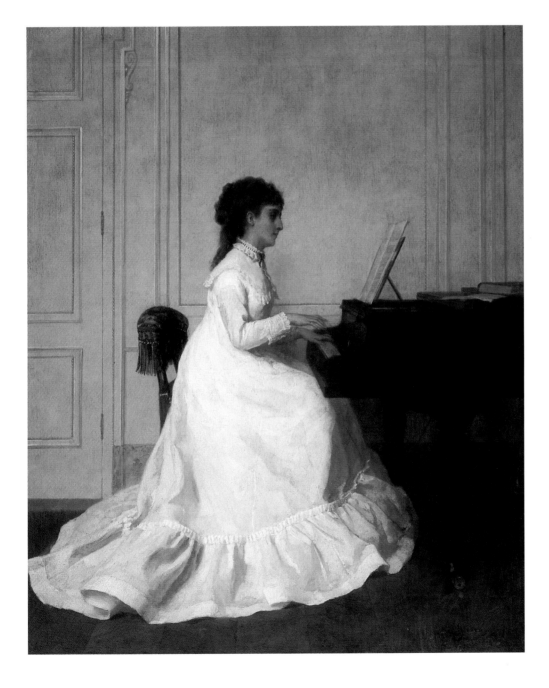

48

Edgar Degas
(French, 1834–1917)

Écolière (The Schoolgirl), c. 1910
(cast 1950)

Bronze, h. 11 in.
Flint Institute of Arts, Michigan, gift of
Mr. and Mrs. William L. Richards, 61.6

*E*dgar Degas participated in all but one of the impressionists' exhibitions, yet he did not pursue typical impressionist interests, such as painting outdoors. The last twenty years of his life were spent in near solitude. Due to his failing eyesight, he concentrated on sculpture, most of which was cast posthumously.

Although often incorrectly titled *Woman Walking in the Street*, this figure, as indicated by her clothing, is clearly of schoolgirl age. The short hemline would have been worn only by a young girl, she carries a book bag, and her long braid, another sign of youth, is held with one hand at her back. The model for this work was likely Marie van Goethem, a fourteen-year-old girl who also posed for some of Degas's dancer sculptures.

Degas was a keen observer of everyday life, and he had an avid interest in fashion. Proust related that he once "spent a whole day in rapture before the materials unrolled by Mme Derot [a fabric seller]. The next day it was the hats of the famous modiste, Mme Virot, that fire[d] his enthusiasm" (Simon 1995).

A version of this sculpture in the Detroit Institute of Arts is dated by the museum to 1881 on the basis of a number of studies for work sketched in that year.

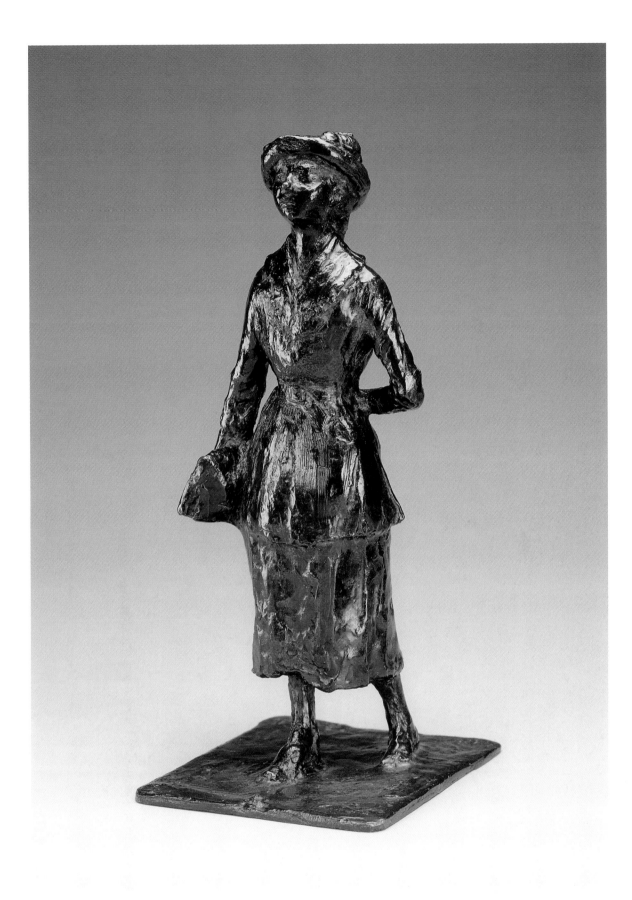

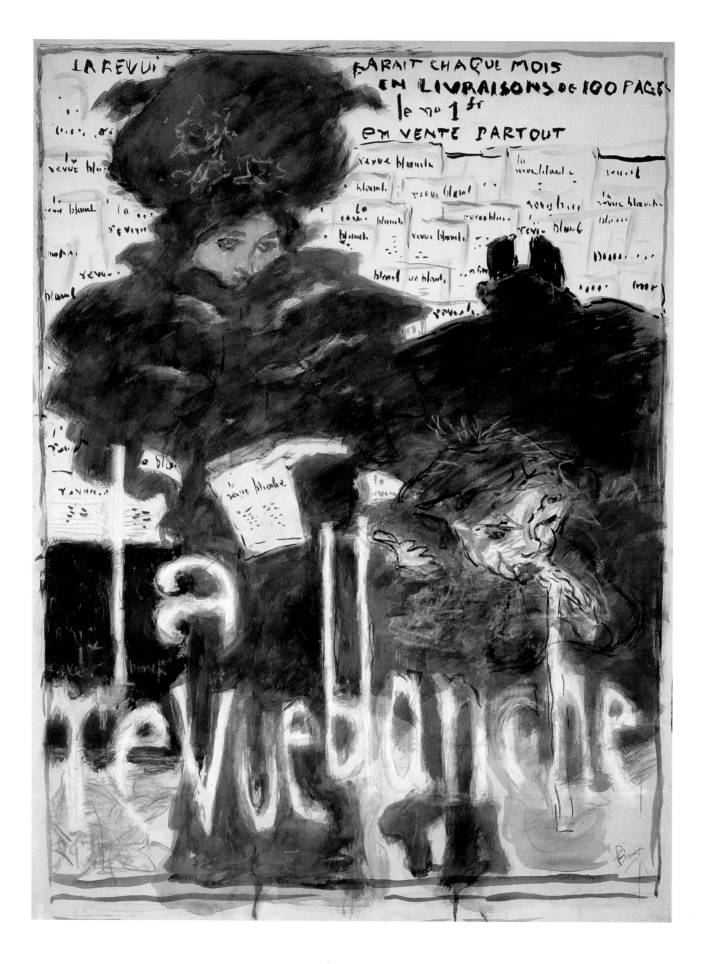

————49

Pierre Bonnard
(French, 1867–1947)

Study for La revue blanche *Poster*, 1894

Gouache on paper, 31¼ × 23½ in.
New Orleans Museum of Art, gift of
Mr. and Mrs. Frederick Stafford, 76.421

*P*ierre Bonnard attended art school while studying for a law degree. With friends and colleagues, including Édouard Vuillard and Ker Xavier Roussel, he joined an artistic society, the Nabis, formed in 1889 by painter Paul Sérusier. The group rejected the formal art teachings of the academies and embraced the more decorative aspects of painting, of which elements of fashion often lent inspiration.

Thadée Natanson, art editor of the *Revue blanche*, commissioned prints and cover illustrations from a number of artists in the Nabi group. Although the model for this work is often considered to be Bonnard's wife, recent scholarship (Groom 2001) suggests it is Misia Natanson, Thadée's wife, who also appears in Henri de Toulouse-Lautrec's cover for the same publication. Natanson's niece, Annette Vaillant, said of her, "She personifies the *Revue blanche* . . . this elegant, self-confident creature, daringly yet meticulously dressed" (Gold and Fizdale 1980).

Born Misia Godebska in St. Petersburg, Misia married a series of wealthy men, including Natanson and newspaper magnate Alfred Edwards, and enjoyed numerous friendships and liaisons with artistic figures, including Jean Cocteau and José Maria Sert. She actively supported Auguste Renoir, Toulouse-Lautrec, and younger emerging Nabi artists such as Bonnard and Vuillard. Her apartment was the setting of many Nabi paintings; the Spanish shawl draped over her piano was a frequent motif in their works. One of Coco Chanel's first patrons, Misia became the designer's close friend and often sketched from Chanel's creations. It was possibly through her that Chanel and other designers made the acquaintance of artists such as Renoir and Bonnard.

The decades before and after 1900 were the last periods of the artificial silhouette in women's fashion and were notable for a sense of elegance and refinement. Mindful of this silhouette, Bonnard often relied on fashion as a compositional element. In this work, he counterbalanced the wide, black hat of the woman at the left with the white lettering of the magazine's name.

_____50

Paul Cézanne
(French, 1839–1906)
Portrait of Alfred Hauge, c. 1899

Oil on canvas, 28¼ × 23¾ in.
Norton Museum of Art, West Palm
Beach, Florida, gift of R. H. Norton,
48.5

*P*aul Cézanne was born in Aix-en-Provence into a prosperous banking family. The young artist exhibited with the impressionists in 1874 and 1877, although his work in these shows was misunderstood and highly criticized. Cézanne grew more and more isolated from his family and artist-friends during the 1880s, a period when he concentrated on volumetric compositions and experimented with color tonalities. These principles helped form the foundation of early cubism, leading to Cézanne's recognition as the father of modernism.

Although Cezanne demonstrated no great interest in fashion, his occasional portraits of bourgeois types attired in fancy dress create a distinct impression. He made many portraits of his wife dressed in the latest fashion, and in two portraits of unidentified women, his sitters wear elegant outfits with broad lapels and puffed sleeves. In his portrayal of the Norwegian painter Alfred Hauge, Cézanne chose a style more befitting a dandy than an artist or laborer. This is consistent with Cézanne's portraits of the 1890s, such as *Gustave Geoffroy* (1895, private collection) and *Ambroise Vollard* (1899, Musée du Petit Palais, Paris), which depict men of accomplishment in refined and fashionable attire. Like other works from this period, the Norton painting is characterized by a somber palette dominated by brown, black, tan, and green.

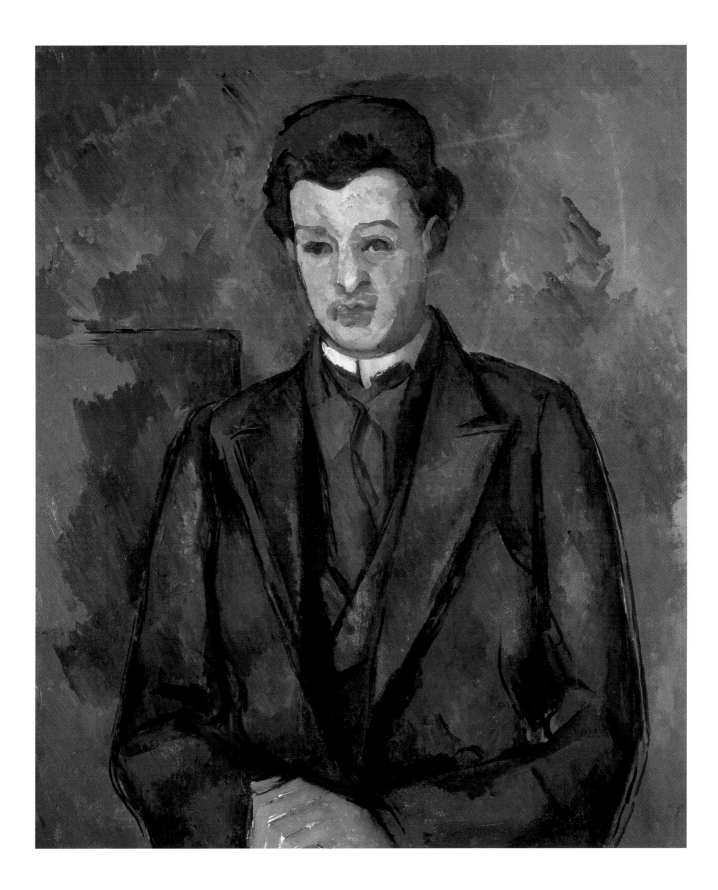

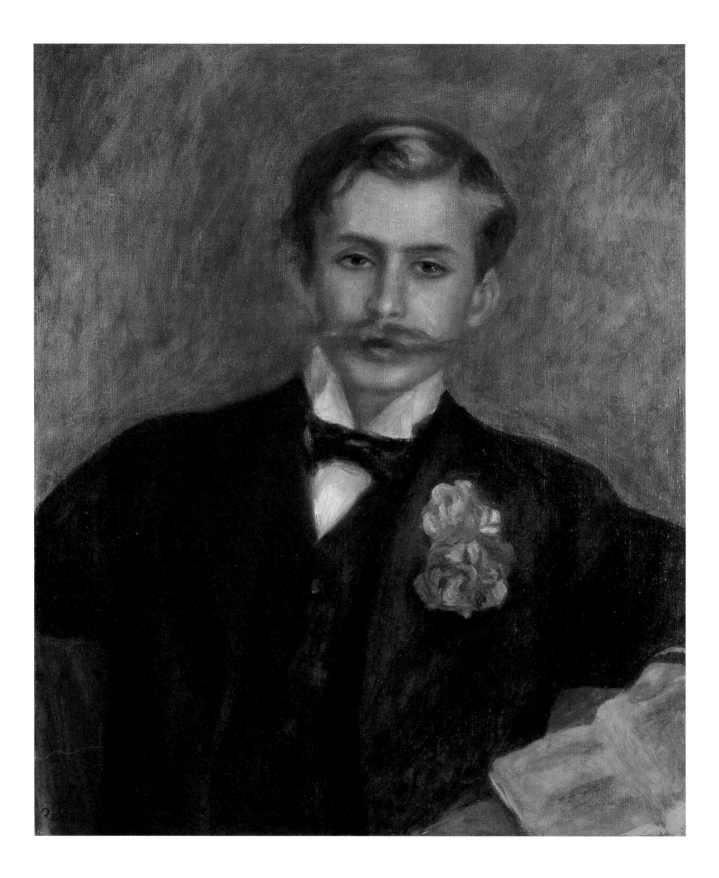

_____51

Pierre-Auguste Renoir
(French, 1841–1919)

Man with Carnation (Monsieur Germain), c. 1900

Oil on canvas, 21¾ × 18¼ in. Norton Museum of Art, West Palm Beach, Florida, bequest of Elizabeth C. Norton, 47.26

*C*harles Baudelaire (1821–1867), the father of modern criticism, believed that self-centeredness is the natural state of humanity, and therefore, virtue is an artificial state that merely restrains our natural tendencies. Baudelaire's ideal modern man, the dandy *(flaneur)*, represented "not, as many shallow-minded people seem to think, merely an immoderate taste for fine dress and elegant surroundings. These things are for the true dandy only the symbols of the aristocratic superiority of his spirit" (White 1984). The notion of the dandy became very popular in the last quarter of the nineteenth century, with many artists adopting the dandy persona.

The subject of this portrait personifies the dandy of the period with his meticulous grooming, refined dark suit (a prerequisite), and fancy boutonniere of pink carnations. The man presents, as Baudelaire described, "above all the [dandy's] burning desire to create a personal form of originality, within the external limits of social conventions" (ibid.).

The identity of the sitter remains problematic. The "Monsieur Germain" associated with the painting could refer to Henri Germain, grandson of the founder of Crédit Lyonnais. The artist's son, filmmaker Jean Renoir, recalled, "The least that can be said of their friendship [Renoir and Henri Germain's] is that it was surprising. . . . Germain was affected and coquettish, and he used perfume. He spoke with a slight Oxford accent and was so effeminate that it seemed a pose" (Renoir 1962). The art dealer Germain Seligmann has also been proposed as the sitter.

Jean-François Raffaëlli
(French, 1850–1924)

La demoiselle d'honneur, c. 1901

Oil on canvas, 99 × 45³⁄₈ in.
Telfair Museum of Art, Savannah,
Georgia, museum purchase, 1910,
1907.17

Jean-François Raffaëlli was a pupil of the great orientalist painter Jean-Léon Gérôme at the École des Beaux-Arts. Like his mentor, Raffaëlli was greatly influenced by his travels abroad to Italy, Spain, and Algeria. After 1876 he set aside the picturesque, and his work took on a greater realism.

This painting of a wedding attendant of honor debuted in the Paris Salon of 1901 and was exhibited two years later at the Venice Biennale. The *Gazette des beaux-arts* (1911) wrote that it was "a new symphony in white, marvelous for its grace and charm."

Until the late nineteenth century bridal wear in a variety of colors was acceptable, and black was not uncommon, especially if the bride was marrying a widower. Uniformity in honor attendant dresses and accessories as common today was not obligatory. Historical precedent for a bride wearing white as a symbol of purity includes Mary Queen of Scots, in her marriage to the dauphin of France, but it did not become a firm tradition until well into the twentieth century. The wearing of white first came into fashion only with Queen Victoria's marriage to Prince Albert in 1840.

The gown is contemporary with fashion of its date, which dictated covering the body from head to toe during the day, exemplified in the painting by the subject's long white gloves and high neckline. Evening wear, however, was quite revealing, often baring the neck and deep décolleté. Feathers, either in boas or as hat plumage, were also in vogue.

After decades of much smaller hats and headpieces, the turn of the century saw a general broadening of hat forms, often with lavish bursts of feathers.

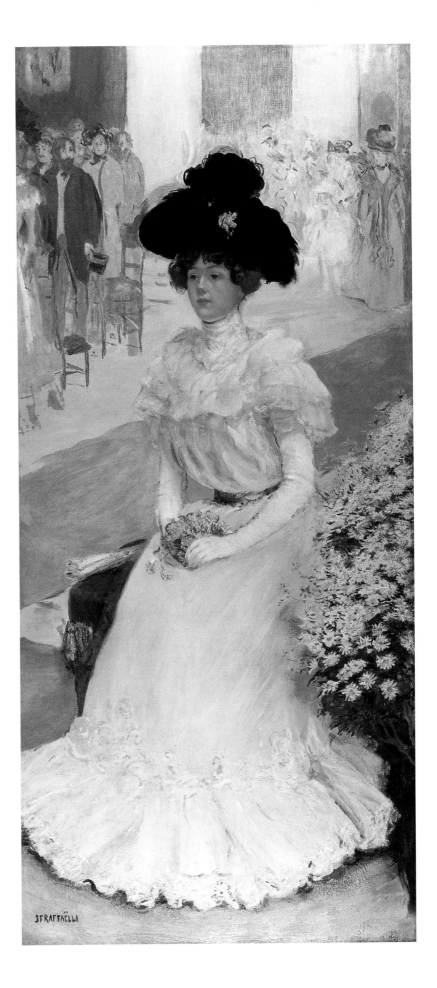

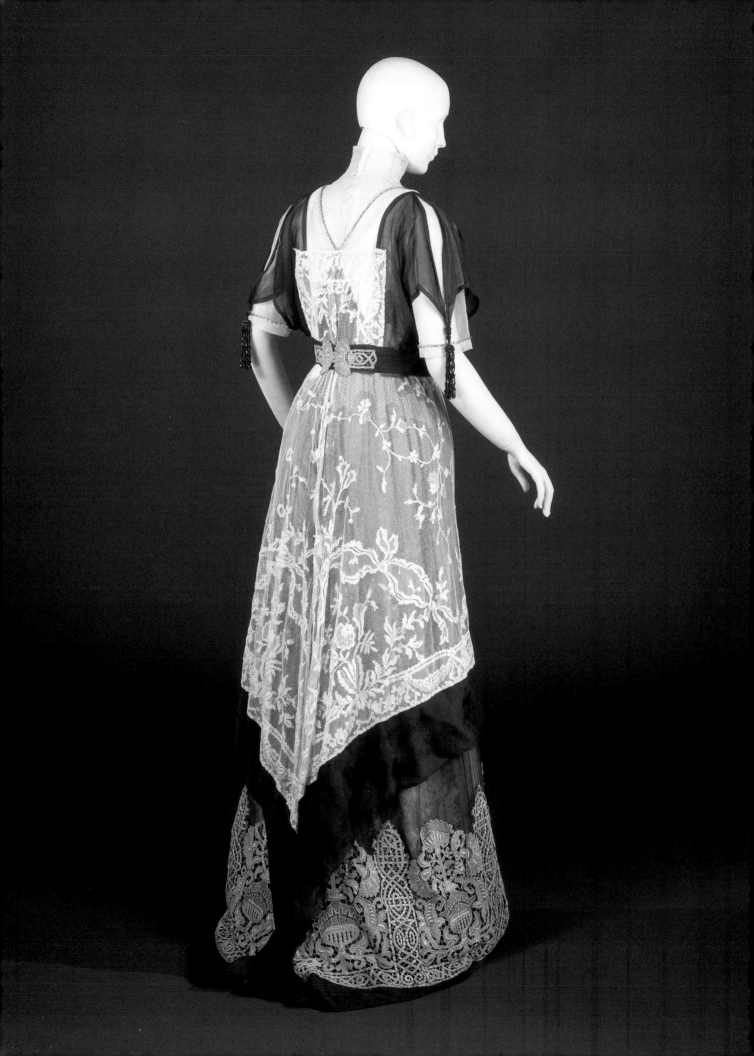

_____53

House of Worth

Gown, c. 1915

Chiffon with diamanté and jet beads
The Louisiana State Museum, New
Orleans, gift of the Museum of the
City of New York, 1957.59

*W*hen Charles Frederick Worth died in 1895, he left his couture house under the control of his wife and sons, Gaston and Jean-Philippe. Gaston Worth handled the financial administration of the house, while Jean-Philippe took over his father's design work. Jean-Philippe's biography of his father, *A Century of Fashion* (1928), did much to celebrate and promote the aura of his father as a designer/artist.

About 1915, beads of paste stones or minerals hanging from or around the shoulders were extremely popular. On this gown, the rhinestones that form a deep V-shape at the back of the neck and the dangling bouquet of black jet beads hanging from the sleeve illustrate the house's commitment to detail and luxurious materials. The angular-cut layers of delicate fabrics and lace of this dress demonstrate the period's emphasis on decoration of the skirt.

_____54

Pierre-Auguste Renoir
(French, 1841–1919)

Madame Renoir, 1916

Bronze, h. 23⅝ in.
Hirshhorn Museum and Sculpture
Garden, Smithsonian Institution,
Washington, D.C., gift of Joseph H.
Hirshhorn, 1966, 66.4218

*R*enoir only began sculpting in 1907, at sixty-six years of age, and his first major project came into being only about 1913. By that time the artist needed the physical assistance of Richard Guino (1890–1973), who worked for Renoir until 1918. The extent of Guino's creative input remains uncertain.

The sculpture is most certainly based on a painting (*Madame Charigot*, 1885, Philadelphia Museum of Art) of Renoir's wife, Aline Charigot, who died in 1915. Renoir first met Charigot in 1880, although they did not marry for another ten years. Charigot first worked as a seamstress and millineress, and it is interesting to speculate whether she herself improvised the simple straw hat adorned with flowers.

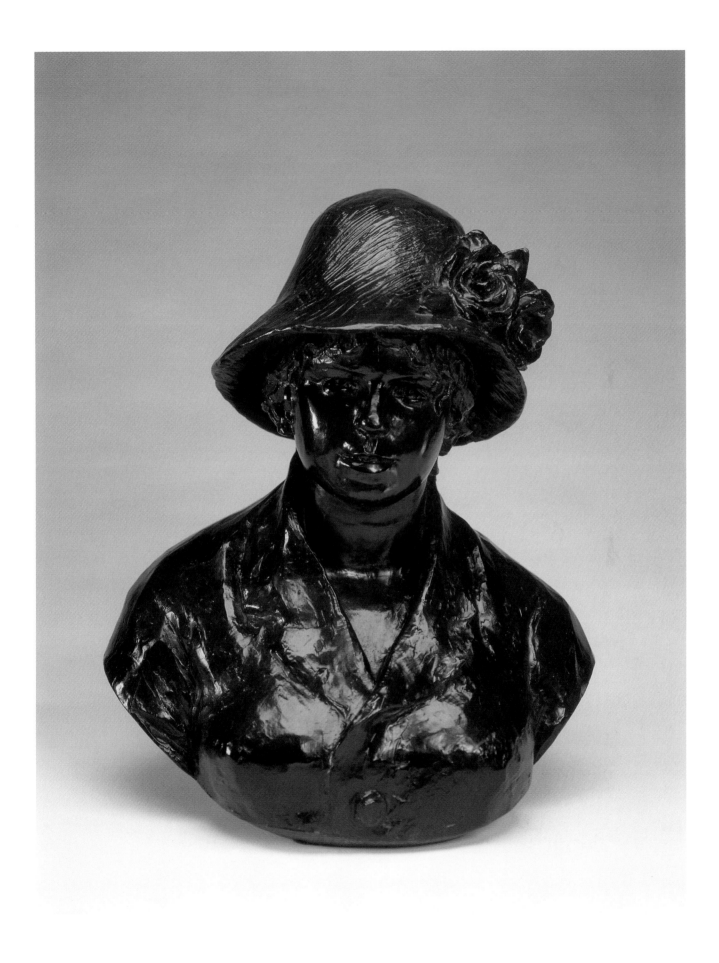

_____55

**Formerly attributed to
Eugène Delacroix**
(French, 1798–1863)

Odalisque, c. 1832–49

Watercolor and graphite on paper,
8½ × 12 in.
Columbus Museum of Art, Ohio,
bequest of Frederick W. Schumacher,
1948.33

*E*ugène Delacroix was so highly regarded and influential in his time that
Charles Baudelaire claimed him to be the last of the great artists of the
Renaissance and the first modern one. Delacroix's early influences were
the Old Masters, especially Rubens and Venetian Renaissance artists such as
Titian. But his travels to Morocco in 1832 profoundly affected him. Nothing
in his academic schooling had prepared him for the exoticism and qualities
of light and color unique to North Africa. In watercolor sketches and quickly
jotted notes he captured a wealth of material that would inspire even his
latest works.

Although this watercolor cannot be attributed to Delacroix with complete
confidence, certain of its features—the head scarf and sash, and the color
against the areas of white—relate to notes Delacroix made in his sketchbooks.

The specifically Moroccan aspects of the sitter's attire can be seen in the
wide-legged "harem pants," the decorative patterning of the orange and black
head scarf and sash, and the jewelry and braids. This influence would find
itself translated into French fashion.

_____56

Jean-Joseph Benjamin-Constant
(French, 1845–1902)

The Scarf Dance, c. 1875–80

Oil on canvas, 24 × 39⅜ in.
The Frances Lehman Loeb Art Center,
Vassar College, Poughkeepsie, N.Y.,
gift of Mrs. Elon H. Hooker (Blanche
Ferry '94), 1939.2.1

Although born in Paris, Jean-Joseph Benjamin-Constant grew up and studied in Toulouse, in southern France. He later studied under Alexandre Cabanel, whose teaching position at the École des Beaux-Arts he would later assume.

Benjamin-Constant traveled to Morocco in the 1870s, a journey that informed many of the exotic themes in his work. In 1875 and 1876 he presented "orientalist" works to the Salon. By 1880 he had abandoned the exotic style, and it is likely that this work dates between 1875 and 1880. After 1880 Benjamin-Constant concentrated on decorative painting. He attained several public building commissions and in the late 1880s achieved a great following in the United States.

Benjamin-Constant's exotica speaks with greater authenticity than does that of some of his contemporaries, no doubt due to his actual visits to Morocco. The women in the painting represent different ethnic types, which many artists of the time found appealing. In France, this taste created a great demand for Jewish and, later, Italian immigrant models, who through French eyes embodied the broader race of "ethnic" peoples.

—————57

Narcisse Diaz de la Peña
(French, 1807–1876)

Turkish Interior, undated

Oil on canvas, 9¾ × 13 in.
The Frances Lehman Loeb Art Center,
Vassar College, Poughkeepsie, N.Y.,
gift of Matthew Vassar, 864.1.23

Narcisse Diaz de la Peña was born in France to Spanish parents. A member of the Barbizon school, whose primary tenet was the direct study of nature, Diaz de la Peña lived in a rural village with likeminded artists. While nature was the source of inspiration for the Barbizon artists, for Diaz de la Peña, who had lost a leg to blood poisoning and never traveled abroad, it was also an avenue for exploring fantasies of other worlds. His friend the artist Félix Ziem commented, "I saw Diaz paint in the forest magical effects of the Orient, mirages that are surprising, true, sun-drenched. The trunks and leaves of beech trees sufficed for the most brilliant poems suffused with the rays of the most enchanting fairyland" (Peltre 1998). Diaz de la Peña's strong use of color was noted by the critic Théophile Gautier: "One can but admire the love of hues for their own sake which Diaz manifests, and on which his reputation rests" (ibid.).

Diaz de la Peña's exotic works, such as this detailed study of a Turkish interior, represents an imagined fantasy, a synthesis of East and West. They were influenced by the orientalist paintings of Eugène Delacroix.

58

Charles-Henri-Joseph Cordier
(French, 1827–1905)

Bust of a Woman, c. 1858–59

Bronze, silver, and goldplate, h. 29¼ in.
The Appleton Museum of Art, Ocala,
Florida, gift of Arthur I. Appleton,
AL2375
not illustrated

Charles Cordier entered the École des Beaux-Arts in 1846. Later he studied under François Rude, a sculptor best known for his work in relief, notably *La marseillaise*, on the Arc de Triomphe.

The Paris Museum of Natural History appointed Cordier to the position of "ethnographic sculptor" in 1851 and commissioned a series of ethnographic busts from him. Government-funded missions took him to North Africa, Greece, and Egypt. Cordier's travels exposed him to a variety of exotic materials such as onyx and red marble, which he incorporated in polychromatic sculptures.

While viewed by contemporary critics as too decorative, Cordier's sculptures of mixed materials and colors were very popular. Cordier realized that his "genre had the freshness of something new. . . . I revitalized the value of sculpture and created the study of race, widening the circle of beauty by showing that it existed everywhere" (1899, in Detroit 1978). As well as scrutinizing physiognomy, Cordier carefully studied native costume, which aided in his identifying and distinguishing different physical types. This sculpture probably dates from his travels to Greece in 1858–59. The toque the subject wears most likely signifies her unmarried status.

Jules-Joseph Lefebvre
(French, 1836–1911)

The Language of the Fan, 1882

Oil on canvas, 51½ × 35½ in.
Chrysler Museum of Art, Norfolk,
Virginia, gift of Walter P. Chrysler, Jr.,
71.2058

Jules-Joseph Lefebvre made his reputation with his paintings of female nudes, which earned him continued success with patrons and at the Paris Salon. In later work, such as *The Language of the Fan* (previously titled *Une japonaise*), his interests turned from the academic to beauty and fashion.

The French craze for *japonisme* (everything Japanese) began in 1854, with Commodore Matthew Perry's opening of Japan to the West. Avant-garde artists such as Degas and van Gogh were especially influenced by Japanese prints, which challenged Western notions of perspective and composition. Other artists with more academic backgrounds, like Lefebvre, created fantasy portraits (portraits *à la japonaise*) in which Western models, often in Western settings, are dressed in kimonos and hold fans.

_____ 60

Alfred Stevens
(Belgian, worked in France,
1823–1906)

The Porcelain Collector, 1868

Oil on canvas, 39 × 26⅞ in.
North Carolina Museum of Art,
Raleigh, gift of Dr. and Mrs. Henry C.
Landon III, 81.11.1

*B*ecause Alfred Stevens is not readily associated with a particular art movement or circle, history has found it hard to appreciate him. In his own time, however, he was well respected as a modernist, and his highly refined technique is evident in his work. Monet, Renoir, and Degas all admired him and prized his advice and approval.

Stevens's father was a collector and sometime art dealer, and his maternal grandparents ran a Brussels café, which was a meeting ground for artists and other bohemian types. He traveled to Paris in 1844 and studied at the École des Beaux-Arts under Ingres. By the 1860s Stevens was a fixture on the Parisian art scene, frequenting the café Guerbois with other artists, especially Edgar Degas, with whom he became great friends.

Along with Whistler and other artists, Stevens became a leading figure of the orientalist style. He collected Japanese porcelains by the 1850s, some of which are no doubt shown here, and fashioned a Chinese boudoir in his home. Stevens's collecting went beyond a taste for luxury. A realist who excelled at the recording of decorative detail, Stevens relied on such furnishings and objects to create a vivid impression of time and place. In this case, Stevens depicts the subject as a connoisseur, who compares the vase to printed sources in the book lying open before her.

Scenes of women in interiors are regarded as Stevens's best work. He generally used models, placing them in settings with decorative objects, sometimes from his own collection, and in gowns borrowed from prominent members of society such as Princess Metternich, wife of the Austrian ambassador to France.

Like Manet, Stevens favored the color black for his subjects' attire, considering it both elegant and modern. The form of the gown and the detail of its small ruffles are reminiscent of the creations of the English designer Charles Frederick Worth (see cat. no. 40). Metternich, one of Worth's most important clients, might have lent the dress to Stevens.

Jacques-Joseph Tissot
(French, worked in England, 1836–1902)

Jacob; Desolation of Tamar; and *Abraham's*
Servant Meets Rebecca, after 1896

Gouache on paper, approx. 10 × 5–7 in. each
The Jewish Museum, New York, x1952–109,
-328, -107

*A*lthough born in France, Jacques-Joseph Tissot lived and worked much
of his life in England, where he anglicized his first name to James. He became
a well-respected chronicler of fashionable society in London and Paris.

After the death from consumption of his beloved companion and model,
Kathleen Kelly Newton, in 1882, Tissot fell into great despair and found it
difficult to work. He turned to religion and spiritualism, and was known to try
to contact Newton in the afterlife through a number of seances. One painting
by him even shows Tissot and Newton reunited in the afterlife (*The Apparition,*
1885, private collection).

Throughout his career, Tissot demonstrated a keen interest in fashion
with a particular emphasis upon the pleats, bows, and ribbons decorating
the dresses of his sitters. He must have kept a few dresses as studio props,
as the same dress appears in different paintings, worn by different models
(for example, a white-striped gown with yellow bows, seen in *The Gallery of
HMS Calcutta* [c. 1876, Tate Britain, London] and *Seaside* [c. 1878, Cleveland
Museum of Art]). At the end of his career, Tissot concentrated on religious
subjects, and his interest in fashion turned to the exotic garb he envisioned
worn by biblical figures.

Tissot devoted eight years to re-creating some 365 scenes from the life of
Christ (Brooklyn Museum of Art) before tackling the Old Testament. To gather
inspiration and material, he visited the Holy Land in 1896; the watercolors
in the Jewish Museum were completed sometime after this trip.

Tissot's colorful and theatrical biblical illustrations inspired a fledgling
visual art form of the period: cinema. Director D. W. Griffith based much of
the set design and costumes for *Intolerance* (1916) upon Tissot's scenes from
the Old and New Testaments which, along with the work of the English artist
Lawrence Alma-Tadema, influenced the pioneer filmmaker Cecil B. DeMille.

Gabrielle "Coco" Chanel
(French, 1883–1971)

Batik cape, c. 1920s

Silk and fur
Kent State University Art Museum,
Ohio, Silverman/Rodgers Collection,
1983.1.1891
Photograph © David M. Thum

"Fashion is not something that exists in dresses only," Coco Chanel observed, "Fashion is in the sky, in the street." In the history of couture, Chanel is known as the creator of simple, easy-to-wear fashions that did much to liberate women's lives in the first half of the twentieth century. The ease of her garments somewhat belies the complexity of their construction and detailing.

Chanel herself came from humble origins. She was raised and educated in a convent orphanage, where she had only a few basic sewing lessons. Later Chanel would express a certain pride in her meager fashion and design training. Beginning in 1908, her first design work was as a millineress in Paris and, later, Deauville. The atmosphere of the beach resort town inspired her to incorporate the freedom of sportswear into her designs for women's daywear.

Chanel followed Paul Poiret's (see cat. no. 78) freeing of the female form from strict Edwardian corsetry but with an overall simplicity that deeply contrasted with Poiret. In a famous exchange between the two designers, Poiret commented on the sobriety of Chanel's designs, "Who are you in mourning for, Mademoiselle Chanel?," to which she replied, "For you, monsieur" (Yeager 2000).

In 1922 Chanel designed the costumes for Jean Cocteau's *Antigone*, with set designs by Pablo Picasso. Both costumer and set designer found inspiration in ancient Greek vases, and they later collaborated on Cocteau's *Le Train Bleu* (1924).

This free-flowing cape's print is inspired by African batik, a resist-dyeing method whereby a waxy substance is applied to selected areas of cloth, rendering them impervious to dye. The palmette pattern reflects the current rage in Paris for Africana, in no small part due to Josephine Baker. The African-American Baker took the Paris stage by storm in 1925 with her all-black revue and so-called *danse sauvage*. The patterned designs may relate not so much to actual African designs but to Baker's exotic costumes decorated with stylized palmettes.

Gabrielle "Coco" Chanel
(French, 1883–1971)

Cocktail suit, c. 1965

Satin with gold and silver brocade
Kent State University Art Museum, Ohio,
Silverman/Rodgers Collection, gift of
Marti Stevens, 1983.1.1865
Photograph © David M. Thum

Chanel famously said, "Simplicity does not mean poverty." The finest materials and craftsmanship have always been hallmarks of her work.

Chanel designed personal and professional wardrobes for many celebrities, including Gloria Swanson, Princess Grace of Monaco, Greta Garbo, and Lauren Bacall. Movie icon Marlene Dietrich commissioned this suit from Chanel about 1965. Dietrich and Chanel were friendly and traveled in many of the same social circles. Most of the Chanel pieces in Dietrich's wardrobe were worn in private, although Dietrich did wear a Chanel suit in the documentary *The Black Fox* (1962).

Dietrich expressly requested a Persian motif for this cocktail suit. She commissioned others in the style, demonstrating the continuing taste for the exotic.

_____ *64*

Madame Grès
(French, 1903–1993)

At-home ensemble, 1964

Silk and brocade
The Fine Arts Museums of San
Francisco, The Eleanor Christenson
de Guigné Collection (Mrs. Christian
de Guigné III), gift of Ronna and
Eric Hoffman, 1985.44.12

*B*orn Germaine "Alix" Barton in Paris, Madame Grès first aspired to be a sculptor. She found she could better support herself by designing toiles, or fabric decorations, and selling them to Parisian fashion houses.

Grès's sensitivity toward sculpture can be seen in the design of pleated evening dresses inspired by Greek statues and in her technique of cutting on the bias. This particular outfit illustrates an Asian influence in silhouette and decoration, leading to its popular designation as a "harem" outfit. *Vogue* magazine took the Asiatic reference even further by calling it the "Dalai Lama robe." Made of white silk and floral brocade, it is cut on the bias, forming two pieces with separate arm and leg openings.

In the 1930s Grès used fabric designs by the artist Raoul Dufy (see cat. no. 84), most notably in a chinoiserie evening coat. She first worked for Maison Alix, but from 1940 used her couturier name of Madame Grès (adopting one of her husband's names).

Paul Poiret
(French, 1879–1944)

Egyptomania dress and hat, 1923

Dress: Silk crepe de chine and velvet
Hat: Silk with leather appliqué
Philadelphia Museum of Art, gift of
Vera White, 1951, 1951-126-3a, b

The son of a cloth merchant, Paul Poiret first apprenticed with Jacques Doucet and later worked for the House of Worth before opening his own design house in 1903. Poiret founded the École Martine art school in 1911, of particular note for its encouragement of women students.

After the 1922 discovery of the intact tomb of the Egyptian pharaoh Tutankhamen, designers eagerly incorporated hieroglyphic motifs and a desert color palette in their fashions. Poiret, who in early designs was greatly influenced by orientalism, also followed the taste for Egyptomania. Here he incorporates a stylized patterning based on hieroglyphics in the decoration of the dress, and the hat, assembled from cutout leatherwork, suggests the silhouette of Egyptian hairstyles.

Poiret was also a painter, who as a young man created portraits, landscapes, and still lifes; he returned his focus to the medium at his retirement. Galerie Charpentier exhibited a show of his artwork, with a catalogue written by Jean Cocteau, a short time before Poiret's death.

_____66_

Emanuel Ungaro
(French, b. 1933)

Woman's ensemble, 1990

Suit: Silk and velvet
Shawl: Velvet
Philadelphia Museum of Art,
The Diane Wolf Collection,
1999-95-160

*E*manuel Ungaro's father was a tailor in Aix-en-Provence, and it was in his father's business that the couturier received his first training. In Paris by 1955, he worked for the important designers Cristóbal Balenciaga (see cat. no. 99) and André Courrèges (see cat. no. 92) until establishing his own firm in 1965. His early youth-oriented designs showed his penchant for mixing textures and prints in ways that until then had been considered fashion faux pas.

This suit evinces couture's ongoing interest in the exotic. The shawl especially is resonant of the tradition in its Persian-inspired motifs and the ends, which are gathered by large tassles.

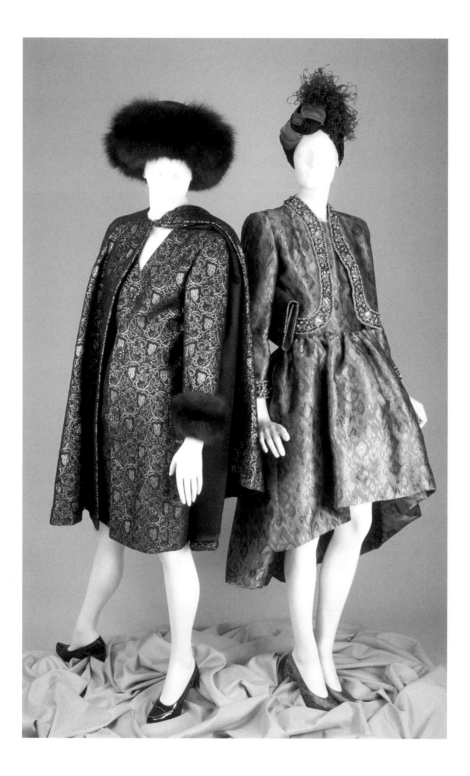

_____67

Hubert de Givenchy
(French, b. 1927)

Evening ensemble, 1990

Silk brocade, rhinestones, and fur
The Texas Fashion Collection at the
University of North Texas, Denton,
gift of Mrs. Sid R. Bass, 1993.007, .018
far left

Evening ensemble, 1990

Ikat brocade, jewels, metallic braid,
and beading
The Texas Fashion Collection at the
University of North Texas, Denton,
gift of Mrs. Sid R. Bass, 1993.007.071

left

The orientalist patterns and sumptuous color of these two ensembles by Hubert de Givenchy demonstrate the persistent influence of the exotic in the work of many contemporary designers. The rich gold brocade and jeweled adornment especially typify haute couture's restatement of humbler garb in luxury materials. In both works, the hats further the ethnic references, with a reinterpreted turban in one ensemble and a Russian-inspired Cossack-styled hat with fur trim in the other.

Givenchy's work has been celebrated in retrospectives at the Fashion Institute of Technology, New York (1982), and the Palais Galliéra, Paris (1991). Givenchy retired in 1996.

Becoming Modern: Invention and Revival

In the early twentieth century, boundaries between fine art and fashion design grew less distinct. Fine artists such as Pablo Picasso and Raoul Dufy designed textiles and costumes. The surrealist movement in particular challenged the boundaries between mediums, encouraging direct collaboration with manufacturers, designers, and producers.

The theater was a significant milieu for exchanges between artists and designers. The theater's creative and bohemian atmosphere, and the wild performances of the Moulin Rouge and Folies-Bergère, stimulated and fascinated artists and fashion designers alike. Sergei Diaghilev, impresario of the Ballets Russes, invited artists such as Henri Matisse and Pablo Picasso to try their hand at costume design and fabrication. The *robe de style*, popularized by Jeanne Lanvin, found a precedent in the fluid tulle skirts and tight bodices of ballet costumes.

The New Look, introduced soon after the end of World War II by a young generation of French designers, revolted against wartime austerity and rationing. Its designs requiring a quality and quantity of materials unthinkable during the occupation, the New Look also celebrated the past, invoking a period of French artistic dominance and stylish grandeur.

The "mod" era of the 1960s and 1970s saw shared interests between artists and designers. Movements such as op art, with its attention to visual dynamism and the inherent structure of basic forms, conveyed the "art for all" convictions of the times.

_____ *68*

Sarah Bernhardt
(French, 1844–1923)

Self-portrait as the Daughter of Roland,
probably c. 1875

Terra-cotta, h. 7½ in.
The Jewish Museum, New York,
museum purchase, gift of Mr. and
Mrs. Steven D. Bloom, by exchange,
and with funds provided by the
Maurice I. Parasier Foundation,
1998-111

*I*ntermittently bored with performing, the temperamental actress Sarah Bernhardt turned to painting and sculpting to revive her creativity about 1869. She actively exhibited her work from 1874 to 1888. "Discouraged and disgusted with the theatre," she wrote in 1907, "my passion for sculpture increased. . . . I was absorbed by the admirable art" (Bernhardt 1907). Many of her works were self-portraits; Henry James commented, "Her greatest idea must always be to show herself. . . . Her finest production is her own person" (Brandon 1991).

Bernhardt's artwork was not always received with seriousness and more often drew reviews in the society pages than the art press. But she was awarded an honorable mention at the 1876 Salon, and many respected artists such as Alfred Stevens (see cat. no. 60) and Sir Frederick Leighton praised her skills. Although Bernhardt produced approximately forty sculptural works, only seven are still extant. She produced a number of sculptural groups, one of which was installed at the Monte Carlo casino, and portrait busts of Adolphe de Rothschild. Other examples of her work can be found in the collections of the Musée d'Orsay, Paris.

Bernhardt commissioned a white silk trouser-suit from couturier Charles Worth to wear when she painted and sculpted; the trousers were no doubt easier to work in but also probably held symbolic power as she assumed the work of a male-dominated profession. Forever the actress, costume was no doubt always of great importance to Bernhardt. Worth made a number of frocks for her, but because she did not pay her bills she eventually was struck from the client list.

Bernhardt performed the role of Berthe in Henri de Bornier's *La fille de Roland* in 1875, which most likely corresponds to the date of the sculpture's creation.

—————— 69

Luigi Loir
(French, 1845–1916)

Théâtre Sarah Bernhardt (Place du Châtelet), last quarter 19th century

Oil on canvas, 13⅛ × 16¼ in.
Montgomery Museum of Fine Arts,
Alabama, bequest of William Pelzer
Arrington in memory of his mother,
Ethel Pelzer Arrington, 1977-P-546

*L*uigi Loir began painting scenes of Paris after his return from the Franco-Prussian War in 1870. This painting derives its title from the building seen at the right, the Théâtre Sarah Bernhardt. The celebrated actress in 1899 took control of and renamed the Théâtre des Nations, which she managed—and sometimes took leading roles at—until her death in 1923. Situated on the Place du Châtelet in Paris's fourth arrondissement, the building is now called Théâtre de la Ville.

The Gothic tower of Saint-Jacques, seen to the left of the theater, was part of the old Parisian church of Saint-Jacques de la Boucherie built in 1508–22. The church, save for the tower, was destroyed during the Revolution. The column to the left, surmounted by a statue of victory, still stands.

The attire of the women in the painting yields clues to its dating. The presence of bustles excludes a date after 1890. While fashionable for most of the last quarter of the nineteenth century, the bustle disappeared between 1878 and 1882 in favor of a smaller hipline. The woman at the center wears a short jacket over a skirt with a bustle, which is consistent with outfits seen in fashion journals about 1875. The smocked dresses worn by the two little girls were designed expressly for children, a newly emerging practice.

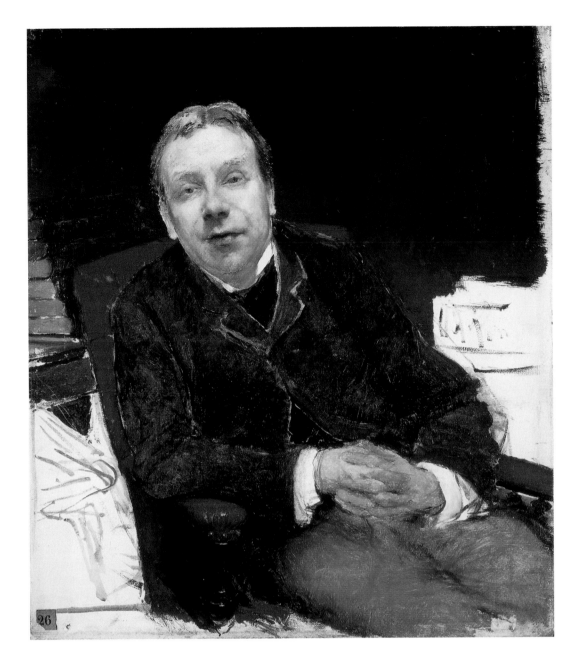

—————70

Jules Bastien-Lepage
(French, 1848–1884)

Portrait of the Actor, Constant Coquelin,
c. 1881–82

Oil on canvas, 13¾ × 12¼ in.
Snite Museum of Art, University of
Notre Dame, Indiana, purchased with
funds provided by the Butkin Founda-
tion, 81.05

Jules Bastien-Lepage was greatly influenced, especially in portraiture,
by Édouard Manet. He is also well regarded as an accomplished artist of
landscapes.

In contrast to the formal finery of artistocratic and bourgeois portraiture,
this picture reveals, through plain clothing and the relaxed presentation of
the sitter, the unconventionality of the actor. The open shirt-collar and easy
fit of the well-worn jacket suggest clothing that facilitated the subject's work,
such as the fluid movement required for stage rehearsals.

Constant Coquelin (1841–1909) was a well-regarded comedic actor
and frequently performed with Sarah Bernhardt (see cat. no. 68). He made
his debut at the Comédie Française in 1860 and achieved fame in classic
comedic roles by Molière and Beaumarchais. He toured the United States
with Bernhardt in 1900 and performed with her in Rostand's *L'Aiglon*.

**Henri de Toulouse-Lautrec
(French, 1864–1901)**

Le divan japonais, 1893

Color lithograph, 31 × 23⅞ in.
Herbert F. Johnson Museum of Art,
Cornell University, Ithaca, New York
not illustrated

Although Toulouse-Lautrec's slight, malformed body precluded him from being a physical embodiment of Baudelaire's dandy (see cat. no. 51), the artist devoted much of his work to the observation of modern public life. Toulouse-Lautrec inhabited the bohemian enclave of Montmartre and was a regular patron and recorder of Parisian nightlife, particularly of the performers and the gaslit theaters in which they toiled.

The Divan Japonais was a Montmartre nightclub owned by Edward Fournier, who commissioned Toulouse-Lautrec to create the print bearing its name. The central figure, Jane Avril, was one of the most famous can-can dancers at the Moulin Rouge. The dynamic line of Avril's black hat, gown, and fan creates a flat planar outline that demonstrates Toulouse-Lautrec's interest in Japanese woodblock prints. (It also presents a nice wordplay with the name of the club itself.) Avril wears not a costume, as in the many images the artist made of her in performance, but street clothes that denote her role as an audience member. Avril clearly was not just a performer but also a participant in Parisian bohemian life.

The performer in *Le divan japonais* is identifiable despite being cropped at the neck (another compositional effect inspired by Japanese woodblocks). The introduction of just one element of fashion—long black gloves—is enough to identify the woman as Yvette Guilbert. Such gloves were her trademark, along with a tight-fitting dress with a low neckline. Toulouse-Lautrec and other artists so invariably portrayed her in long gloves that they alone are enough to suggest her presence. Interestingly, the gloves were a purposeful tool for Guilbert, who in her memoirs related that she tried to dress respectably so that she could risk anything in her performances.

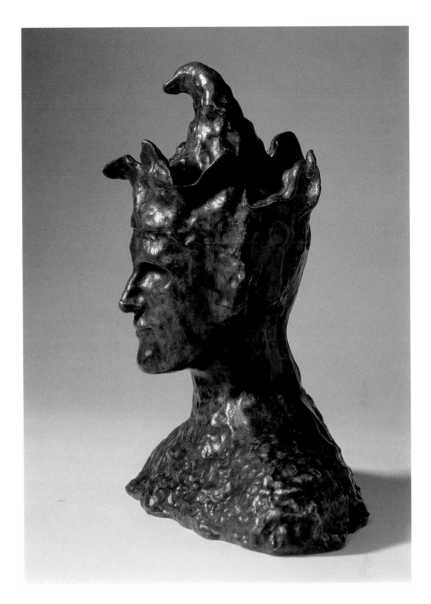

—————72

Pablo Picasso
(Spanish, worked in France,
1881–1973)

Le fou (The Jester), 1905

Bronze, h. 15¼ in.
The Walker Art Center, Minneapolis,
Minnesota, gift of the T. B. Walker
Foundation, 1956, 56.5

*M*ost of Picasso's early portraits, few of which were commissioned, represent his friends and lovers. He often presented his friends as stock characters of *commedia dell'arte*; he depicted the poet Guillaume Apollinaire, for instance, in the guise of king, jester, and athlete. This sculpture, of Picasso's sometime roommate the poet Max Jacob, was executed in 1905, at which time Picasso was living and working at the Bateau Lavoir, a dilapidated apartment house and studio space in Montmartre, where Jacob also resided.

The jester dominated Picasso's Rose period of 1905, a time when the artist developed a great interest in the theater and the circus, which he attended three or four times a week. Pierrots, jesters, harlequins, and saltimbanques populate these works. Like Juan Gris (cat. no. 74) and other artists, Picasso was attracted to the contradictory identities of the *commedia dell'arte* characters. The jester, for example, was both fool and sage, an important and influential member of the royal court yet a servant, who despite his lowly status was free, and sometimes encouraged, to criticize or lampoon the king.

Picasso, while making minimal reference to the jester's traditional costume, succinctly evoked Jacob's role within their circle of friends.

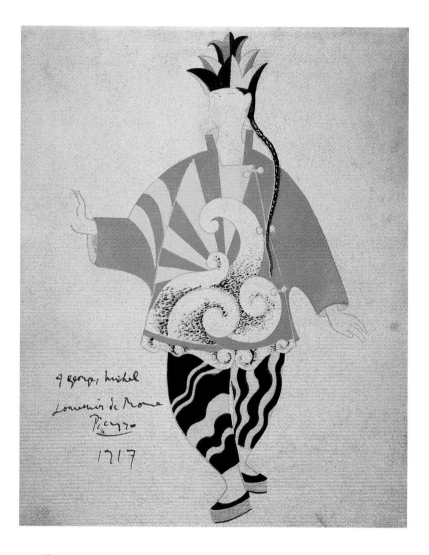

—————73

Pablo Picasso
(Spanish, worked in France, 1881–1973)

The Conjuror, 1917

Line block print after the original drawing, 10¾ × 8⅞ in.
The Fine Arts Museums of San Francisco, Theater and Dance Collection, gift of Mrs. Adolph B. Spreckels, T&D1959.50

*I*n 1917 the impresario Sergei Diaghilev commissioned Pablo Picasso to design costumes and sets for the one-act ballet *Parade* to be performed by his Ballets Russes. It was the first time Diaghilev had employed any but Russian artists to design for his company. The collaboration extended to Jean Cocteau, who wrote the libretto, and composer Erik Satie (1866–1925). Satie's jazz-infused score included untraditional instruments such as typewriters. The avant-garde production met with great public outcry; Satie was heralded as a cultural anarchist but also incurred instant celebrity.

Parade was staged as a circus sideshow, with performers from the circus, music hall, and other forms of lowbrow entertainment gathered to lure pass-ersby (the audience) "inside" for further amusements. This particular costume was created for the conjuror, a character based in part on a popular magician of the time, known as Chung Ling Soo. It was performed by Léonide Massine, the leading male dancer of the Ballets Russes and the choreographer of *Parade*.

Picasso developed a strong friendship with Diaghilev, and the men traveled together, especially to Italy. The artist eventually married Olga Kokhlova, a Ballets Russes dancer.

The actual costume, made of orange silk and appliquéd with gold-colored flames, is in the collection of the Victoria and Albert Museum, London, where it was recently conserved.

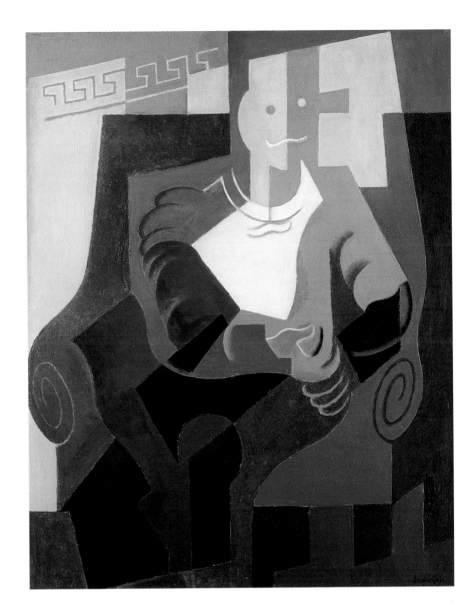

—————74

Juan Gris
(Spanish, worked in France,
1887–1927)

Seated Harlequin, c. 1920

Oil on canvas, 36 × 29½ in.
The Minneapolis Institute of Arts, gift
of Mr. and Mrs. John Cowles, 58.33

Juan Gris was born José Vittoriano González in Madrid in 1887, but by 1904 he had changed his name and was working as an illustrator. Two years later he was in Paris, living in the Bateau Lavoir, a building of low-rent apartments in Montmartre inhabited by a number of illustrious literary and artistic figures, including Pablo Picasso. He witnessed firsthand the development of cubism by Picasso and Georges Braque, and by 1910 Gris was determined to be a painter.

Gris first painted harlequins, usually playing the guitar or another musical instrument, about 1918–19, although the monumentality of this harlequin, and its lack of musical reference, probably dates the work to the mid-1920s.

A highly intellectual artist, Gris relished the double meanings associated with the *commedia dell'arte* figures, especially their association with layered or multiple meanings, an obvious link to cubism.

Gris was at first hesitant when ballet impresario Sergei Diaghilev invited him to design sets and costumes for the Ballets Russes, but in 1922 he agreed to design costumes and sets for *Les tentations de la bergère* (Temptations of the Shepherdess). It was the first of many such projects for Gris in the theater.

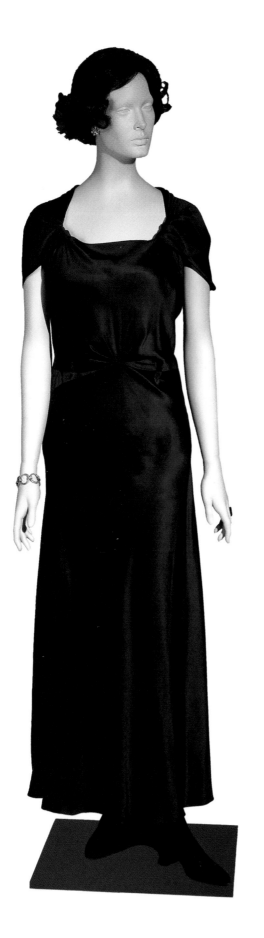

_____75

Madeleine Vionnet
(French, 1876–1975)

Dress, 1935

Satin
Chicago Historical Society, gift of
Mrs. Moise Dreyfus, 1940.15a, b

Vionnet was only eleven when she began her career as an apprentice seamstress in the French town of Aubervilliers. She later trained under Jacques Doucet and Madame Gerber before opening a design house in Paris in 1912.

Fashion of the late 1920s and 1930s was forced to address a new, corset-free silhouette, and Vionnet perhaps more than any other designer of the period met this challenge with aplomb. The seemingly minimal appearance of her designs belies a complex construction of forms with stitches and folds.

Vionnet is renowned for her bias-cut skirts and drapery, elements employed in this dress, most notably in the seamless fabric, which drapes over the shoulder to gather at the front of the garment. To achieve this effect, the designer often ordered bolts of fabric two yards wider than standard. The dress has no fastenings or closures and was meant, like so many of her creations, to slip right over the wearer's head. Vionnet's attention to shape over color and her experimental, even radical approach to structuring her pieces have led to a consideration of her work as part of the cubist and futurist idiom (see Leventon essay, above).

Pablo Picasso
(Spanish, worked in France,
1881–1973)

L'apéritif, 1901

Watercolor on paper, 17 × 13½ in.
Columbus Museum of Art, Ohio, gift
of Ferdinand Howald, 1931.086

*T*he male figure is probably a self-portrait of the artist, dressed as a turn-of-the-century dandy, replete with a straw boater. The woman wears a very fashionable hat for 1901, when the width of hats was just starting to broaden—and would continue to do so until 1910. The feather boa around her shoulders was a common evening wrap. The discernable S-shape of the woman's bodice creates a very typical Edwardian silhouette. The raised plume of the hat is reminiscent of the *aigrettes*, or spray of feathers, that had first adorned hats in the early nineteenth century and would remain fashionable, in various forms, through the 1920s.

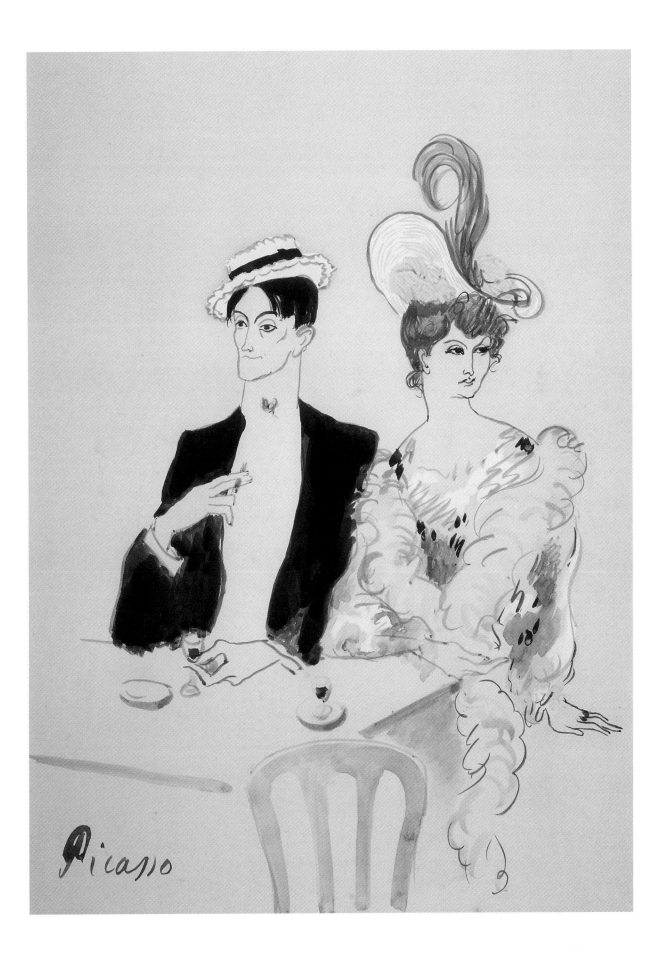

Pablo Picasso
(Spanish, worked in France,
1881–1973)

Au café, 1901

Pastel on cardboard, 21½ × 29½ in.
Norton Museum of Art, West Palm
Beach, Florida, gift of R. H. Norton,
53.150

In his native Barcelona, Picasso and his friends were frequent visitors to the café Quatre Gats (Four Cats), the city's version of Paris's bohemian Chat Noir. Quatre Gats paid homage to and, indeed, tried to re-create the lively ambiance of Parisian café-life. Jamie Sabartes, Picasso's lifelong friend, acknowledged that their Barcelona circle considered "art [to be] on the other side of Pyrenees" (Léal et al. 2000). It was this belief that brought many artists from around the world to Paris.

During his first visit to Paris in autumn 1900 Picasso sketched extensively, primarily works by impressionists and postimpressionists, in museums and art galleries. But he was also drawn by the city, and many sketches depict women promenading along Parisian streets wearing the broad, sweeping hats so fashionable for the period. Picasso's second visit to Paris was precipitated by a 1901 solo exhibition at Ambroise Vollard's gallery. The work—portraits of courtesans and nudes, bouquets of flowers, elegant women, and festive celebrations—is depicted in pure color, revealing the influences of impressionism and van Gogh. Just as important is the effect of the city: Parisian life astounded the young artist. Public displays of affection and womens' flamboyant, provocative manner of dress, for example, would not have been acceptable in conservative Barcelona. The artist's early café scenes, such as this one, describe his fascination with the spectacle of Parisian bohemia.

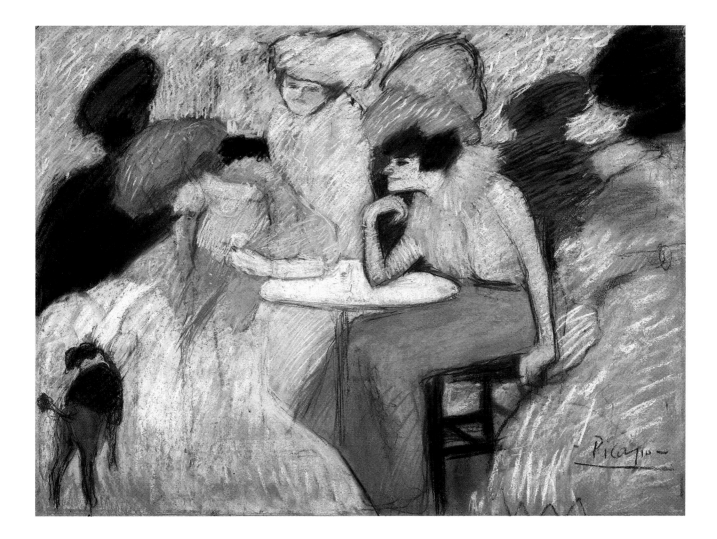

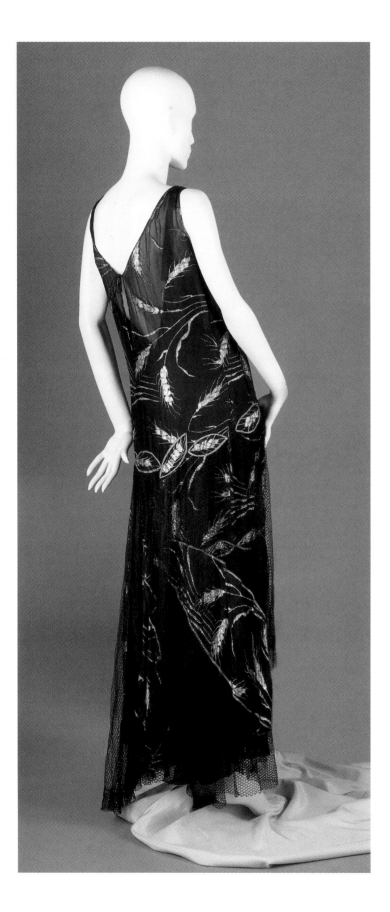

Paul Poiret
(French, 1879–1944)

Gown, late 1920s–1930s

Chiffon and embroidery
The Louisiana State Museum,
New Orleans, gift of Mrs. Sydney
Besthoff, 1982.131.13

*T*he curriculum of Paul Poiret's École Martine emphasized sketching from nature, which possibly inspired the gold-embroidered wheat motif of this gown. The movement of the wearer was probably intended to create the motion of stalks swaying in a field.

One of the leading designers of the art deco movement, Poiret influenced fine artists like Raoul Dufy, who studied textile design under him. Poiret stated, "I declared war on the corset. My slogan would be freedom for the tummy" (White 1973). Although credited with freeing the female silhouette from the restrictiveness of corsetry or padding, some of Poiret's designs instigated their own limitations on the wearer's movement, especially his "hobble skirt," which allowed freer motion at the hips while virtually cinching the ankles with the skirt's hem.

Shorter hemlines had been in fashion for much of the 1920s, but the end of the decade saw a return to full-length dresses, especially for evening wear. The diaphanous lower portion of the skirt, however, flirtatiously reveals the leg while still following the fashion for longer skirts, which would remain popular throughout the 1930s.

Poiret worked for Jacques Doucet from 1898 to 1900, during which time he created costumes for Sarah Bernhardt. He had a brief stint with the fashion house Worth before opening his own *maison* in 1902. Another version of this gown is in the Costume Institute, Metropolitan Museum of Art.

Jeanne Lanvin
(French, 1867–1946)

Robe de style, 1924

Taffeta with pearls, beads, and silver
and mirror discs
The Fine Arts Museums of San
Francisco, gift of Barbara D. Jostes,
1981.53.1

Jeanne Lanvin began her career as a milliner and moved on to designing fashions for women and children. Extensive embroidery and appliqués characterize most of her work, in which she implemented a variety of materials and techniques.

The *robe de style*, long associated with Lanvin, incorporates the straight lines of 1920s fashion with a more traditional bell-shaped skirt. The decoration also represents differing impulses, joining chinoiserie roundels, evocative of the Manchu court, with delicate Western embroidery.

Lanvin found influences from many sources but especially art, and she collected paintings by a number of artists, including Vuillard and Renoir.

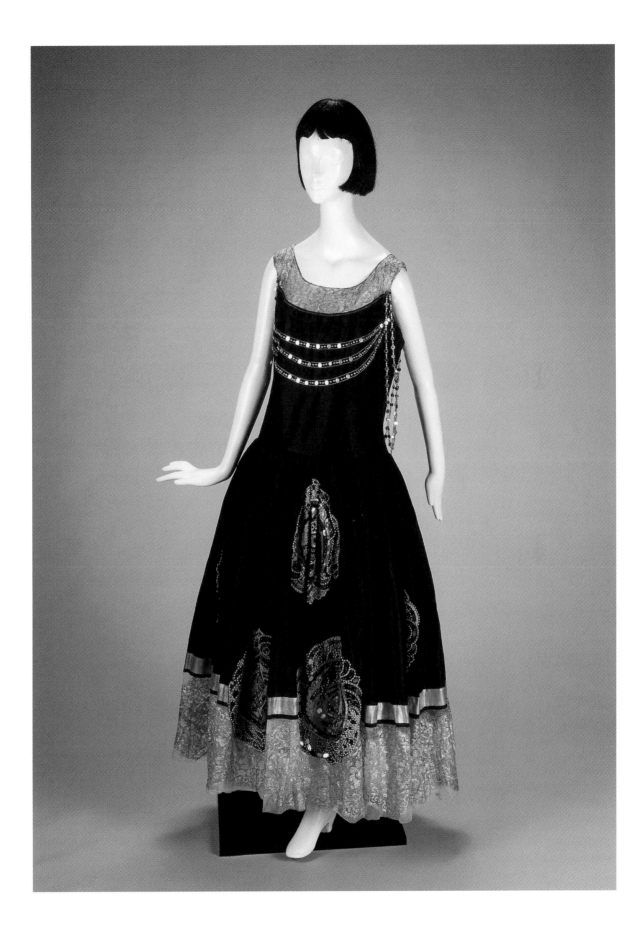

Henri Matisse
(French, 1869–1954)

Portrait à la toque velours bleue, 1919

Oil on wood panel, 18⅛ × 14¾ in.
Norton Museum of Art, West Palm
Beach, Florida, gift of Jean and
Martin Goodman, 86.28

One of the great masters of modern art, Matisse had an abiding interest in color and pattern that often played out in his work through his use of fashion. He assembled articles of clothing and hats as studio props that appear in a number of paintings (for example, *White Plumes*, 1919, Minneapolis Institute of Arts).

This portrait of Matisse's daughter Marguerite is matched by another (1919, Wadsworth Atheneum, Hartford, Conn.) in which a similar palette and pose are employed. The only significant alteration is the different hat Marguerite wears in each painting. The works seem as much portraits of hats as of Matisse's daughter, who posed extensively for her father during this period. Marguerite's mother was Caroline Joblaud, a Parisian shop clerk. Despite her parents' separation in 1897, Matisse and his second wife, Amelie Parayre, remained active in Marguerite's life. A member of the French resistance during World War II with her stepmother, Marguerite was at one point arrested but soon after escaped the Nazis.

Matisse's fashion consciousness was certainly heightened in 1919 by his work in costume design for Sergei Diaghilev's Ballets Russes. He closely supervised the manufacture of the garments he created for the ballet *The Song of the Nightingale*, a process that in part inspired him to work with appliqués.

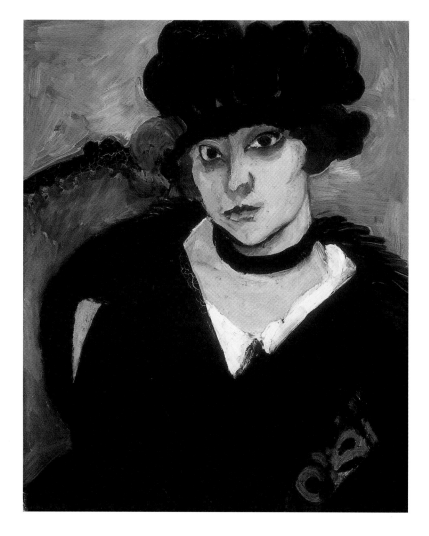

_____ *81*

Henri Matisse
(French, 1869–1954)

Head of a Woman, Number 1, 1937

Pen and ink on paper, 24 × 16⅛ in.
The Santa Barbara Museum of Art,
gift of Wright S. Ludington, 1941

*P*en and ink drawings dominate Matisse's work from 1935 to the end of the decade. These drawings in his mind were autonomous works of art and not merely preparatory studies: "Those drawings are more complete than they appear to some people who confuse them with a sketch" (Carlson 1971).

Matisse had a great interest in fashion and was known to have made some dress props—for example, a large, white plumed hat—which he kept in his studio and used repeatedly in his work, often modeled by different individuals. The ruffled, full-sleeve blouse (or top portion of a dress) in this drawing seems identical to a garment worn in other Matisse works in collections of the Saint Louis Art Museum, the Baltimore Museum of Art, and the Gosudarstvennyi Museum, Moscow. The blouse is also strikingly similar to the garment worn in Matisse's *Lady in Blue* (1937, Philadelphia Museum of Art). Both *Lady in Blue* and the Santa Barbara drawing were modeled by Lydia Delectorskaya, who posed extensively for Matisse from 1935 to 1937 and also worked as his studio assistant.

Lucien Lelong
(French, 1899–1958)

Coat, 1930

Velvet
The Louisiana State Museum,
New Orleans, gift of Mrs. Matilda
Gray Stream, 1972.36.28

*L*ucien Lelong's parents owned a small dressmaking business in Paris. He studied at the Haute Études Commerciales and was a decorated soldier in World War I. He was president of the Chambre Syndicale de la Couture, the governing body of the French couture houses, from 1937 until his retirement in 1947.

The graceful folds and gentle drape of the attached neck scarf suggest the elegant movement created by this coat when worn, an effect highlighted by the fabric's glimmering velvet sheen. Lelong favored clean, simple lines, cut to move with the wearer, a concept he called "kinetics." In fact, one of his great interests outside fashion was sculpture. An accomplished artist of some note, his sculptures received an award at the 1938 Salon.

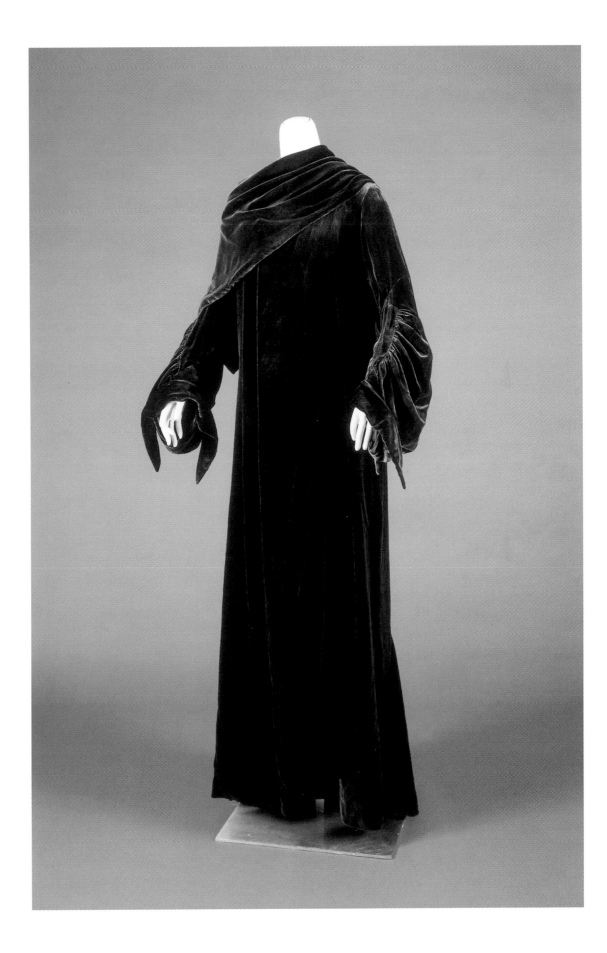

_____ 83

Raoul Dufy
(French, 1877–1953)

Le concours hippique, c. 1924

Watercolor on paper, 17⅛ × 23½ in.
Norton Museum of Art, West Palm
Beach, Florida, gift of Mr. and
Mrs. Bartlett Richards, 71.7
© 2002 Artists Rights Society (ARS),
New York/ADAGP, Paris

above

Beach Scene, c. 1922

Oil on canvas, 16¾ × 21¾ in.
Norton Museum of Art, West Palm
Beach, Florida, bequest of Gertrude
Perlberg, 2001.18
© 2002 Artists Rights Society (ARS),
New York/ADAGP, Paris

opposite

*B*orn in the seaside town of Le Havre, Dufy began studying art at the age of fifteen. In 1900 the town granted the promising young artist funds to go to Paris, where he encountered the work of the impressionists and the vibrant palette of the fauves. The work of Matisse was a revelation to him, and, like Matisse, Dufy consistently engaged with pattern and shape. In his paintings, this is generally expressed in loosely applied swabs of vibrant color.

Dufy maintained his colorful painting style while he designed textiles for Bianchini-Férier throughout most of the 1920s (see cat. no. 84). His paintings remained informed by the artistic traditions that had so impacted him as a young artist, yet in later years they developed a more graphic quality, a result of his freer experimentation in textile design.

Dufy regularly toured beach communities, one of his favorite subjects, and finally settled on the Riviera in 1919.

Raoul Dufy
(French, 1877–1953)

Shawl, c. 1928

Silk and metallic thread
Philadelphia Museum of Art, gift
of Mrs. Lawrence Fuller, 1970,
1970-158-1
opposite

The Thresher, c. 1922

Plain woven cotton
Cooper-Hewitt, National Design
Museum, Smithsonian Institution,
New York, given by Au Panier Fleuri
Fund, 1934-14-1
below

The Jungle, c. 1920–35

Plain woven cotton
Cooper-Hewitt, National Design
Museum, Smithsonian Institution,
New York, gift of Mary Halle, 1989-74-1
p. 176

The Hunter, c. 1930

Plain woven cotton
Cooper-Hewitt, National Design
Museum, Smithsonian Institution,
New York, given by Au Panier Fleuri
Fund, 1934-14-2
p. 177, detail

Raoul Dufy's journey to textile design began with his work in woodcut prints, whose flat stylization was greatly conducive to decorative design. It was Dufy's prints for the poet Guillaume Apollinaire's *Le bestiaire ou Cortège d'Orphée* (1910) that brought the artist to Paul Poiret's (see cat. no. 78) attention. Poiret convinced Dufy to work at his design studio, L'Atelier Martine, in 1911, and Dufy opened a small printing shop with Poiret, La Petite Usine (Little Factory) in Montmartre. With the aid of a chemist proficient in the creation of brilliant dyes, they printed graphic patterns often inspired by Japanese designs, which Poiret integrated into his couture pieces. The collaboration met with great success. A year later Dufy further committed to textile design by signing a contract with textile manufacturer Bianchini-Férier in Lyons.

Charles Bianchini, from an Italian textile manufacturing family, came to Paris to become an artist. Most of his employment, however, came as a theatrical costume designer, notably for the Opéra and Comédie Française. With his partners, including the financier François Férier, he formed a silk-weaving house in Lyons in 1888. Bianchini-Férier achieved great success,

supplying textiles of complex patterning to designers including Charles Frederick Worth and Jacques Doucet.

Bianchini employed many artists as fabric designers, including Sonia Delaunay, Paul Iribe, and Clare Vasarely. He seemingly had a sixth sense about fashion trends and, like Poiret, was quick to see the developing influence of modern art on fashion. Dufy remained under contract with Bianchini-Férier until 1927, and many French designers, including Jean Patou, Vionnet, and Jacques Fath, used textiles of his design.

In the first years of his contract Dufy executed more than three hundred sketches, although only a few were actually produced by the firm. Three of these are represented in the works from the Cooper-Hewitt, National Design Museum. The compressed plane of these fabrics recalls Dufy's early experimentation with woodblock prints. In particular, *The Thresher* illustrates a visual dynamic of movement akin to the cubist tradition. The shawl from the Philadelphia Museum of Art is printed from the design *La chasse à l'arc*, dated 1928, one of the last works Dufy created for Bianchini-Férier.

_____ 85

Edward H. Molyneux
(British, worked in France,
1891–1974)

Artist on a Quay, 1962–64

Oil on fiberboard, 8⅝ × 10⅝ in.
National Gallery of Art, Washington,
D.C., Ailsa Mellon Bruce Collection,
1970.17.126

Molyneux was born in London to Irish parents. His great ambition was to become a painter, but he was diverted into fashion after winning a competition sponsored by the British designer Lady Duff Gordon, who employed him as an illustrator. He would go on to open a fashion house in Paris, with branches in London and Monte Carlo.

A war hero, Molyneux suffered injuries during World War II that precipitated the loss of vision in his left eye. He retired in 1950 and devoted most of his time to painting. His work met with some success and was exhibited, most notably, at the Hammer Galleries in New York and the Galerie André Weill, Paris.

Molyneux was also an exceptional art collector. The designer's collection of impressionist and early modern works reveals a cultured aestheticism consistent with his fashion design. Paintings by Degas, Manet, Renoir, and Bonnard, among others, formerly in his collection are now in the National Gallery of Art, Washington, D.C.

Edward H. Molyneux
(British, worked in France, 1891–1974)
Wedding ensemble, 1936

Satin and lace
The Texas Fashion Collection at the University of North Texas, gift of Mrs. Jaquelyn Masur McElhaney, 1993.008.002a–d

While working for the British designer Lucille, Molyneux traveled in Europe and America, developing a sophisticated style that appealed to aristocrats on both sides of the Atlantic.

The wedding gown was worn by Bertha Marie Masur at her marriage to Milton Gorn at the Temple B'nai Israel in Monroe, Louisiana, on December 20, 1936. The *Monroe Morning World* effused, "The bride, never more beautiful, . . . wore a superb gown by Molyneaux [*sic*] of supple Duchess satin, with inserts of exquisite rose point lace" (December 27, 1936). Among its many points of interest is the highstanding collar, which is stiffened by bands of horsehair. The ensemble consists of a robe of satin and lace over a sleeveless dress of matching satin. The intricately decorated lace is balanced by the overall fluidity of the silhouette so fashionable in the 1930s.

Edward H. Molyneux
(British, worked in France 1891–1974)
Suit, 1948

Faille moiré nylon and wool
The Texas Fashion Collection at the
University of North Texas, gift of
Neiman Marcus, 1900.412.001

To fashion critics of the 1920s and 1930s, Molyneux's designs exemplified a severe elegance and purity of line distinct from other designers. Molyneux worked in a modernist idiom, adhering to an eloquent simplicity that belied a complex infrastructure—an approach that had parallels in the strategies of many modern artists.

This suit was created during the postwar period, a time in which Molyneux's designs retained a simplicity that in part inspired the younger generation of designers who inaugurated the New Look. Molyneux closed his doors in 1950, mostly due to his failing eyesight. A return to fashion design in 1965, at the height of the "mod" period, proved unsuccessful, his work by then sadly outdated.

Christian Dior
(French, 1905–1957)
"Dalí" dinner dress, 1949

Silk brocade
The Costume Institute, The Metropolitan
Museum of Art, gift of Mr. and Mrs. Henry
Rogers Benjamin, 1965 (CI 65.14.2a–c)
Photograph © The Metropolitan Museum
of Art

Christian Dior probably first made the
acquaintance of Salvador Dalí in his first
career as a Paris art dealer. Dior and Dalí
became lifelong friends and admirers of
each other's work and even collaborated
on the decorations and designs for a 1951
ball at the Palazzo Labia, Venice.

In this dinner dress, Dior paid homage
to the great surrealist by including illu-
sory devices, such as pocket flaps at the
bust that create the appearance of a waist-
coat or vest. The pockets may also be an
amusing visual trick, in the true surrealist
tradition, in their odd and impractical
placement so high on the body, rendering
a functional clothing element into one of
near uselessness.

Elsa Schiaparelli
(born Italy, naturalized French
citizen, 1890–1973)

Hat, 1940s

Wool

The Louisiana State Museum, New
Orleans, gift of Mrs. Avis Ogilvy,
1983.28.113

*E*lsa Schiaparelli was born in Rome, the daughter of a well-to-do Jewish aristocrat. She first worked as a translator and scriptwriter in New York and did not enter fashion professionally until the relatively late age of thirty-seven.

Schiaparelli first rose to fame as a designer of sweaters decorated with trompe l'oeil designs, most typically a scarf tied around the shoulders, that alluded to her interest and later association with surrealists such as Salvador Dalí and Jean Cocteau, who also challenged visual perceptions. She became established in the Parisian fashion world in the late 1920s and early 1930s, becoming a French citizen in 1931.

The boxy silhouettes and visual puns of Schiaparelli's work were in deep contrast to the style of her rival Coco Chanel (see cat. no. 62), who once referred to her as "that Italian artist who makes clothes" (Charles-Roux 1979). Like her surrealist friends and collaborators, Schiaparelli liked to shock— she created the color "shocking pink," named her perfume "shocking," and entitled her autobiography "Shocking Life" (1954). It was in this book that Schiaparelli observed: "So fashion is born by small facts, trends, or even politics, never by trying to make little pleats and furbelows, by trinkets, by clothes easy to copy, or by the shortening or lengthening of a skirt."

The hat is decorated in leaves, which, like the earlier sweaters, create a punning visual effect. While not one of Schiaparelli's more aggressive designs, it nonetheless recalls the influence of the surrealist use of the ordinary in extraordinary ways. Among Schiaparelli's most famous creations in this vein are her "Shoe Hat" (1937), "Lamb Chop Hat" (1937), and "Hen in Nest Hat" (1938). Schiaparelli was the first designer to organize her collections by theme, conferring a strong narrative dimension to her creations.

_____90

Gabrielle "Coco" Chanel
(French, 1883–1971)

Coat and scarf, c. 1960s

Wool tweed and ostrich feathers
The Louisiana State Museum, New
Orleans, gift of Madame Josette
LeGouix, 1988.82.2.1–.2

*C*hanel retired from fashion design in 1939, but the restrictive silhouettes made famous by the New Look of young French designers like Christian Dior and others after World War II brought her out of retirement in 1954, at age seventy-one. Her creations, in direct stylistic conflict with the New Look, were met with little fanfare. Not until well into the 1960s did Chanel's suits, more consistent with the social temperance of women's liberation, return to vogue.

Chanel's work is often a study in contrasts, at once seemingly simple and complex. This coat offers a wonderful interplay between the rough (tweed) and the fragile (feathers), emphasized by the contrast of black and white. The lion-head motif adorning the brass buttons was a typical Chanel decoration and carries an almost baroque tone.

—————91

Victor Vasarely
(Hungarian, worked in France,
1908–1997)

Avant la lettre, 1970

Silkscreen, 27¾ × 23⅛ in.
California State University, Long Beach
Library, Special Collections, 1970.073.1
V373 A92
© 2002 Artist Rights Society (ARS),
New York/ADAGP, Paris

Victor Vasarely trained in the Bauhaus tradition in Budapest before settling in Paris in 1930. He enrolled briefly in medical school and had a lifelong interest in science, especially astrophysics and quantum mechanics. Vasarely was first employed as a graphic artist and painted in the manner of a figurative expressionist until about 1946, when he embraced a more geometric abstraction. Experimenting with visual techniques, including layering images with transparencies, and media, using aluminum and glass, Vasarely became a leading figure in the op art movement, a geometric abstraction that deals with optical illusion.

This silkscreen demonstrates Vasarely's ability to transcend the flat surface of the canvas and create dimension where there is none. Vasarely believed that op art had a profound social implication in that, through what he perceived to be its honest depiction of shapes and structures, every segment of society could respond to it: "Art must be a common treasure or not be art at all" (Vasarely 1973).

_____92

André Courrèges
(French, b. 1923)

Evening dress, late 1960s

Embroidered organza and wool
Kent State University Art Museum, Ohio,
gift of Aileen Mehle, 1986.2.12
Photograph © David M. Thum

*A*ndré Courrèges opened his own couturier in 1961, after working for many years for Balenciaga (see cat. no. 99). With the British designer Mary Quant, Courrèges is credited with the 1962 introduction of the miniskirt. Op art and space travel were prevalent themes in his work. Courrèges innovated the use of unconventional materials, including PVC (polyvinyl chloride) and untraditional fabric combinations, such as the organza and wool of this dress.

Op artists placed geometric shapes in specific relationships to create a sense of motion, emphasizing the tricks of the eye that fixed objects can play depending on their color and positioning. Courrèges and many of his contemporaries applied the same principles and exploited the movement inherent in all worn clothing to add to the visual dynamic.

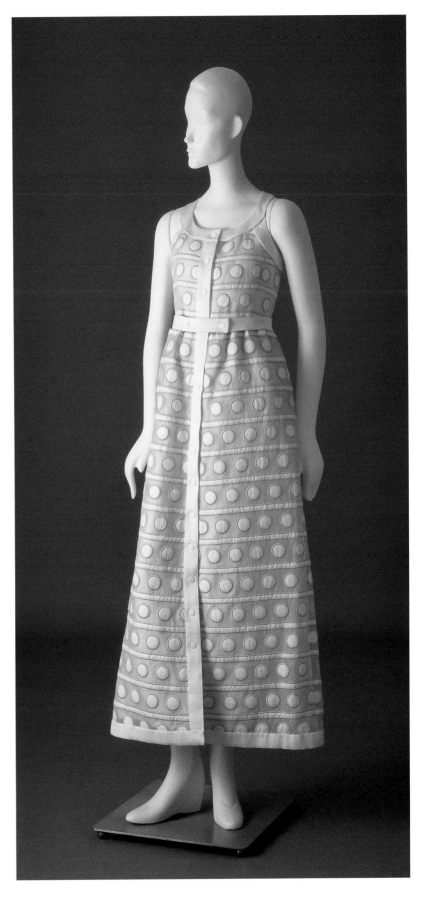

_____93

Hubert de Givenchy
(French, b. 1927)

Evening ensemble, c. 1968

Silk crepe
Kent State University Art Museum,
Ohio, Silverman/Rodgers Collection,
1983.1.506
Photograph © David M. Thum

Hubert de Givenchy studied art at the École des Beaux-Arts before apprenticing to Jacques Fath, Lucien Lelong, and later Elsa Schiaparelli. He worked alongside other assistants at Lelong's who would later make their names in fashion, including Christian Dior and Pierre Balmain. In 1952 Givenchy went into business for himself, designing collections that emphasized simplicity and flawless construction.

An *enfant terrible* who took the fashion world by storm at the age of twenty-five, Givenchy responded to the "mod" art movements of the day, especially op art, the inspiration for this gown. Among the innovations he brought to the fashion world were designer, ready-to-wear separates. His greatest fame, however, came from his achievement in creating the classic, elegant style embodied by his greatest muse, the actress Audrey Hepburn.

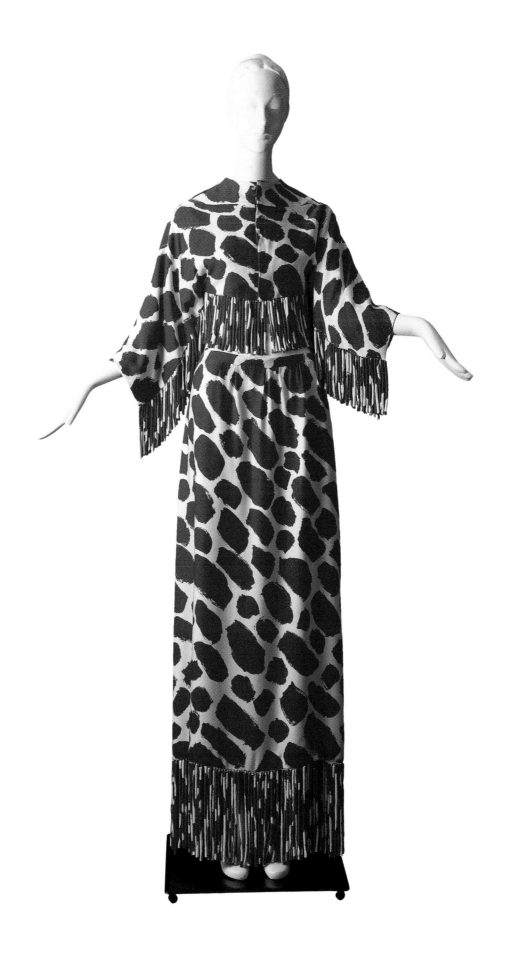

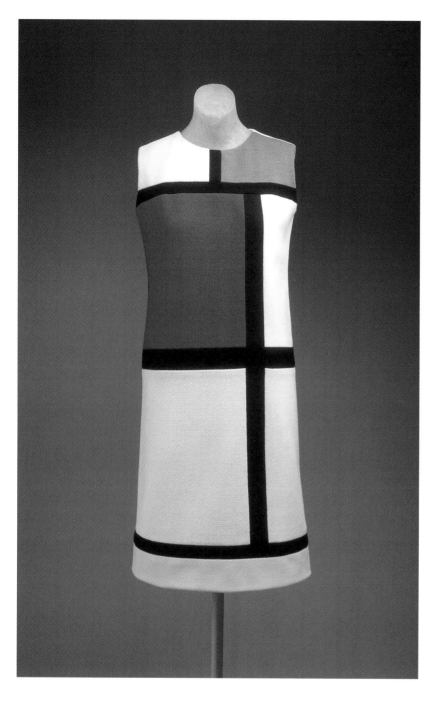

Yves Saint Laurent
(French, b. 1936)

"Mondrian" day dress, 1965

Wool jersey
The Costume Institute, The Metropolitan
Museum of Art, gift of Mrs. William
Rand, 1969 (CI 69.23)
Photograph © The Metropolitan Museum
of Art

left

"Mondrian" day dress, 1965

Wool jersey
The Fine Arts Museums of San Francisco,
gift of I. Magnin & Co., 66.7a, b

opposite

Piet Mondrian (Dutch, 1872–1944). *Place
de la Concorde*, 1938–43. Oil on canvas,
37 × 37¼ in. Dallas Museum of Art, Foun-
dation for the Arts, gift of the James H.
and Lillian Clark Foundation. © 2002
Mondrian/Holtzman Trust.

A Frenchman born in Algeria, Yves Saint Laurent has throughout his career demonstrated an interest in fine art. His work intermittently hints at its visual inspiration; this dress, from 1965, is a direct quotation.

In the 1960s Saint Laurent envisioned the "shift"-style dress as a medium for demonstrating the planarity principles of Mondrian and De Stijl. The designer saw the movement as the philosophical precedent for mod fashion, and he demonstrated his own artistic sensibilities through his arrangement of color blocks and black lines in the De Stijl tradition in unique compositions befitting the female form.

In the 1980s the designer continued to display his interest in fine art with "Picasso" suits, integrating blocks of black and white in cubist form, and "Van Gogh" dresses, which replicated the painter's famous *Irises* on the skirt of an evening gown.

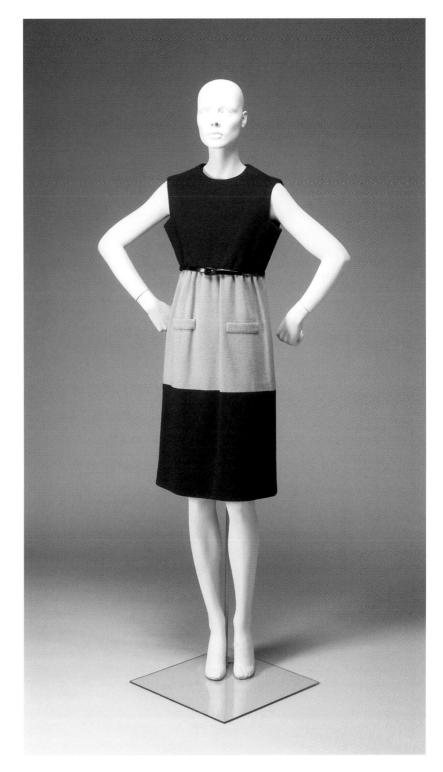

_____95

Hubert de Givenchy
(French, b. 1927)

Hat, 1988

Satin and velvet
Philadelphia Museum of Art, purchased
with funds contributed by an anony-
mous donor, 1993, 1993-52-3

*G*ivenchy may have inherited his artistic sensibilities from his grandfather, who was a student of the famed Barbizon artist Camille Corot and later the administrator of the Gobelins and Beauvais tapestry factories.

Givenchy's emphasis on line over decoration, demonstrated in the hat's undulating wave form, owes much to postminimalism, which arose in the 1970s. Postminimalism assumed the basic tenets of minimalism—minimal color, shape, line, and texture—combined with a more sensual tactileness, all of which are discernable in this hat, as much a piece of sculpture as headwear.

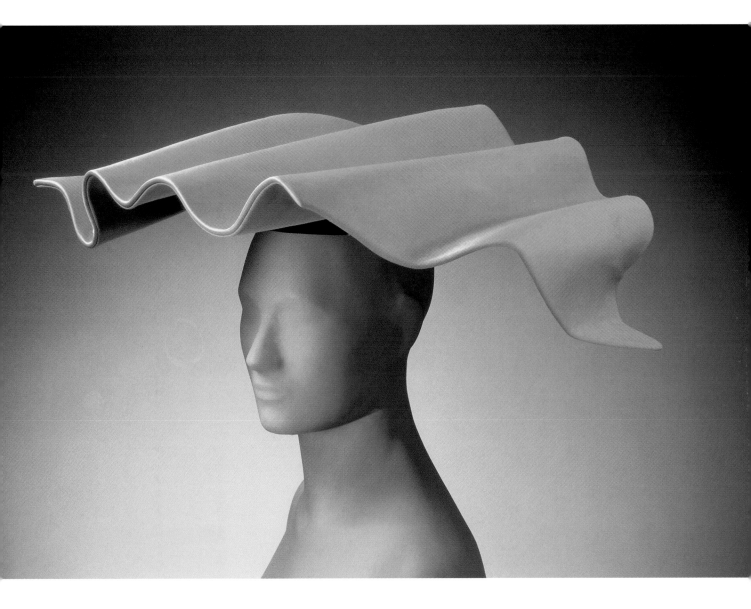

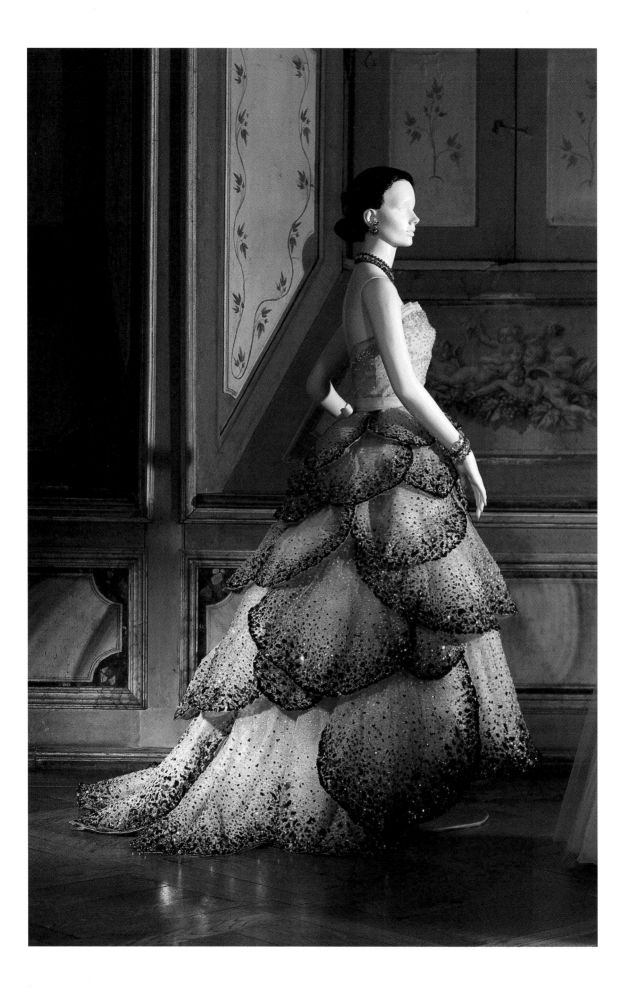

——————*96*

Christian Dior
(French, 1905–1957)

Juno ballgown, 1949

Silk net with sequins
The Fine Arts Museums of San
Francisco, gift of I. Magnin & Co.,
49.25.2a, b

Although named after Juno, the wife of the mythological Zeus, this ball-gown visually alludes to French history, specifically the grandeur of the court of Versailles. The cultural implication of the gown is profound, because this masterpiece of couture was created just four years after World War II. The Nazi occupation of Paris nearly decimated the French fashion industry, including the manufacture of fine materials such as silk and sequins. Decorated with skill and vision in graduated sequins, the gown is a bravura assertion of the French return to, and domination of, the contemporary fashion world. With its pendant, the Venus ballgown, made the same year, Dior achieved one of his most spectacular historic styles.

It was Juno who granted her favorite bird, the peacock, the brilliant tail of bright blue and turquoise feathers, stunningly reinterpreted in the curved flounces of the gown's skirt. The moral of this mythical tale, in which the peacock is unable to fly under the heavy burden of his plumage, bears a striking analogy to the Juno ballgown, and Dior's designs in general. While creating works of complex and luxurious decoration, and reviving the feminine hourglass silhouette with the reintroduction of crinolines and corsets, the designer, like Juno, sacrificed physical comforts and freedoms for the sake of rare and exquisite beauty.

Christian Dior
(French, 1905–1957)
Soirée fleurie, 1955

Satin with gold embroidery
The Fine Arts Museums of San
Francisco, bequest of Jeanne Magnin,
1987.25.4a–c

The gown's silhouette—notably the full skirt and hourglass form that came to define the New Look—clearly finds inspiration in the eighteenth century. In color and decoration, however, the dress also recalls the era during which the French monarchy fell.

The luxuriant satin and stark elegance of the gown's white fabric recall the stylistic austerity of the eighteenth-century revolutionary period when *marchandes de modes* employed exceedingly fine, although less ostentatious materials. The dramatic cummerbund and exaggerated sash are a reinterpretation of the postrevolutionary tradition of taking utilitarian designs and making them fashionable. Dior, as one of the principal designers of the New Look, did much to revitalize the French fashion industry after World War II. The gown's delicate embroidery recalls the needlework promoted by Napoleon to salvage a similarly decimated market after the Revolution.

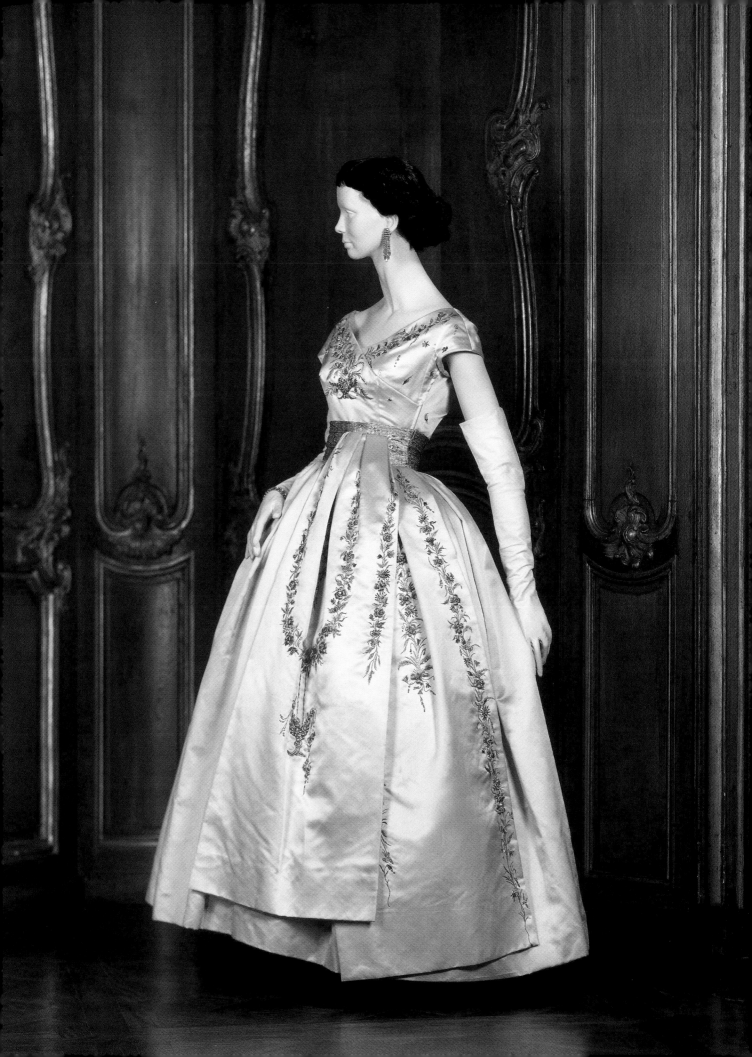

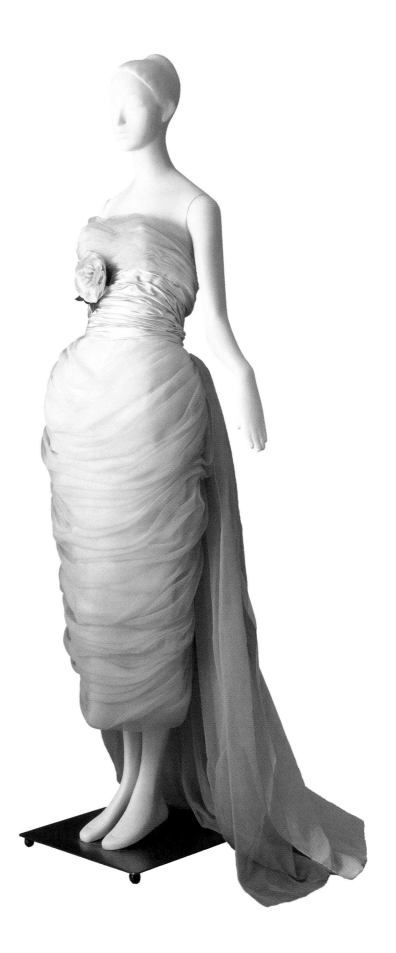

Pierre Balmain
(French, 1914–1982)

Evening dress, c. 1952

Silk crepe organza
Kent State University Art Museum,
Ohio, Silverman/Rodgers Collection,
1983.1.443
Photograph © David M. Thum

Although from an early age Pierre Balmain wished to study fashion design, his family wanted him to become a doctor. They compromised on the study of architecture. His early studies perhaps inclined his remark, "Dressmaking is the architecture of movement" (Seaman 1997). Indeed, Balmain believed that designers and architects shared a similar responsibility—to beautify city streets, one with buildings, the other with dress.

Balmain worked under Edward Molyneux and Lucien Lelong before opening Maison Balmain in 1945. Gertrude Stein, a great patron and early advocate of artists such as Pablo Picasso, was also one of Balmain's first supporters. With her companion Alice B. Toklas, Stein did much to promote Balmain in his early years. Toklas, perhaps with Balmain in mind, wrote, "A dress is to once more become a thing of beauty, to express elegance and grace" (ibid.).

After World War II, which had greatly diminished the French garment industry, Balmain became an active ally in rebuilding trade and frequently traveled to America on lecture tours. From 1950 he also designed for stage and film productions, including *The Roman Spring of Mrs. Stone* (1961) and *Tender Is the Night* (1962).

Cristóbal Balenciaga
(Spanish, born in France, 1895–1972)

Swan-tail gown, c. 1952

Silk and beading
The Louisiana State Museum, New
Orleans, gift of Ms. Anne Strachan,
1977.59.2

Cristóbal Balenciaga left his native Spain at the onset of the Spanish Civil War in 1936 and opened his own couture house in Paris in 1937.

This gown demonstrates many of the hallmarks of the New Look, including its architectural monumentality, expressed in the voluminous skirt and clean, well-cut bodice. Balenciaga's extraordinary skill in tailoring and construction was well regarded; Hubert de Givenchy called him the architect of the haute couture. Intricate turquoise-beaded and silver-thread fleurettes are briefly and luxuriously expressed along the graduated hemline, which falls from the back's voluminous pleats.

To maintain a sense of mystery about his creations, Balenciaga introduced his collections a month later than other designers. He chose his models not for their beauty but for their sense of personality. Despite his contrary ways, Balenciaga influenced many French designers, especially Givenchy (see cat. no. 93) and Emanuel Ungaro (see cat. no. 66), with his elegant and seductive fashions. This gown was worn by Rose Strachan, a prominent citizen of New Orleans.

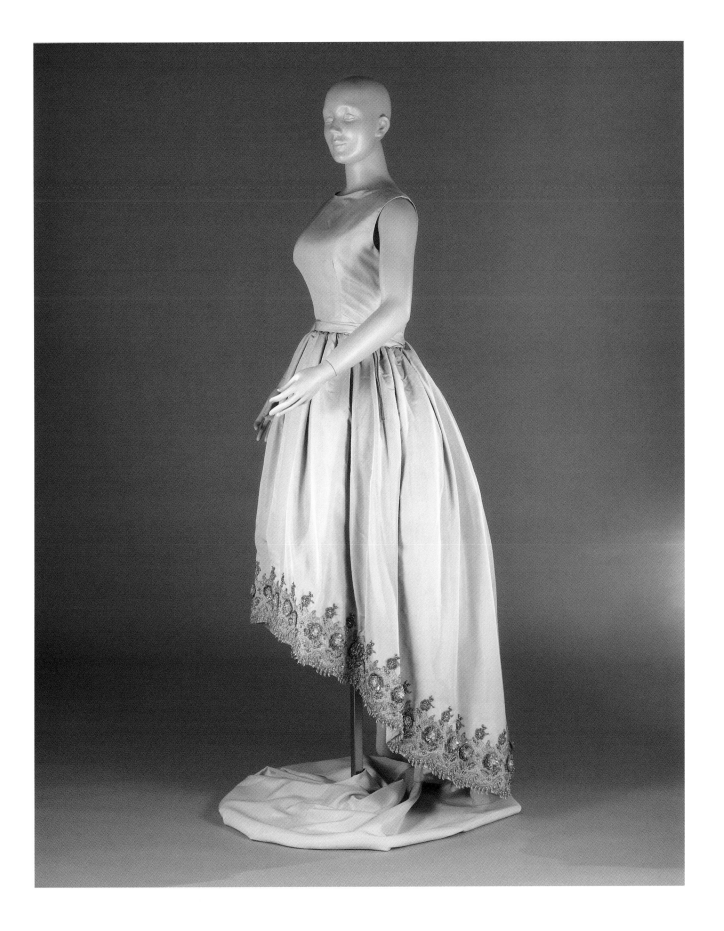

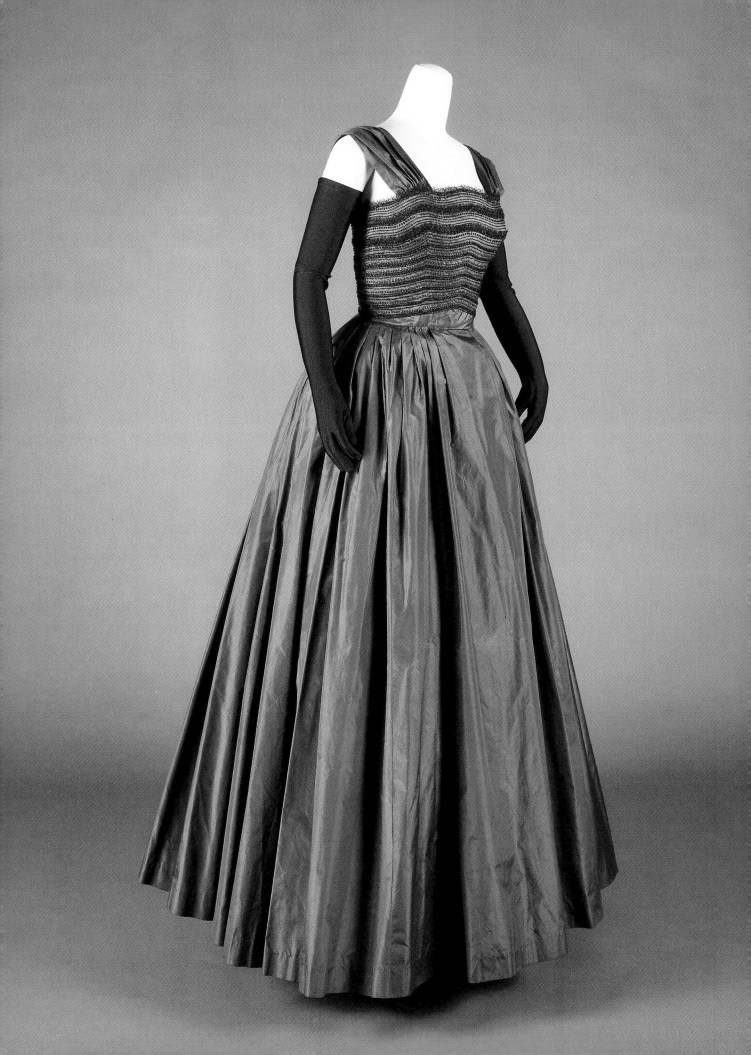

Christian Dior
(French, 1905–1957)

Evening gown, c. 1955

Silk taffeta with beading and tulle
The Louisiana State Museum, New
Orleans, gift of Mrs. Matilda Gray
Stream, 1987.27.16

Dior's ballgowns are some of the most luxurious and flamboyant of the postwar era. Cleverly incorporating an outward simplicity, the designs sometimes show intricateness in their construction rather than adornment.

Dior himself proclaimed in 1946, "The hardships of the war were finished. I revived the ripe bosom, the wasp waist, and soft shoulders, and molded them into the natural curves of the feminine body. It was a nostalgic voyage back to elegance" (Dior 1957). It is particularly interesting to note the contrasting visions of "natural curves" of Dior and Chanel, skewed to some degree, no doubt, by their genders.

Dior's restricted silhouette manipulated the female body in celebration of artifice. Decades earlier, Chanel had forsaken the corset, embracing a more androgynous look, which also facilitated freer movement and the pursuit of sports for women.

Attributed to Christian Dior
(French, 1905–1957)

Day dress, c. 1948

Wool
Kent State University Art Museum,
Ohio, gift of Anne Slater, 1990.68.1a, b
Photograph © David M. Thum

opposite, left

Christian Dior
(French, 1905–1957)

Dress, 1952

Satin faille
The Texas Fashion Collection at the
University of North Texas, Denton, gift
of Bert de Winter, 1973.001.015a, b

opposite, right

Christian Dior was born in the Loire Valley to a wealthy family, and his interest in design first revealed itself when as a boy he made clothing for his sisters. Although he studied political science, his first real profession was as an art dealer in Paris, whereby he made lifelong friendships with Salvador Dalí and Christian Béraud and became acquainted with Pablo Picasso and Jean Cocteau. A protracted illness forced him to leave the business and Paris, and when he returned to the city in 1942, it was to work as an assistant to the designer Lucien Lelong (see cat. no. 82).

Five years later, in 1947, Dior set up his own fashion house with the aim of going against everything fashion had known before. He introduced designs that required more fabric than ever would have been available during World War II and emphasized the feminine hourglass silhouette, which had all but been forgotten in the severe and serviceable suits women wore during the war. His first collection, introducing the New Look, was actually a revival of the pinched-in silhouette accentuating large bosoms and hips, with tiny, corseted waists, reminiscent of fashion a century earlier. The multitude of small back pleats in this day dress, for example, emphasize the hips with an almost bustlelike effect. A dramatic contrast to the austerity of the wartime years, Dior's flamboyant stylishness became phenomenally popular.

Because it is without a label, this ensemble is only attributed to Christian Dior, although everything about its material, construction, and design suggests it is by the designer.

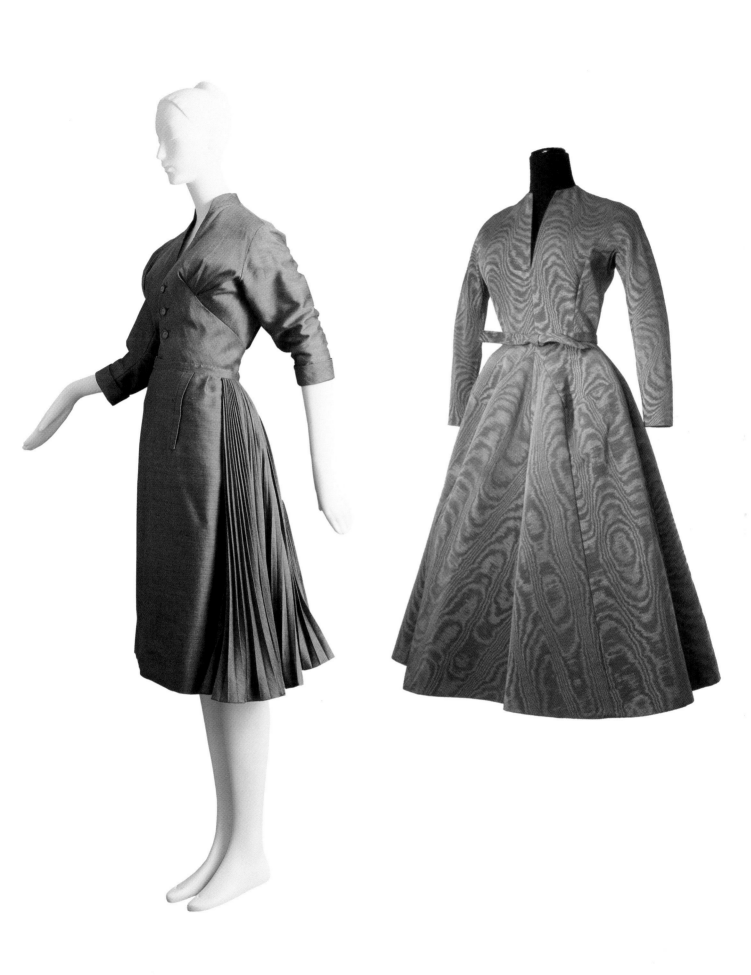

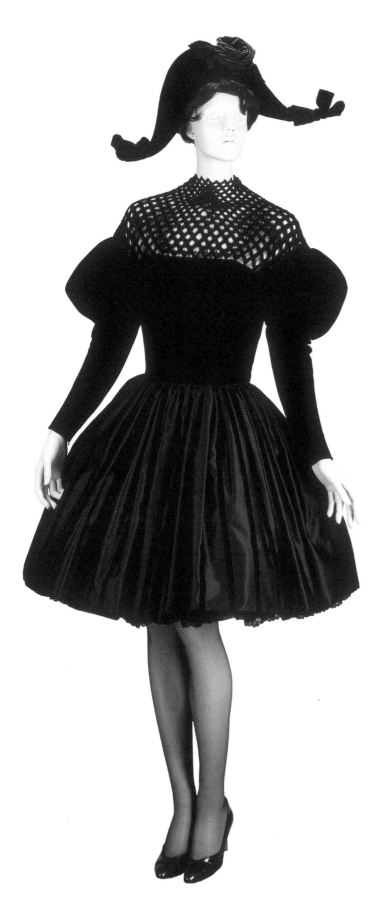

Christian Lacroix
(French, b. 1951)
Columba, 1987

Velvet
The Fine Arts Museums of San Francisco,
gift of Maison Lacroix, 1989.20.01

Christian Lacroix presented his first collection
in Paris in 1987 and almost instantaneously was
lauded as the most important force in contem-
porary fashion. Previously, he had revived the
house of Patou, and even his early work demon-
strated the designer's historical sympathies; he
often evoked rococo silhouettes, including frock
coats, redingotes, and gowns in the tradition of
the *robe à la française.* Combining the finest bro-
cades, lace, and embroidery (often gold) in untra-
ditional ways, Lacroix not merely alludes to but
embellishes French eighteenth-century taste in
creations that are at once humorous parodies and
historical homages.

A student of art history and a contemporary
artist, Lacroix naturally found inspiration in
French historical styles and artistic themes, such as
the characters from the *commedia dell'arte.* The
saucy servant girl Columba, identified in art by her
crescent-shaped hat, was the object of the young
servant Pierrot's unrequited love. The hourglass
lines, created by the puffed sleeves and full, gath-
ered skirt demonstrate Lacroix's genius at creating
works in step with the fashion of the time (in this
case the exaggerated contours of the 1980s) while
referencing centuries-old fashion elements.

_____ *103*

Jean-Paul Gaultier
(French, b. 1952)

Jacket, 1994

Cotton organdy and seashells
The Costume Institute, The Metropolitan Museum of Art, gift of Claudia
Payne, 1996.482.6 a, b

not illustrated

Jean-Paul Gaultier founded his own design company in 1978 and has achieved great success in joining street fashion and the principles of couture. Historical and literary traditions also inform his work, as seen in the heraldic motifs in many of his designs and in his presentation of a collection inspired by Toulouse-Lautrec.

The line of the jacket clearly recalls the man's coat worn throughout most of the eighteenth century, yet in the hands of Gaultier, it is strikingly modern. Emphasizing the bold structure of the jacket, Gaultier nods to centuries-old craftsmanship while contextualizing it with a modern line and construction.

Madame Grès
(French, 1903–1993)

Evening dress, c. 1963

Silk
The Costume Institute, The Metropolitan
Museum of Art, gift of Mrs. Leon L. Roos,
1973 (1973.104.2)
Photograph © The Metropolitan Museum
of Art

This white columnar gown, with its
intricately pleated forms, represents a
design that, with her exotic caftans of the
1960s (see cat. no. 64), is nearly synony-
mous with Madame Grès.

The dress responds equally to two art
historical sources, antique sculpture and
neoclassicism. Its reference to classical
sculpture is indirect, however, because
the dress is a further reinterpretation of
the French rendering of the antique in the
neoclassical styles worn by so many por-
trait subjects of the early nineteenth cen-
tury. Indeed, rather than the loose flowing
garments of the ancients, Madame Grès's
gown is intricately constructed and, par-
ticularly at the bodice, strict and confining.

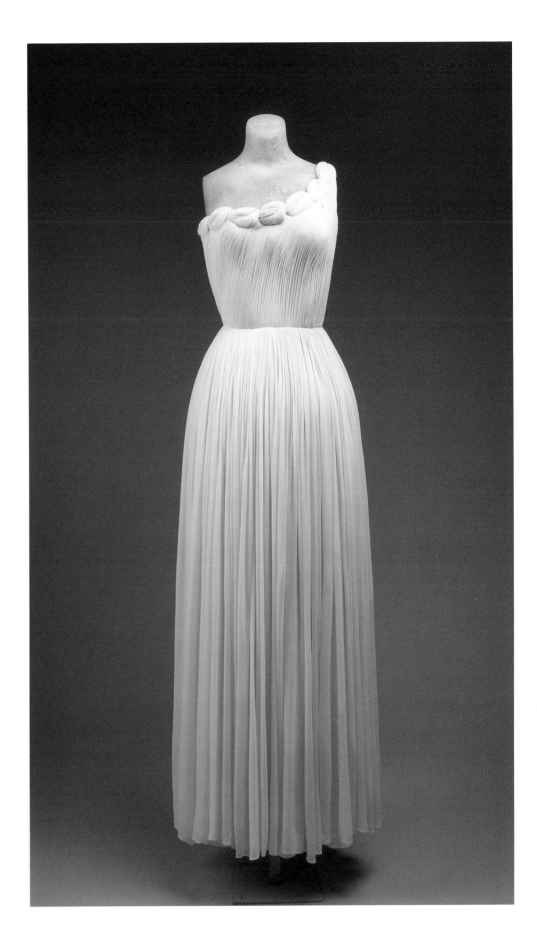

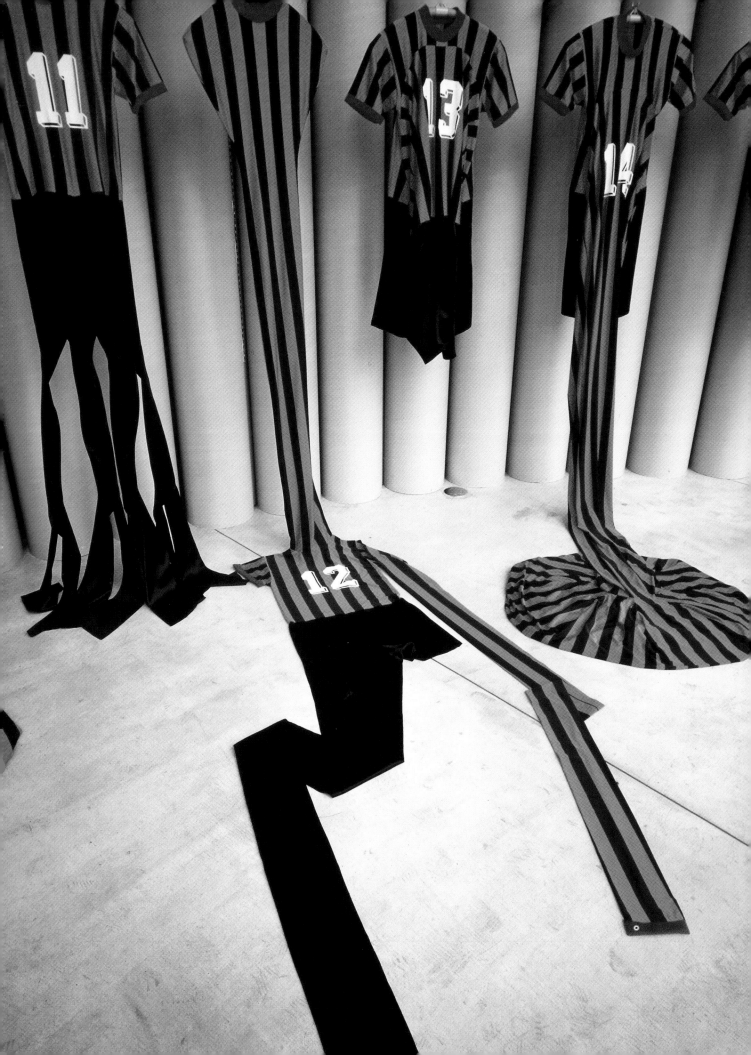

*M*any artists working today contribute to the ongoing discourse between art and fashion in works that address issues of consumerism and body politics. Designers like Christian Lacroix cross over traditional boundaries, working in both art and fashion, informing each arena with the resources of the other. Collaborations between artists and designers on shared projects continue. These artists respond to broadly different impulses, but their reactions are underscored by a deep respect for the craft tradition that invites a deeper contemplation of its role in today's world.

GOTSCHO
(French, n.d.)

Solo GOTSCHO/UNGARO, 1996

Installation: Emanuel Ungaro silk
taffeta skirt, grand piano, and bench
Collection of the artist

The implications of body and forms dominate Gotscho's work, as does mystery. The artist keeps his personal biography, including his full name, private. He appeared on the contemporary art scene in 1991 and has collaborated with other designers and fashion houses, including Commes des Garçons and Christian Lacroix. In 1997 he created a number of pieces for the House of Christian Dior, called *Suite Dior,* that incorporated the works of chief designer John Galliano. For the striking *Solo GOTSCHO/UNGARO,* he collaborated with Emanuel Ungaro, the leading French designer known especially for his dramatic and highly feminine creations. Gotscho's work is collected around the world, notably by the Museum of Contemporary Art, Los Angeles, and the Musée d'Art Moderne et Contemporain, Geneva.

Gotscho has stated, "My work associates elements made for the body—clothing—with elements made for the interior—furniture, objects, curtains, etc. The general idea is to explore the relationship between the body and its environment, but always with the absence of the body" (Middleton 1998). This large-scale work was originally created for exhibition at Paris's Opéra Comique. Flowing waves of white silk and taffeta flood the piano bench and keyboard, suggesting a crescendo of movement and emotion.

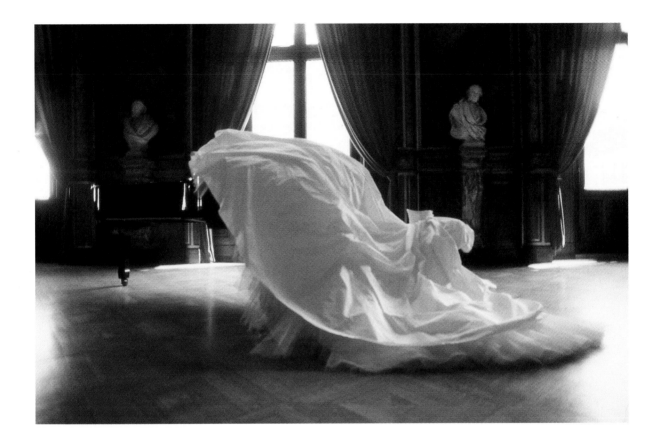

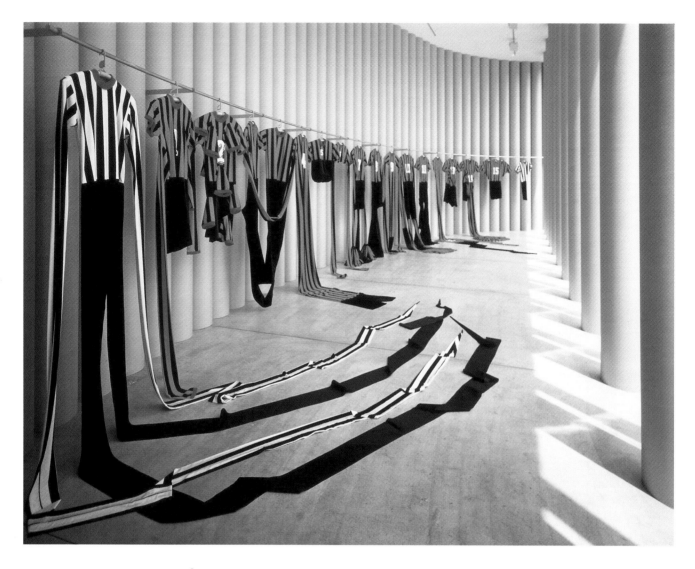

_____ *106*

Matthieu Manche
(French, b. 1969)

World Cup, 1994

Installation: polyester textile,
silkscreen, and hangers
Collection of the artist

\mathscr{M}atthieu Manche studied at the Musée des Beaux-Arts in Grenoble, the city of his birth. The artist has exhibited mainly in France and Japan, where he lives and works part-time, often collaborating with the fashion designer Issey Miyake.

Manche works primarily in installations, which often challenge notions of beauty, incorporating scars and varied body silhouettes in spaces that often reference the commercial display of clothing. In *World Cup*, Manche manifests a vision of unity—reinforced by the linearity of the uniforms—but with obvious differences: short, long, or missing legs and arms, truncated or lengthened torsos. The effect is to create a vision of disparate individuals who are aligned on the global team of humanity.

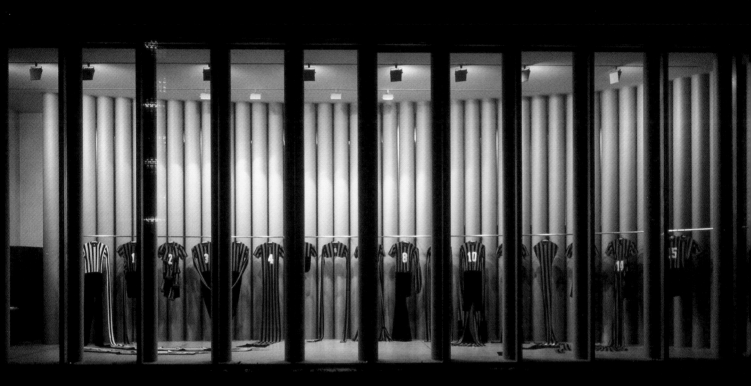

Christian Lacroix
(French, b. 1951)

Souvenir pieu, or *Le piétinement
de la croix*, 2000

Metal wire, silk, and cotton,
35⅝ × 16⅜ in.
Collection of the artist

\mathcal{C}hristian Lacroix studied art history and later museum studies at the
Sorbonne, Paris, from 1973 to 1976. It is not surprising that so much of his
couture work is infused with fine art references. He occasionally creates
art pieces, such as *Souvenir pieu*, that integrate art and craft.

For this camisole, Lacroix collaborated with lace makers skilled in tradi-
tional techniques to create a garment that is thoroughly contemporary. The
work captures Lacroix's ambition to place haute couture "between respect
and transgression" (Louviers 2001).

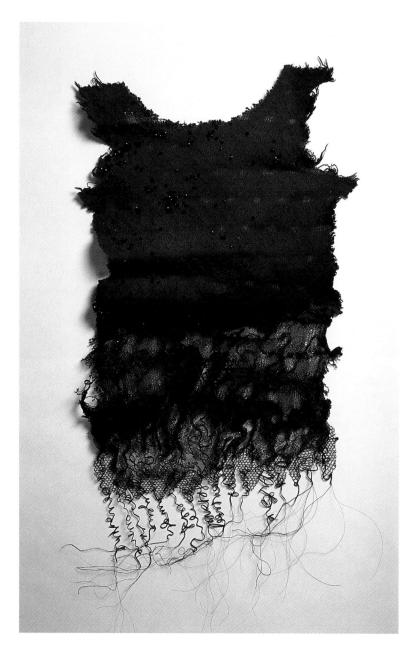

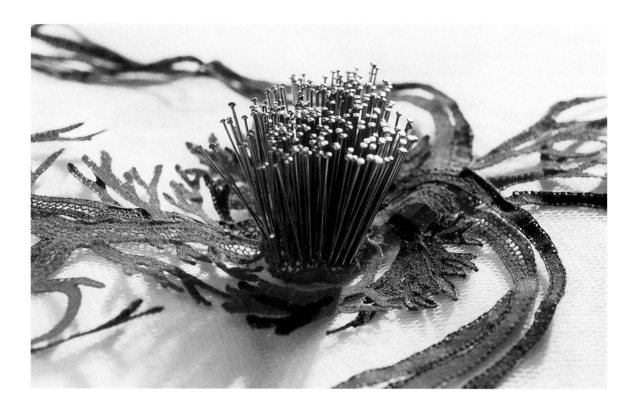

_____ *108*

Annette Messager
(French, b. 1943)

Pénétration, 1996

Silk thread and tulle
Collection of the artist, Paris

Detail, see also p. 26

\mathscr{A}nnette Messager studied at the École des Arts Décoratifs in Paris. Thread, the most basic element of all fabric art, is intrinsic to her work. Messager also considers feminist issues, an appropriate concern given the relationship between women and the applied arts, especially sewing.

Messager creates a link to her feminist themes by using simple domestic materials in her work. "I only wanted to use materials that you would be likely to find in a home," she said in 1995, "a ball of wool, colored pencils, fabric. . . . As if you could make art with everything you find in the house, and only with that" (Guggenheim 1998).

Marie-Ange Guilleminot
(French, b. 1960)

Dress on Wheels, 1992

Lycra, skateboard, 16¼ × 11⅝ × 3⅛ in.
Anne and William J. Hokin Collection,
Chicago

*M*arie-Ange Guilleminot's work consistently displays her infatuation with the body and its dressed form. Known particularly for her "sculpted dresses," Guilleminot has also created tubular hats that fold down over the body, counterpoints to the *Dress on Wheels*, which sheathes the body from the floor upward. A cross between functional fashion and fantastical sculpture, Guilleminot's creations argue our definitions of dress.

Bernadette Genée
(French, b. 1949)

Décorations civiles et militaires, 2000

Cotton and wool, 28¾ × 14⅝ in.
Collection of the artist

\mathcal{L}ike Christian Lacroix, Bernadette Genée is fascinated by the intricacies of lace and embroidery. Since the 1970s she has created many works evoking an interesting dynamic between functionality and decorativeness. In this work, she explores the utilitarian military jacket, suitably pressed, cuffed, and pocketed, but lightened by a spirited display of symbols, insignias, appliqués, and embroidery.

References Cited

Bernhardt, Sarah. 1907. *Memories of My Life.* New York: D. Appleton.

Bradfield, Nancy Margetts. 1981. *Costume in Detail: Women's Dress, 1730–1930.* London: Harrap.

Brandon, Ruth. 1991. *Being Divine: A Biography of Sarah Bernhardt.* New York: Mandarin.

Brookner, Anita. 1972. *Greuze: The Rise and Fall of an Eighteenth-Century Phenomenon.* London: Elek.

Carlson, Victor I. 1971. *Matisse as a Draughtsman.* Baltimore: Baltimore Museum of Art.

Charles-Roux, Edmonde. 1979. *Chanel and Her World.* New York: Vendome.

Detroit Institute of Arts. 1978. *The Second Empire, 1852–1870: Art in France under Napoleon III.* Exh. cat. Detroit: distributed by Wayne State University Press.

Dior, Christian. 1957. *Dior by Dior.* Trans. by Antonia Fraser. Harmondsworth, Middlesex: Penguin Books.

Gold, Arthur, and Robert Fizdale. 1980. *Misia: The Life of Misia Sert.* New York: Knopf.

Groom, Gloria Lynn. 2001. *Beyond the Easel: Decorative Painting by Bonnard, Vuillard, Denis and Roussel, 1890–1930.* Exh. cat. Chicago: Art Institute of Chicago; New Haven, Conn.: distributed by Yale University Press.

Guggenheim Museum Soho. 1998. *Premises: Invested Spaces in Visual Arts, Architecture, and Design from France: 1958–1998.* Exh. cat. New York: distributed by Harry N. Abrams.

Jiminez, Jill, ed. 2001. *Dictionary of Artists' Models.* London: Fitzroy Dearborn.

Léal, Brigitte, Christine Piot, and Marie-Laure Bernadac. 2000. *The Ultimate Picasso.* New York: Harry N. Abrams.

Louviers, Musée de. 2001. *Métissages: Regard contemporain sur la broderie, la dentelle, et la passementerie.* Exh. cat.

Middleton, William. 1998. "Art House." *W Magazine* (March 1998).

Passez, Anne Marie. 1973. *Adélaïde Labille-Guiard, 1749–1803: Biographie et catalogue raisonné de son oeuvre.* Paris: Arts et Métiers Graphique.

Peltre, Christine. 1998. *Orientalism in Art.* New York: Abbeville.

Renoir, Jean. 1962. *Renoir, My Father.* London: Collins.

Rouen, Musée de Beaux-Arts. 1997. *Jacques-Emile Blanche, Painter 1861–1942.* Exh. cat.

Seaman, Margo. 1997. "Pierre Balmain." In *The Saint James Fashion Encyclopedia: A Survey of Style from 1945 to the Present.* Ed. by Richard Martin. New York: Visible Ink.

Simon, Marie. 1995. *Fashion in Art: The Second Empire and Impressionism.* London: Zwemmer.

Vasarely, Victor. 1973. *Notes brutes.* Paris: Denoël/Gonthier.

White, Barbara Ehrlich. 1984. *Renoir: His Life, Art, and Letters.* New York: Harry N. Abrams.

White, Palmer. 1973. *Paul Poiret.* New York: Clarkson Potter.

Worth, Jean-Philippe. 1928. *A Century of Fashion.* Boston: Little, Brown.

Yeager, Lynn. 2000. "Elements of Style." *Village Voice*, June 7–13.

Acknowledgments

I extend my sincerest gratitude to the institutions that so generously loaned objects to this exhibition and to the staff members who helped facilitate the loans: Keith Wemm, Curator of Public Programs, Appleton Museum of Art; Gail Andrews Trechsel, Director, Melissa B. Falkner, Registrar, Birmingham Museum of Art; Irene Still Meyer, Supervisor of Special Collections, California State University Library, Long Beach; William J. Hennessey, Director, Linda M. Cagney, Assistant Registrar, Chrysler Museum of Art; Michael Conforti, Director, Richard Rand, Senior Curator, Kris Walton, Assistant Registrar, Sterling and Francine Clark Art Institute; William B. Bodine, Jr., Deputy Director and Chief Curator, Cindy Connor, Collections, Columbia Museum of Art; Charles T. Butler, Director, Aimee Brooks, Registrar, Columbus Museum (Georgia); Irwin M. Lippman, Director, Nannette Maciejaunes, Curator, Jennifer Seeds, Assistant Registrar, Columbus Museum of Art (Ohio); Paul Tompson, Director, Lucy A. Commoner, Textile Conservator, Steven Langehough, Associate Registrar, Jill Bloomer, Rights and Reproductions, Cooper-Hewitt, National Design Museum, Smithsonian Institution; Philippe de Montebello, Director, Harold Koda, Curator, Amy Beil, Research Associate, Alex Kowalski, Research Associate, Stephan Houy-Towner, Costume Institute Library, The Costume Institute, The Metropolitan Museum of Art; Graham Beale, Director, Michelle Peplin, Associate Registrar, Sylvia Inwood, Visual Resources Department, Detroit Institute of Arts; Harry S. Parker, Director, Melissa Leventon, former Curator of Costumes and Textiles, Beth Szuhay, Textile Conservator, Trish Daly, Curatorial Assistant, Maria Reilly, Registrar, Sue Grinols, Rights and Reproductions, Fine Arts Museums of San Francisco; John Henry, Director, Melissa Miller Farr, Registrar, Flint Institute of Arts; James Mundy, Director, Joann Potter, Collections Manager, Karen Hines, Assistant Registrar, Frances Lehman Loeb Art Center, Vassar College; Frank Robinson, Director, Nancy E. Green, Senior Curator, Warren Bunn, Registrar, Herbert F. Johnson Museum of Art, Cornell University; Frederick Fisher, Director, Anne Odom, Deputy Director for Collections and Chief Curator, Ruthann Uithol, Collections Manager, Hillwood Museum and Gardens; James T. Demetrion, Director, Phyllis Rosenzweig, Curator of Works on Paper, Loan Coordinator, Amy Densford, Photo Lab, Hirshhorn Museum and Sculpture Garden, Smithsonian Institution; George Ellis, Director, Jennifer Saville, Curator of Western Art, Sanna Saks Deutsch, Registrar, Pauline Sugino, Assistant Registrar, Honolulu Academy of Arts; Thomas K. Seligman, Director, Bernard Barryte, Chief Curator Noreen Ong, Registrar, Alicja Egbert, Collections Assistant, Iris and B. Gerald Cantor Center for Visual Arts, Stanford University; Norman Kleeblatt, Curator, Irene Zwerling Schenck, Research

Associate, Juli Cho, Collections Manager, Jackie Goldstein, Assistant Registrar, Joshua Cox, Visual Resources, Jill Bloomer, Rights and Reproductions, The Jewish Museum; Aaron H. DeGroft, Deputy Director for Collections and Programs, Rebecca J. Engelhardt, Acting Collections Manager, Heidi Tayler, Rights and Reproductions, John and Mable Ringling Museum of Art; Marsha V. Gallagher, Chief Curator, Theodore W. James, Collections and Exhibitions Manager, Larry Mensching, Rights and Reproductions, Joslyn Art Museum; Jean L. Druesedow, Director, Anne Bissonnette, Curator, Joanne Fenn, Registrar, Kent State University Art Museum; Edward E. Sullivan, Acting Director, Carrie Morgan, Curator, Kathleen Jones, Registrar, Krannert Art Museum, University of Illinois; George Bassi, Director, Tommie Rodgers, Registrar, Lauren Rogers Museum of Art; Andrea L. Rich, Director, Nancy Thomas, Deputy Director, Curatorial Affairs, Michele Ahern, Registrar, Los Angeles County Museum of Art; James F. Sefcik, Director, Wayne Phillips, Curator of Costumes and Textiles, Nathanael Heller, Assistant Registrar, Jessica Hack, Conservator, Owen Murphy, Photographer, Louisiana State Museum; Dennis Fiori, Director, Melissa Ray, Assistant to the Director, Jennifer Cathro, Registrar, Maryland Historical Society; Evan Maurer, Director, Patrick Noon, Curator, Tanya Morrison, Associate Registrar, Minneapolis Institute of Arts; Mark M. Johnson, Director, Pamela Bransford, Registrar, Montgomery Museum of Fine Arts; Heather Haskell, Director, Wendy Stayman, Collections Administrator, Diane Waterhouse Barbarisi, Assistant Registrar, Barbara Plante, Rights and Reproductions, Museum of Fine Arts, Springfield, Massachusetts; George Ewert, Director, Dave Morgan, Curator of Collections, Museum of Mobile; Robert MacDonald, Director, Phyllis Magnusson, Curator, Kaia Black, Registrar, Museum of the City of New York; Earl A. Powell III, Director, Lisa Coldiron, Assistant, Modern and Contemporary Art, Judith Cline, Associate Registrar, Alicia B. Thomas, Loans Officer, Peter Huestis, Department of Visual Services, National Gallery of Art, Washington, D.C.; Marc F. Wilson, Director, Julie Mattson, Registrar, Nelson-Atkins Museum of Art; E. John Bullard, Director, Gail Feigenbaum, Chief Curator, Paul Tarver, Registrar, Jennifer Ickes, Associate Registrar, New Orleans Museum of Art; Lawrence Wheeler, Director, John Coffey, Associate Director of Collections, Carrie Hedrick, Registrar, Marcia Erickson, Assistant Registrar, North Carolina Museum of Art; Kevin Sharp, Curator, Karol Lurie, Curatorial Department Administrator, Kathleen Mrachek, Curatorial Research Assistant, Norton Museum of Art; Jan Keene Muhlert, Director, Beverly Balger Sutley, Registrar, Palmer Museum of Art; Anne d'Harnoncourt, Director, Dilys Blum, Curator, Howard Sutcliffe, Conservator, Nancy Wulbrecht, Registrar, Stacy Bomento, Rights and Reproductions, Philadelphia Museum of Art; Marcia Y. Manhart, Executive Director, Christy Fasano, Registrar, Philbrook Museum of Art; Robert H. Frankel, Director, Robert Henning, Chief Curator, Tiele Larson, Rights and Reproductions, Santa Barbara Museum of Art; James Clifton, Director, Leslie Scattone, Registrar, Sarah Campbell Blaffer Foundation; Maura A. Ryan, Associate Provost, University of Notre Dame, Charles R. Loving, Director, Robert Smogor, Registrar, Snite Museum of Art, University of Notre Dame; Peter Morrin, Director, Charles C. Pittenger, Registrar, Lisa Parrott Rolfe, Associate Registrar, Susie Loredo, Assistant Registrar, Speed Art Museum; Guy Vadeboncoeur, Chief Curator, Sylvie Dauphin, Collections Services, Stewart Museum at the Fort; Diane B. Lesko, Executive Director, Beth Moore, Assistant Curator, Telfair Museum of Art; Myra Walker, Director, Texas Fashion Collection,

University of North Texas; Hal Fischer, Director of Exhibitions, James Peterson, Administrator, Timken Museum of Art; Roger Berkowitz, Director, Patricia J. Whitsides, Registrar, Nicole Rivette, Registrar Assistant, Toledo Museum of Art; Kathy Halbreich, Director, Gwen Bitz, Registrar, Heather Scanlan, Assistant Registrar, Ann Gale, Rights and Reproductions, Walker Art Center.

I also extend my sincere appreciation to the private collectors and individual artists who graciously loaned objects to the show, including Anne and William J. Hokin; Gotscho and his representative, Deborah Irmas; Matthieu Manche and his representative, Natsuko Odate; Christian Lacroix; Annette Messager; and Marie-Ange Guilleminot.

In addition to The J. L. Bedsole Foundation, the museum is grateful to the following for financial and programmatic support for the exhibition: the Alabama Humanities Foundation, the National Endowment for the Arts, the Alabama Bureau of Tourism & Travel, the Bay Area Art Educators, and Dogwood Productions, Inc.

Our wonderful corps of volunteers have contributed significantly to the exhibition, especially Xanthy Stavropoulos, Paige Renée Muratore-Myrick, Mary Herring, Patrice Baur, and Dr. Robert Bantens.

Cécile Peyronnet, Cultural Attaché, and Johana Nadler, Assistant Cultural Attaché, French Consulate, Atlanta, and Yves Sabourin in Paris have lent invaluable support in aiding our communications with France.

For the catalogue, we were lucky to have the capable participation of essayists Kimberly Chrisman Campbell, Melissa Leventon, and Sean M. Ulmer. I would also like to thank our colleagues at Marquand Books, especially Ed Marquand, Amy Cilléy, Susan Kelly, Matt Lechner, Jennifer Sugden, and Marie Weiler, for their skilled production of the book. I'd especially like to thank our editor, Suzanne Kotz, for her many talents, particularly her patience!

The board of directors of the Mobile Museum of Art have demonstrated great vision in supporting this project and have been invaluable advocates to the museum and its programs. Lastly, I would like to thank the staff of the Mobile Museum of Art, all of whom have contributed their unique talents to the exhibition: Dr. Paul Richelson, Arthur Alexander, Regenia Blanchette, Marjorie Brumfield, Mark Davis, Rubye Dreading, Lynne Edwards, Danny Goodwin, Christina Hamilton, June Harter, Rowena Van Hoof, Donan Klooz, Meredith Madnick, Silvanus Newton, Jr., Virginia Otts, Jacqueline Pettaway, Cindy Raymond, Steve Roberts, Albert Robinson, Jr., and Ora W. Wormsby.

Joseph B. Schenk

Index